SACRED CONSUMPTION

SACRED CONSUMPTION
FOOD *and* RITUAL *in* AZTEC ART *and* CULTURE

ELIZABETH MORÁN

UNIVERSITY OF TEXAS PRESS
Austin

This book is a part of the Latin American and Caribbean Arts and Culture publication initiative, funded by a grant from the Andrew W. Mellon Foundation.

Copyright © 2016 by the University of Texas Press
All rights reserved

First edition, 2016

Requests for permission to reproduce material
from this work should be sent to:
Permissions
University of Texas Press
P.O. Box 7819
Austin, TX 78713-7819
http://utpress.utexas.edu/index.php/rp-form

LIBRARY OF CONGRESS CATALOGING-IN-PUBLICATION DATA

Names: Morán, Elizabeth, Ph.D., author.
Title: Sacred consumption : food and ritual
in Aztec art and culture / Elizabeth Morán.
Description: First edition. | Austin : University of Texas Press, 2016. |
Series: Latin American and Caribbean arts and culture publication
initiative (Andrew W. Mellon foundation) | Includes bibliographical
references and index. | Description based on print version record
and CIP data provided by publisher; resource not viewed.
Identifiers: LCCN 2015043235 (print) | LCCN 2015044243 (e-book)
ISBN 9781477310595 (cloth : alk. paper)
ISBN 9781477310694 (pbk. : alk. paper)
ISBN 9781477310700 (library e-book)
ISBN 9781477310717 (non-library e-book)
Subjects: LCSH: Aztecs—Food. | Food in art. | Food—Social
aspects—Mexico. | Aztec art—Themes, motives. | Aztecs—
Social life and customs. | Art, Mexican—History.
Classification: LCC F1219.76.F67 (print) |
LCC F1219.76.F67 M67 2016 (e-book)
DDC 394.1/20972—dc23
LC record available at http://lccn.loc.gov/2015043235

doi:10.7560/310595

*To Mayra, for her endless knowledge
and willingness to always share it*

CONTENTS

PREFACE ix

ACKNOWLEDGMENTS xi

INTRODUCTION 1

CHAPTER 1
CEREMONIAL CONSUMPTION IN EVERYDAY LIFE 15

CHAPTER 2
FOOD IN AZTEC PUBLIC RITUAL 37

CHAPTER 3
AZTEC MYTHS, COSMOVISION, AND FOOD 63

CHAPTER 4
FOOD AND RITUAL AFTER THE CONQUEST 79

EPILOGUE
SOME FINAL THOUGHTS ON FOOD 95

APPENDIX 103

NOTES 107

BIBLIOGRAPHY 123

INDEX 133

PREFACE

This research began as a seed when I came across the funeral portraits of the nineteenth-century Mexican photographer Juan de Dios Machain. In so many images, a child appeared along with offerings of food and flowers. Almost always present was the maize offering. As an art historian working on Mesoamerican art, I began wondering about food rituals in Aztec culture. What foods were depicted in art? What was the context for these representations? What can this tell us about Aztec culture and Mesoamerica in general?

Food rituals are certainly not unique to the Aztecs; every culture on earth, ancient and contemporary, has set rituals that involve food. The Aztecs, like all Mesoamerican peoples, connected many of their food-related rites to agricultural activities. However, this study illustrates that food is much more than a symbol of agricultural abundance in rituals: food gives meaning to the many facets of the Aztec worldview.

Celebrations during the 365-day solar calendar demonstrate the complexity of meanings in food rites. Maize could appear as a food offering for consumption, but it could also be used as a weapon to torture soon-to-be sacrificial victims. Food could identify a person: bride, groom, newborn child, old person, priest, ritual participant, or sacrificial victim. It could also mark time, both cosmic and mundane. For example, food use in ritual marked when a child became a functioning member of Aztec culture, but it also marked the creation and destruction of the five "eras" of the Aztec world. Time and space are created and destroyed by consumption.

The absence of food, whether voluntarily (as fasting) or not (as hunger), is just as powerful in Aztec ideology and rites as the foods themselves. In the Aztec rituals recorded in ethnographic sources, individuals who fast have access to benefits that others do not. In Aztec myth,

food absence due to natural disasters is of course a clear indication of something misaligned in the cosmic ordering of things.

Food always comes from and goes back to the earth. This cyclic pattern is repeated in Aztec rituals and is part of the larger Mesoamerican ideology on the nature of the relationship between humans and gods. The ebb and flow of that relationship, much like the movements of a river, is never the same. French anthropologist Maurice Godelier writes that "reciprocal exchanges of benefits can never be truly reciprocal, since the benefits that are shared and given are never equivalent."[1] The abundance of the earth received by the Aztec people was often sustained by sacrificial blood offerings but also by following strict food regulations in ritual. The scholar Ptolemy Tompkins writes: "The fate of most things in the natural world is to be eaten."[2] Consumption is part of that reciprocal relationship between people and divine powers; food received is consumed, ingested, and eventually returned to the earth. That is the order of things.

ACKNOWLEDGMENTS

This project has been worked on for many years, covering many different parts of my life—as scholar, colleague, wife, sister, and daughter, among many others. Therefore I have numerous individuals and institutions to acknowledge.

I have been fortunate to meet a great many creative and supportive individuals through my teaching and scholarship and I would like to thank in particular Susan Mullally and Caroline Garrett Hardy, who have been colleagues, sisters, mentors, and mothers to me. I appreciate the many conversations that I had with Dr. Angela Herren Rajagopalan on research, the Mexicas, Mexican manuscripts, and life in general. Her friendship and support have been invaluable. I am greatly indebted to Dr. Eloise Quiñones Keber for sharing her love of Mesoamerican cultures and art with me and for guiding me as a graduate student and now as a colleague.

This project would have never been completed without the help of my husband, Jeffrey Clayton, who understood that it was his turn to cook dinner again because I was working on "the book." His patience and generosity are boundless. I would also like to thank my family, the Morán clan, for their support and love. My sister Mayra has been my constant cheerleader since I went from crawling to walking. It is to her that I dedicate this book. I thank my parents, María and Heriberto, for allowing me to follow my passion.

I would like to thank my home institution, Christopher Newport University (CNU), Newport News, Virginia, specifically my colleagues in the Department of Fine Art and Art History, who have always supported my research endeavors. It has been a privilege to work alongside such generous faculty. I also thank the many art and art history students at CNU who wanted to know more about my work and were excited to learn about Mesoamerican art and cultures.

Many individuals at museums and archives helped me throughout this research, and I would like to thank those at the Brooklyn Museum of Art, New York; the National Museum of the Native American Indian, Washington, DC; El Museo del Templo Mayor, Mexico City; and El Museo Nacional de Antropología, Mexico City. Finally, I am extremely grateful to the editors at the University of Texas Press, especially Kerry Webb, who worked so patiently with me on this manuscript.

SACRED CONSUMPTION

INTRODUCTION

The people popularly known as the Aztecs are often introduced and discussed from the point of their contact and eventual conquest by Europeans in the sixteenth century. The Aztec story seems to run backward in history, starting with their "end" rather than their beginning. But this common narrative is neither the end nor the beginning; it is simply one version of the history of these people. The Aztec culture was one of many cultures that existed in the Americas. From Alaska to the Caribbean and South America, Amerindian populations existed with various forms of political order, population size, and religious concepts. The Aztecs are part of Mesoamerican cultures that extend from modern-day Mexico to various southern areas, including Honduras and Belize. Mesoamerican cultures such as the Olmec, Zapotec, and Maya peoples shared similar religious ideologies based on nature and the universe, such as analogous similar constructions of creation accounts and deities. These people also created monumental art and architecture to communicate their ideologies and developed similar cultural characteristics, like the use of calendars and ritual sacrifice.[1]

The Aztecs were relative latecomers to the long history of Mesoamerican peoples. Their migration accounts suggest that they came from a place called Aztlan in the twelfth century, founded the settlements of Tenochtitlan and Tlatelolco in the Central Basin of Mexico around 1325, and became partners with the cities of Tetzcoco and Tlacopan to establish the Triple Alliance in the 1430s. The Aztecs were in fact divided into various groups who spoke the same language, Nahuatl, including the Mexicas. Scholars often refer to the group that founded the settlements at Tenochtitlan and Tlatelolco as "Mexica," a name that they assumed during the migration.[2] Elizabeth Hill Boone comments that these stories of the Aztec rise to power in the Basin of Central Mexico should be read as ritual drama that was reenacted

and communicated through their pictorial manuscripts. Rather than taking these accounts as either historical or mythical narratives, she suggests that we might want to view them as the way in which the Aztecs chose to transform themselves from one location/identity to a different space and identity: from Aztlan to Tenochtitlan, from Mexicas to Aztecs.[3]

The Aztecs reached their ascendancy in the fifteenth and sixteenth centuries before the Spanish conquest of 1521. At that time, the population in Tenochtitlan was believed to be about 200,000 people, with a basin-wide population between 1 million and 2.65 million.[4] While we use the term "empire" for the Aztecs' imperial organization, scholars like Michael Smith have noted that they were not like other empires, whose armies and ruling class interfered greatly in conquered areas.[5] Rather, as long as the conquered provinces continued to pay their tributes, Aztec emperors were content to leave them alone. Other scholars have noted that even in the case of deities the Aztecs preferred to assimilate elements in a syncretic manner, integrating gods from diverse sources.[6]

In fact, it is clear from Aztec art that they also assimilated elements from earlier cultures: skeletons, warrior images, feathered serpents, and *chacmool*s (reclining sculptures of a fallen warrior used as receptacles for sacrificial offerings) were all derived from earlier cultures like the Huastecs, Toltecs, and the people who settled sites such as Cacaxtla and Xochicalco.[7] Their visual culture encompassed sculptural forms from a broad range of materials that included stone and wood but also more perishable materials such as paper, resin, and dough. Even with the massive destruction of war during European contact and systematic destruction of religious and cultural materials during the colonial period, the Aztecs left behind a wealth of artworks.[8] Every few years there is a blockbuster exhibition at a museum featuring Aztec art. Numerous artistic traditions like featherwork and manuscript painting continued into the colonial period. Additionally, many Aztec cultural traditions continue into the modern era. Many scholars have noted the use of maize and paper in contemporary ritual culture.[9]

SACRED CONSUMPTION: FOOD AND RITUAL IN AZTEC ART AND CULTURE

This manuscript is about the ritual use and meaning of food in Aztec culture. Food and eating are part of daily existence. They also play im-

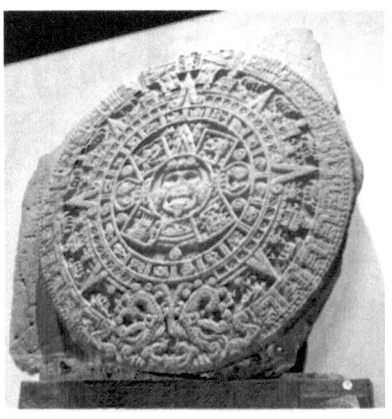

0.1
Detail of the Sun Stone, from the Museo Nacional de Antropología, Mexico City, Mexico. Author's own photo.

0.2
Relief of Tlaloc-Tlatecuhtli underneath the Coatlicue statue, from the Museo Nacional de Antropología, Mexico City, Mexico. Courtesy of the Museo Nacional de Antropología.

portant roles within a society: they commemorate significant events and give meaning to social and religious activities. Integral to a society on many levels, food is often a cultural reflection, mirroring what is significant to a particular group.

The Aztecs depicted eating and foodstuffs in an array of artistic mediums. They painted images of people preparing, transporting, and storing foods as well as the foods themselves. Many of these images come from postconquest sixteenth-century manuscripts such as the Spanish friar Bernardino de Sahagún's *General History of the Things of New Spain*, also referred to as the *Florentine Codex*.[10] Aztec artists rendered fish, birds, and other animals as well as plants and vegetables in stone, wood, clay, and paint. They also created stone and clay images of deities that were connected to foods, such as sculptures of maize deities. Food was sometimes used in Aztec ceremonies to create images of deities. Beans, squash, amaranth, and maize dough were shaped into the likeness of a god or goddess. There are also countless images of teeth and open mouths, which are sometimes devouring, as seen in canonical works like the Sun Stone and representations that include the earth lord Tlatecuhtli (figs. 0.1 and 0.2).

Food was an integral part not only of the Aztecs' daily subsistence but of the ways in which they viewed their larger world. Among other subjects, comprehensive sixteenth-century works by Sahagún and

INTRODUCTION

his Dominican contemporary Diego Durán document ceremonial practices that included the use of foods.[11] It is no surprise that the foods used in those religious rituals were staple items such as maize and beans. The historian Felipe Fernández-Armesto writes: "Staples are almost always sacred, because people depend on them: they possess divine power. The fact that staples in their turn usually depend on people for cultivation does not seem to compromise their sacred status."[12] This is particularly true of the Aztecs' main staple, maize, which needs human intervention for its cultivation. Yet it was also one of the most widely used foods in Aztec ritual.

The aim of this book is to analyze how these basic foods were transformed into sacred elements within particular Aztec rituals and how food in turn gave meaning to the rituals performed. Although feasting and consumption are often seen as a secondary aspect of ritual performance, a close examination of food rites in Aztec ceremonies demonstrates that rituals were in fact significant because food was *present* or in some cases significantly *absent*. In comparing textual and pictorial sources, it becomes evident: for the Aztecs, not only were foods transformed in ritual performances through a physical or symbolic metamorphosis but the rituals themselves were transformative because of the use of food.

Food takes on a supernatural role in Aztec mythology by being the catalyst for cosmic change. For example, one myth in the anonymous Legend of the Suns recounts how each cosmic age began and ended in connection with the eating of specific foods or the conversion of humans into foodstuffs.[13] Deities are transformed into food in some myths. For example, the god Xolotl (Dog or Twin) tries to escape Death by transforming himself into three different foods: maize, maguey, and a salamander.[14] In another story, the creation of the world and everything in it, including food items necessary for the continuation of life, comes about through the transformation of the remains of a dead (or sacrificed) creature.[15] In the "Historye du Mechique," the gods Quetzalcoatl and Tezcatlipoca tear apart the body of a large crocodilian creature, a symbol of the earth itself. From her body came the heavens, the earth, and all its bounty.

While these cosmic transformations relegate food to a supernatural realm, changes in food are also part of a natural process. The cycle of a maize seed growing into a plant, which in turn is harvested and prepared in various ways, is a powerful example of a food's transformation from one state to another. Rituals performed in Aztec agricultural ceremonies often paralleled the natural metamorphosis of food.

In the agricultural ceremony called Hueytecuihuitl (Great Feast Day of the Lords), in honor of the young maize goddess Xilonen, tortillas of green maize and cooked amaranth greens were eaten.[16] This communal meal was fitting for a celebration of the young fertility goddess, whose domain included the young and tender stages of maize and other plants.

To explore the role of food in Aztec life, I rely on primary sources that encompass indigenous and Spanish sixteenth-century accounts as well as the wealth of remaining Aztec artworks. Whereas eating and rituals have been scrutinized independently (the former primarily by anthropologists and the latter by religious specialists), my project on food and ritual in Aztec art is the first integrated study by an art historian. Recent studies have treated the ritual dimensions of Aztec social life,[17] but none has dealt specifically with eating and ritual. Much extant information on the Aztecs depends on visual culture, particularly painted manuscript images and an enormous corpus of sculptural works, so it is crucial to incorporate them into the ongoing dialogue on Aztec ritual practices. Most importantly, my study explores the everyday and ritual as intertwined aspects of life, a point of view that is more in keeping with Aztec philosophy.[18] The acts of eating and the various rituals performed by the Aztecs were not relegated to separate realms; instead these sacred acts were allied with everyday life. Women, for example, performed daily rituals in the home that mimicked those performed by priests and priestesses in the temples and at shrines.[19]

A NOTE ON SOURCES

My project employs an interdisciplinary approach, utilizing research on food, religion, and ritual from anthropology, archaeology, and religious studies in addition to art history. An interdisciplinary approach is necessary because only this kind of cross-cultural investigation allows a multilayered understanding of both eating and religious ritual in Aztec thought and culture. In gathering sources, my project uses what Davíd Carrasco calls an "ensemble approach," integrating a variety of sources and types of evidence such as pictorial manuscripts, colonial texts, sculpture, ceramics, and other forms of art.[20] When played or experienced together, these form a fuller picture of the key role of consumption in Aztec ritual.

VISUAL SOURCES

The Aztecs were prolific artists who created food imagery in many mediums. My manuscript includes a discussion of objects that are now in many museums across the United States and Mexico. I also make use of figural works, including deity statues and monumental sculptural art, such as the Sun Stone, many of which were found in the Aztec capital of Tenochtitlan, as well as smaller pieces that are now on display at museums such as El Museo Nacional de Antropología and the Templo Mayor Museum, both in Mexico City.

Fundamental to my project are copies of sixteenth-century pictorial manuscripts that illustrate Aztec deities, religion, and ritual. Foremost among these manuscripts is the Codex Borbonicus,[21] which contains detailed images of the eighteen agricultural and feasting ceremonies that the Aztecs staged yearly. Other painted manuscripts that are essential to the study of rituals are the Codex Magliabechiano and the Codex Telleriano-Remensis.[22] Pictorials that illustrate and describe the Aztec migration such as the Codex Boturini and the Codex Azcatitlan are also relevant to this study.[23] Manuscripts that give information about Aztec "daily" life, such as the Codex Mendoza, as well as the lavishly illustrated works of Fray Diego Durán and Fray Bernardino de Sahagún are also used in this study. While based on preconquest sources, the images in these volumes were created in the post-conquest period by indigenous artists who blended visual components from both old and new worlds.

PRIMARY WRITTEN SOURCES

Written texts for this project encompass primary accounts from indigenous, mestizo, and European writers, written mainly in the sixteenth century. They include works gathered by Spanish missionaries such as Sahagún and Durán as well as accounts by Sahagún's fellow Franciscan, Fray Toribio de Benavente (Motolinía),[24] the mestizo historian Hernando Alvarado Tezozomoc, who produced the *Crónica mexicana* in the sixteenth century,[25] and others. In 1589 Tezozomoc wrote his history of the Aztecs and their kings from the fourteenth-century to the arrival of the Spaniards. He was the great-grandson of the Mexica ruler Axayacatl (ruled 1469–1481) and grandson of Moctezuhma Xocoyotzin II (ruled 1502–1520).[26]

Sahagún arrived in New Spain in 1529 (eight years after the con-

quest), learned Nahuatl, and with the assistance of Nahua elders, assistants, and artists compiled what is literally an encyclopedia of Aztec culture and religion.[27] The Franciscan's writings, as well as his collection of painted images, continue to allow scholars the opportunity to reinterpret Aztec culture and conduct an ongoing dialogue about Aztec religion and art.[28] Diego Durán was brought to Mexico as a small child and lived in Tetzcoco after moving to New Spain.[29] He had joined a Dominican monastery by the age of nineteen and, like Sahagún, took great interest in recording the history and customs of the indigenous population, although he often seems less sympathetic in his descriptions and writings.[30] Arriving in Mexico in 1524 as one of the original "twelve" Franciscan missionaries, Toribio de Benavente (Motolinía) spent several years writing a history of New Spain, which he completed in February 1541.[31] His writings on the rituals and customs of the Aztecs contain valuable information and add another rich layer of understanding to the works of Sahagún, Durán, and Alvarado Tezozomoc.

Although later than these works, the writings of the priest Hernando Ruiz de Alarcón, completed in 1629, are helpful in examining the survival of food rituals after the conquest. Ruiz de Alarcón was born in Taxco, Guerrero, and served as a parish priest in the town of Atenango.[32] He began compiling his *Treatise on Superstitions* as early as 1617. Although his work is not from the Basin of Mexico, it provides a valuable supplement and contrast to the earlier writings of Sahagún, Durán, and Motolinía. All of these postcontact works certainly reflect a European mind-set and recount events through a European lens, but they are essential in providing an eyewitness look into the indigenous and early colonial Aztec worlds.[33]

SECONDARY SOURCES: RITUAL

Sahagún, Durán, and Motolinía were some of the first Europeans to observe, describe, and examine Aztec ritual. Their writings have provided a solid foundation for later scholars. Earlier scholars of the Aztecs focused their work on the identification and classification of deities and rituals, with the emphasis on exploring the Aztec calendar and its relation to ritual. The Mexican archeologist and scholar Alfonso Caso's *El pueblo del sol* and *El calendario mexicano*, for example, are still significant in their scope and breath. Shorter but just as significant for the foundation of ritual studies is ethnohistorian H. B.

Nicholson's "Religion in Pre-Hispanic Central Mexico," a seminal work on the many aspects of Aztec religion and ritual to which current scholars continue to refer. Also important are the investigations of anthropologists working in Mexico such as Alfredo López Austin, Miguel León-Portilla, Johanna Broda, and Doris Heyden, who have written at length on Mesoamerican rituals, cosmovision (worldview), and ideology.[34]

More recently, study of Aztec ritual has moved from classification to conceptualization and more theoretical treatment. In *Aztec Ceremonial Landscapes*, for example, scholars from various disciplines explore the different dynamics that reinforced the Aztec ritual world, such as the marketplace, warfare, and ritual as performance. Aztec ritual as performance is also the central theme of *Representing Aztec Ritual: Performance, Text, and Image in the Work of Sahagún*, a collection of essays by an interdisciplinary group of authors who focus on ritual images in the *Primeros memoriales* and *Florentine Codex*.[35] Aztec ritual has also been explored in connection with the creation of identity in indigenous populations in *Cosmovisión, ritual e identidad de los pueblos indígenas de México*, another collection of essays by Mexican scholars.[36]

Although it is a major component of Aztec ritual, food has been only minimally explored and is usually secondary to other notions such as landscape. Such, for example, is the central theme of historian of religions scholar Philip P. Arnold's *Eating Landscape: Aztec and European Occupation of Tlalocan*. Although most scholars of ritual have recognized the significance of feasting and food in Aztec rituals, no major work has focused on this area. This book is intended to remedy this omission.

A NOTE ON RITUAL

A lot has been written about ritual. By no means do I desire to provide a full historiography of the study of ritual in Mesoamerica. However, some studies that have proven particularly useful to this manuscript should be noted. The social variation of public/private and state/popular categories in Aztec rituals defined by archaeologist Michael Smith is important. Smith differentiates between rituals that are performed (1) outside, in open, public spaces and organized by the state; (2) in private by rulers, priests, and other state officials; (3) outside, in open, public spaces and organized by the public; and (4) in private and organized by the public.[37]

Smith notes that this differentiation does not encompass the totality of social variation in Aztec ritual and that different types of ritual have varying social implications. In this study I borrow this classification of public/private and state/popular yet emphasize that many Aztec rituals might fall in between two or more of these categories. Additionally, as noted by Smith, many of the sources in which "rituals" are recorded come from chroniclers who mostly emphasize state and public ritual.[38] This of course poses a challenge to those of us studying Aztec ritual.

SECONDARY SOURCES: FOOD AND CONSUMPTION

For the most part, food and feasting as a topic of Aztec scholarship has been largely ignored by scholars. Perhaps exploring a subject that evokes pleasure and the senses on various levels is not regarded as worthy of serious research. Anthropologist Brian Hayden has noted that, despite the many descriptive accounts of feasts in earlier ethnographies, few anthropologists have addressed the theoretical importance of feasting.[39] Within recent years, however, several studies have shown how important feasting is for understanding cultural processes.[40] Among these works are food studies such as Gary Paul Nahban's *Coming Home to Eat: The Pleasures and Politics of Local Foods* and Jeffrey M. Pilcher's *¡Qué Vivan los Tamales! Food and the Making of Mexican Identity*. Particularly important to my project are works that specifically deal with food in Mesoamerica, before and after the Spanish conquest. One of the earliest and most influential food studies is historian Alfred Crosby's *The Columbian Exchange: Biological and Cultural Consequences of 1492*. Crosby's work was one of the first serious studies of the conquest in terms of food exchange and is often cited by later scholars.

Anthropologist Sophie Coe's *America's First Cuisines* is an important study that examines food and its significance for indigenous cultures. In *The True History of Chocolate*, she and anthropologist Michael D. Coe focus on chocolate and its significance before and after European contact. More recent works include historian John C. Super's *Food, Conquest, and Colonization in Sixteenth-Century Spanish America* and an interdisciplinary Mexican collection titled *Conquista y comida: Consecuencias del encuentro de dos mundos*, edited by Janet Long, who has continued to work on several other food studies specific to Mexico, most recently *Food Culture in Mexico*.[41] In the last several years, there has been a focus on identity and cultural history of food

with publications such as Paula Morton's *Tortillas: A Cultural History* and Enrique Salmón's *Eating the Landscape: American Indian Stories of Food, Identity and Resilience*.

Innovative studies on feasting as ritual and on domesticity as part of the sacred realm are also relevant. Both historian of religion Kay Almere Read and anthropologist Michael Smith address the role of the everyday in the creation of the sacred.[42] Anthropologist Elizabeth Brumfiel and ethnographer Yólotl González Torres are pioneers who have begun to examine feasting as ritual in Mesoamerica.[43]

While my work makes use of these various studies, it is decidedly different in nature from them because it focuses on the role that food played within ritual and, specifically, the role of basic staples in highly sacred religious activities. Through history and surviving works of art, it examines the ritual use of food from the beginning of Aztec mythic history through contact with Europeans. It thus allows for an examination of specific foods and rituals that survived the conquest, the ways in which they were recorded after contact, and the reasons why.

A NOTE ON FOOD PRODUCTION

Agricultural work was neither the primary type of occupation nor the major basis for household subsistence in the city of Tenochtitlan.[44] The Aztecs employed various agricultural methods on the lakeshore and beyond to provide some form of sustenance for the general population. Among these were chinampa agriculture, terracing, and multicropping. Chinampas are artificial planting areas built up from mud scooped from the bottom of a lake or freshwater swamp, held in place by posts and roots, and separated by canals.[45] The narrow size of the plots allowed for an intense porosity of the soil. Chinampas received enough moisture to provide a continuous, stable, and intensive agriculture. Through these methods the yield of chinampas in Aztec times was high.[46] Edward Calneck's work from the 1970s demonstrated that chinampas existed in Tenochtitlan in various sizes but were not always included in city planning.[47] Household gardens were created spontaneously by individuals and were not part of the larger state agricultural organization. These small chinampa plots were used as a source of garden vegetables. Others shared larger plots, allowing several families to be sustained from their yield, while some parts of Tenochtitlan were completely chinampa free.[48] While chinampa agriculture was fundamental for the Aztecs, it certainly did not provide for all the food needs

of the city. The Aztecs did, however, develop chinampa technology to its fullest potential, expanding the existing chinampa system to cover more than seventy-five square miles to support as many as 100,000 people.[49]

Sahagún's artists illustrate yet another agricultural technique employed by the Aztecs. Farmers would often intercrop plants, mixing various crops on one patch of land. Maize was often intercropped with beans and squash, as illustrated in Sahagún's *Florentine Codex*. Experiments have shown that multicropping decreases the risk of weeds and parasites and therefore increases crop yields.[50] The Aztecs used their natural resources to the best of their abilities. Extremely productive labor-intensive chinampa agriculture was used throughout the city, lakeshores were also irrigated, and banks were terraced.[51] This broad range of techniques allowed for a maximum utilization of available land.

Although the southern district of the Basin of Mexico was heavily used for chinampas or artificial planting areas, most of the foodstuffs consumed came into the city through trade and tribute. Sophie Coe notes that the Codex Mendoza gives the average amount of tribute from each province as twenty-eight *troxes* of maize, twenty-one each of beans and chia, and eighteen of amaranth.[52] Raw foods included squash, honey, cacao, and chiles, among many other things. In addition, the Aztecs received many other types of foods already prepared, including several meat dishes.[53]

The Aztec tribute system was a useful method of supplementing not only the food needs of Tenochtitlan but its labor needs as well. A tribute workforce could be redistributed to provide better service for the urban population and ruling elite. Men and women supplied the labor for cooking and other food preparation as well as labor in the marketplace. Labor redistribution was intricately organized by the Aztec state.[54]

ORGANIZATION OF CHAPTERS

Chapter 1, "Ceremonial Consumption in Everyday Life," explores verbal and visual descriptions of ritualized eating, particularly in ceremonies recorded in Sahagún's *Florentine Codex*, Durán's *The History of the Indies of New Spain* and *Book of the Gods and Rites* and *The Ancient Calendar*, and painted sixteenth-century manuscripts like Codex Mendoza. This chapter examines the role of feasting in Aztec culture

in both domestic contexts, such as those having to do with life cycle events (births, marriages, funerals), and household ceremonies.

Chapter 2, "Food in Aztec Public Ritual," examines the role food and feasting played in specific *veintena* ceremonies (a series of eighteen public ceremonies performed annually in accordance with the 365-day solar calendar) as represented in both textual descriptions and related images of ritual activities. Of greatest relevance are ceremonies in which everyday grains such as maize and amaranth become sacralized. Through the *veintena* depictions we can best understand how food served as both an everyday and a cosmic sustenance. My study demonstrates that food was a multifaceted element in *veintena* ceremonies, used in a variety of ways that included the ephemeral and esoteric. For example, food was sometimes transformed into a threat of violence and sometimes used as a weapon.

Chapter 3, "Aztec Myths, Cosmovision, and Food" introduces the role food played in Aztec culture in the Basin of Mexico. It focuses on the importance of food throughout the Aztecs' history, from their nomadic beginnings in the late twelfth century to their rise in power in the fifteenth century in the Basin of Mexico.[55] It begins with a discussion of the first foods as recorded in various pictorial migration accounts and anonymous textual manuscripts such as the "Leyenda de los soles," "Histoyre du Mechique," and "Historia de los mexicanos por sus pinturas," which reveal the importance of food in Aztec myth and early history.[56] Painted historical manuscripts, such as the Codex Azcatitlan and Codex Boturini, illuminate the relationship between food and Aztec history and society, beginning with the migration period.[57] These works show that food was vital in Aztec migration stories, creation myths, and their overall worldview.

Chapter 4, "Food and Ritual after the Conquest," examines what happened to food rituals and representations after the Spanish conquest in 1521. It discusses food in the early colonial period (ca. 1521–1600), changes in pre-Hispanic eating patterns, the introduction of new foods, and the food-related rituals that survived. Of specific interest are whether first foods such as maize remained important and whether myths relating to food continued to be significant after the conquest. This chapter also examines the new ways in which foods were used in hybrid rituals that reflected a merging of indigenous and European cultures. It makes use of postconquest images found in colonial pictorial manuscripts as well as murals like those in the cloister of the sixteenth-century Augustinian monastery of Malinalco.

The epilogue presents final thoughts about food, art, and ritual. It

summarizes the findings of the preceding chapters about the role of food in Aztec thought as seen in origin and migration accounts, Aztec art, and ritual performance, especially the way in which basic staples became sacred substances in ritual use. The epilogue emphasizes the role of food as a symbol of transformation and a metaphor for cosmic continuity. After noting the changes brought about by contact with Europeans, it briefly considers continuities in the use of pre-Hispanic foods in the daily life and ritual practices of modern-day Mexico.

CHAPTER 1
CEREMONIAL CONSUMPTION
in EVERYDAY LIFE

The various everyday foods available to the Aztecs of central Mexico formed an important component of ceremonial and ritual activities. These occasions ranged from domestic activities such as births and marriages to state-sponsored religious, political, and agricultural events, often associated with fertility deities. Everyday staples such as maize and beans were eaten, along with special foods such as amaranth and chocolate. This chapter examines feasting in Aztec culture, focusing on domestic rituals that include life-cycle events and household ceremonies.

It would be simplistic to think of rituals having to do with the home as private and those having to do with the state as public. This does not correlate with the way in which the Aztecs saw the world and their place it in. Anthropologist Louise Burkhart observes that the Aztec house served as a model of the cosmos: the domestic space was the one in which the Aztec child developed a sense of orientation and time, learned the pattern of the day's activities and the calendrical cycles, and realized that order is fragile and temporary.[1] Indeed, when a child was first named, the children participating in the ritual shouted the new name to the four corners of the universe, indicating that from very early on children and their identity were tied to the Aztec cosmos.[2] The importance of daily life lived in relationship with the cosmos is also evident in the Codex Mendoza, which devotes its third section to the mundane events in an Aztec youngster's life that defined his or her place in the Aztec world.

FEASTING IN AZTEC CULTURE

Cultural anthropologists define a feast in various ways. Some scholars believe that a feast is a form of ritual activity that involves the communal consumption of food and drink, while others identify a feast as a sharing of special foods between people.[3] My own definition of "feasting" includes (1) the aggregation of people; (2) food sharing and food distribution; (3) a specific occasion (for example, to honor ancestors, initiate youth, marry, bury the dead); (4) some form of display; and (5) abundance.[4]

Feasting for the Aztecs was a multifaceted event and involved an array of elements other than food. An Aztec feast could include music, singing, storytelling, dancing, the burning of incense and copal, flowers, tobacco smoking, offerings, and gift-giving, among other activities. A critical requirement was that these items should be provided in abundance. Sixteenth-century chroniclers emphasize this throughout their descriptions of Aztec feasts. Friar Bernardino de Sahagún's informants record that a good feast was one in which guests were given plenty in food and offerings.[5] Friar Diego Durán also notes that "everything was to be created in abundance."[6]

Aztec feasts were also about display of material culture and wealth as well as social and political relations. A feast allowed hosts to make their wealth and power visually evident. In addition to the abundance of food served and offerings made, some feasts required that the hosts provide gifts and lodging to their guests. Durán lists goods that were given to the guests at a feast, including luxury items such as mantles and jewelry.[7] Royal feasts often involved inviting both friends and enemies from afar. These special guests needed to be provided with lodging for several days, if not weeks. The wealth of goods displayed at a feast could often belong to a group or several individuals, allowing for group or class distinction and association.[8]

While the political uses of a feast are significant, it is important to remember that feasts are inherently social events.[9] The sharing of food and drink creates a communal setting. Sahagún's informants describe such a scene:

> There was the giving of pleasure, of much contentment. There was the encouragement of one another, and tearful greetings. And some only hummed, singing secretly, or did nothing. And some did nothing else but sit content and rejoicing, laughing, and making witty remarks, making others burst into laughter as if their sides were sore.[10]

An Aztec feast was never single-minded in its purpose. Due to the complexity of feasting behavior, few feasts had a pure function. In some cases the pretext for a feast, such as a funeral, may have had very different components in dissimilar types of households, such as a poor one versus a wealthy one.[11]

Another important aspect of Aztec feasts, and indeed of feasting in general, is the sequencing or organizing of events. Sequence in a feast can be so structured that it can itself become a ritual.[12] Sahagún's informants note that eating at a feast corresponded to rank. They go on to say: "And thereupon went the server, following him those who changed the courses and carried [the food] in their arms. They served the people, placed them in order, went placing the people in line, putting them all in line."[13] This passage emphasizes social order and structure in Aztec feasting. Davíd Carrasco has also noticed the locative terms used in ritual performance, such as "each person's home," "set them up carefully," and "arrangements of them all in rows" (this emphasis on arrangement is both physical and social).[14] When Sahagún's informants describe the feasting during the merchant's banquet, they note not only the significance of the organization of events but also the way in which the events follow one another: "First he offered one the tobacco tube . . . And then they followed with the flowers . . . And then they followed with the food."[15] In all the ceremonies noted by the sixteenth-century writers, sequence is a significant part of the ritual experience.

DOMESTIC RITUALS AND FEASTING

Many domestic rituals applied to all of the various classes of Aztec society on different occasions, especially life cycle events such as the birth of a child, marriage, or death. But the information recorded in the sixteenth-century derives mainly from the ruling or noble class; most sixteenth-century sources say very little about Aztec commoners. The kind of feasting attached to these rites of passage would have varied not only from household to household but from region to region as well.

CHILD-NAMING CEREMONIES

What Sahagún and other sixteenth-century writers refer to as "baptism" was the indigenous ceremony of bathing and naming a newborn

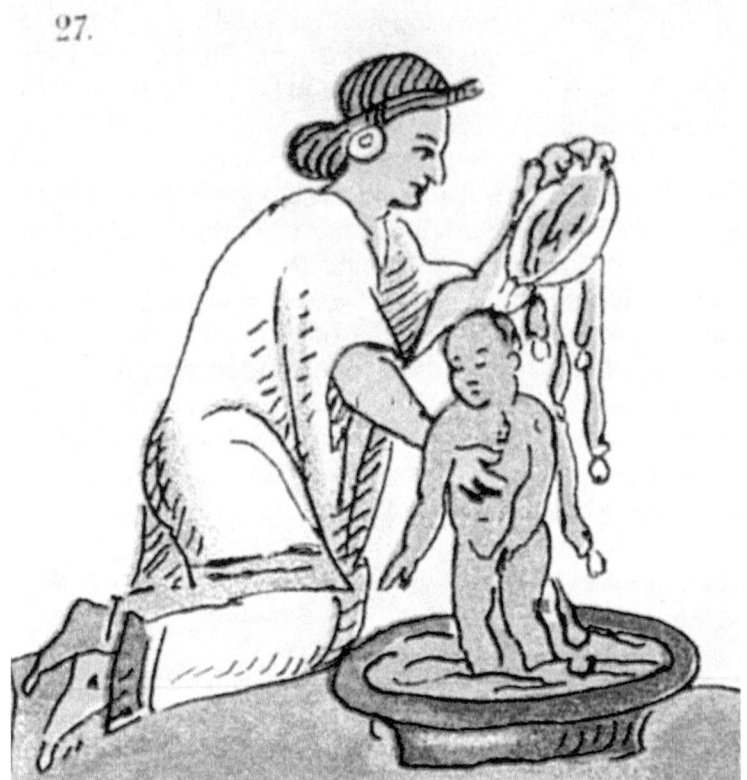

1.1
Ritual bathing of a child, from Sahagún's Florentine Codex, *Books 4–5, figure 27. Courtesy of the University of Utah Press.*

child.[16] This event occurred several days after birth, always on a favorable day determined by the calendar specialist. If the day on which the child had been born was not a good one, then the diviner advised the parents to postpone the event to a more auspicious day.[17]

The event had several components, the first of which was a ritual bathing of the child. Sahagún's artist depicts the child standing in a small tub filled with water, while the midwife pours water from another vessel (fig. 1.1). While the image is certainly influenced by more realistic European art conventions, the indigenous artist has used the pre-Hispanic way of depicting water; small round circles are attached to the streams of water as they fall onto the child's body. In describing the bathing ceremony for a female child, Sahagún's informants write:

When the baby girl was bathed, the midwife placed the water in a new basin. Then she uncovered the baby. Then she raised it as an offering in the four directions; then she lifted it up, she raised it as an offering to the heavens. Then she took the water. First she made it taste the water; then she placed water on its chest; then she poured water on the crown of its head.[18]

The second component of the event involved naming the child. This activity included other children shouting the chosen name through the streets, offering maize and beans and, of course, a feast in honor of the gods. Sahagún's informants note the abundance of food and drink at these feasts.[19]

The Codex Mendoza conflates aspects of the ritual bathing and naming ceremony (fig. 1.2). At the top left (not shown), the mother sits on the ground with the infant in a cradle. Above the infant are four rosettes that refer to the four days after the baby's birth on which the naming ceremony occurred, the day 4 Xochitl (flower). Interestingly, four rosettes are also part of the headdress decoration of the goddess of maize, Chicomecoatl. The indigenous artist uses the Aztec convention of dots and footprints to connect images that are conceptually linked; these dots take the viewer from the baby to the four rosettes to the scene to the right.[20] Here the midwife holds the baby in her hands

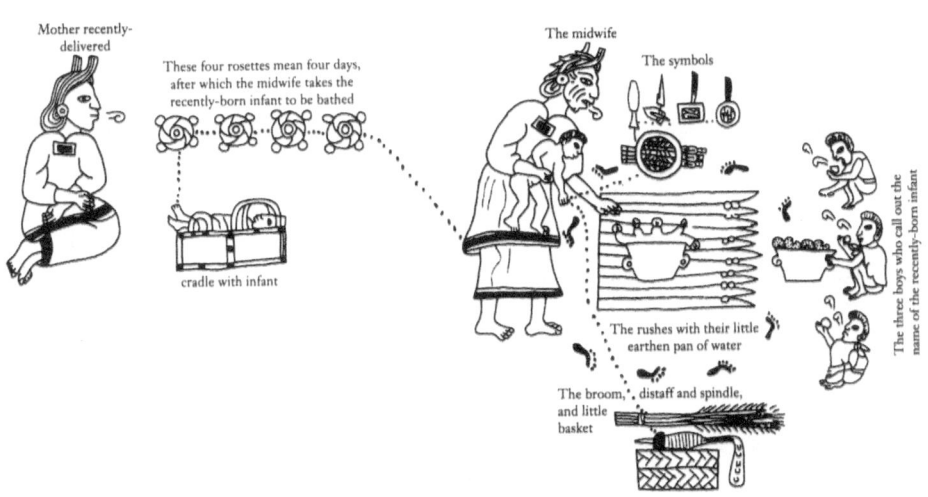

1.2

Drawing of child naming ceremony, detail from Berdan and Anawalt,
The Essential Codex Mendoza, *folio 57r. Courtesy of Dr. Frances F. Berdan.*

as both child and woman lean over a basin filled with water. Across from them are three boys who are eating from a vessel filled with food. Berdan and Anawalt identify the food in the vessel as *izquitl* (parched maize kernels), a food item that Sahagún includes in the list of foods served at the naming ceremony.[21] The three boys would "call out" the new name of the child, and the artist paints speech scrolls emanating from their mouths.

The banquet then held in honor of the child provided not just food and entertainment for guests but also numerous offerings that included tobacco, flowers, and clothing. The preparations described by Sahagún's informants also illustrate the attention to the cuisine that was a part of these feasting ceremonies:

> And some plucked and removed the feathers from birds, and dressed them; or slew, singed, and dressed dogs; or prepared and cooked meat, and braised it in pots . . . They made tamales and wrapped them in husks. They made tamales using dried grains of maize; they made white ones with beans forming a seashell on top, and meat cooked with maize. They made tamales of meat. Some cooked the tamales in an olla. Some washed the maize grains which had been cooked in lime. Some carried and drew water, or poured it. Some broke up, ground, and pulverized cacao beans. Some mixed cooked maize with chocolate. Some cooked stews, or roasted chilis—different kinds of chilis.[22]

This description emphasizes the attention that the Aztecs paid to ceremonial cuisine. A good feast required not only a great diversity of foods but foods that were prepared and presented exquisitely. While child-naming ceremonies occurred across class divisions, Sahagún's description clearly refers to an event that was held by individuals of some wealth. Commoners did not have access to chocolate; nor could they serve an abundance of food to many people. Sahagún's informants mention the need for vigilance by those in charge of the crowds at these well-attended events. Disorganization was not a part of the feast.[23]

The successful feast was one with order, structure, and an abundance of food, drink, and offerings. It was necessary for hosts to provide guests with as much as possible "in order to meet the obligations of banqueting, lest it be said [of the host] that the guests were slighted and found discontent there." In Aztec banquets there was a reciprocal

relationship between host and invited guests. Sahagún's informants note: "No one wished to be deflated or to lose stature; all persons wished to be given recognition, fame and distinction."[24] These comments illustrate the delicately balanced dynamics between the host and guests and the social complexities of these feasting rituals.

The purpose of such a feast indeed went beyond naming a child and introducing him or her to society. All Aztec feasting ceremonies allowed guests and host to carry on social interactions crucial to the workings of a larger society. Sahagún's informants note that when wine was served the server began with those of highest rank. If guests were not happy or satisfied, it was the host's obligation to make them feel better.[25]

In several vignettes Sahagún's *Florentine Codex* illustrates the feasting that occurred in connection with the child-naming ceremony (figs. 1.3–1.6). The image on the top left depicts offerings being given to the guests. Three guests, all male, sit before two huge baskets laden with foodstuffs, perhaps tamales filled with meat. The artist renders them in an animated fashion with speech scrolls enlivening the interaction among them. Two other men approach them with offerings of a bouquet of flowers and copal.[26] All talking has ceased at the top right: the two men are too busy eating from the heaping food baskets in front of them. Their offerings of flowers and copal lie next to the food baskets.

The lower registers depict women in much the same sequence of events as in the male-dominated scenes. At the lower left a woman approaches two seated women with offerings. Communication among the three is indicated by the speech scrolls. Notice that the goods being offered are the same as those offered to the men: bouquets of flowers and copal. At the lower right the two women sit talking and eating with two vessels and a basket set in front of them, while a third woman approaches them with yet another basket filled to the brim with food.

These scenes are noteworthy: in addition to illustrating the abundant food and material wealth at these feasts, they also show gender interactions. In none of the four scenes is there a mixed-gender eating group; women and men dine separately. In her discussion of cacao and feasting, Sophie Coe has proposed that chocolate could have been limited to men: some of the banquet descriptions by Sahagún's informants mention that men were served a chocolate drink, while women were served a gruel of chia with a dressing of chili on top.[27] Although it is very likely that special foods such as cacao and pulque were limited to specific class, gender, and age groups, it seems likely from these

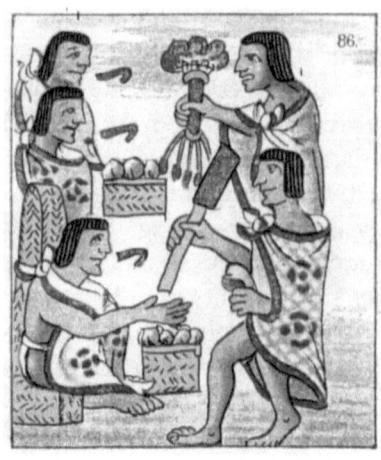

1.3
Feasting scene from Sahagún's
Florentine Codex, *Books 4–5, figure 86.*
Courtesy of the University of Utah Press.

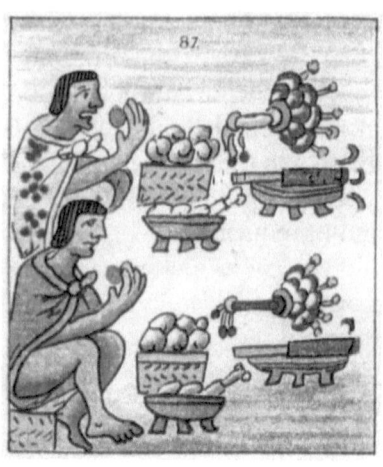

1.4
Feasting scene from Sahagún's
Florentine Codex, *Books 4–5, figure 87.*
Courtesy of the University of Utah Press.

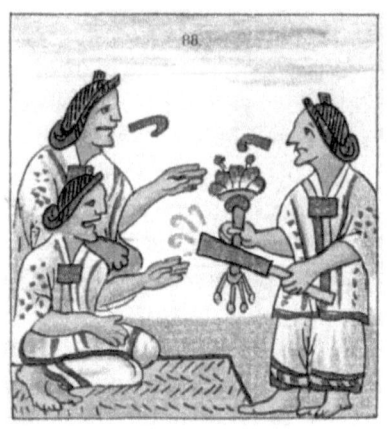

1.5
Feasting scene from Sahagún's
Florentine Codex, *Books 4–5, figure 88.*
Courtesy of the University of Utah Press.

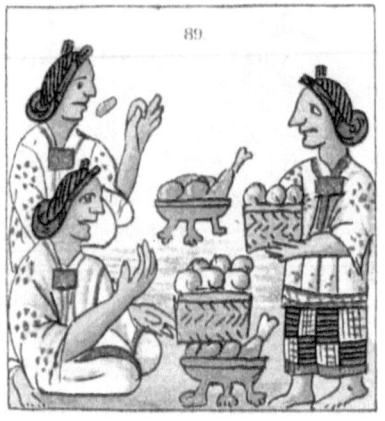

1.6
Feasting scene from Sahagún's
Florentine Codex, *Books 4–5, figure 89.*
Courtesy of the University of Utah Press.

four scenes that both men and women ate the same foods, at least in a naming ceremony.[28] It is possible that ceremonial consumption in the common class would offer a different view of gender and food use.

IZCALLI "COMING OUT" CELEBRATIONS

Another significant event in a child's life was also connected to the agricultural calendar and celebrations during the 20-day "month" or period called Izcalli (Growth or Rebirth). While the agricultural calendar is discussed more thoroughly in chapter 2, including a more detailed examination of Izcalli, I find it necessary to include this component of the feast in this discussion of life-cycle celebrations.

Every fourth Izcalli celebration included the presentation of children born during this four-year period to the larger Aztec community. In Book 2 (The Ceremonies) of Sahagún's *Florentine Codex*, his informants relate the various activities performed during these celebrations.[29] Izcalli was celebrated in honor of the fire god Xiuhtecuhtli, and every four years slaves and captives were sacrificed and offered to the deity. A deity image was created and adorned quite lavishly: "And they dressed him in a cape of quetzal feathers, replete with quetzal feathers . . . it was dragging a great deal on the ground." The deity image rested on a mat adorned with an ocelot skin. "Tamales stuffed with green" or "precious green stone tamales" were offered; even the common folk ate these.[30] Other rituals were singing, dancing, and processioning to and from temples.

Aztec artists used feathers from various birds to create a wide range of objects from shields to capes, a time-intensive process often used in the dressing-up of deity impersonators and images. Art historian Esther Pasztory writes that green quetzal feathers were among the rarest and most sought after feathers. Red and yellow feathers were more common, while blue and green were more precious. The Aztec word for "quetzal" could also mean precious. Pasztory notes that the Aztec people considered three materials the most precious: quetzal feathers, turquoise, and greenstone. Notice that preciousness appears in abundance in Sahagún's description of the Izcalli ceremony: the green quetzal feathers and the "green stone" tamales. In Mesoamerican ideology green stone was not just considered a precious material but was also symbolically equated with the green of water, vegetation, and the fecundity of the earth. The color green was a metaphor for life and fertility.[31] In the passage by Sahagún's informants, the abundance of material wealth (long capes made of precious green feathers, mats

adorned with ocelot skin) is linked with cosmic notions of abundance as well (the earth and its fecundity). The children presented at these ceremonies would also be connected to the most precious things in Aztec culture and ideology.

In addition to celebrations in honor of the fire god Xiuhtecuhtli and the sacrifice of many victims, Sahagún notes that children were also presented: "And they pierced the ears of all the children who had been born in those years, and they gave them godfathers and godmothers."[32] It was the duty of these adults, at other times referred by his informants as "aunts" or "uncles," to help with presentation rites.[33] In addition to the piercing of their ears, children were also dedicated over fire, being held by their uncles or aunts, and then were allowed to feast, eating special tortillas made for the occasion and drinking pulque.

Pulque was one of several intoxicating beverages produced in Mesoamerica. It was made from the maguey plant (*metl* as it was known by the Aztecs). Both pulque and *metl* are associated with various deities.[34] Pulque was also one of several food items that were highly controlled in Aztec society; drunkenness was not viewed lightly. Sources note that pulque was regularly drunk by the Aztec elderly. The Codex Mendoza shows an elderly woman drinking pulque (fig. 1.7). She sits on the ground with a pulque cup in her left hand and a jar full of pulque in front of her. At her side a younger man and woman speak to her, as the younger woman assists her by holding her right arm. A third woman, slightly younger than the woman drinking pulque, approaches the group and speaks. The older woman is active in the conversation as well: speech scrolls emanate from her mouth. The Spanish commentary provides the following explanation of the scene:

> It is shown how, according to the laws and customs of the lords of Mexico, they forbade drunkenness except to those of seventy years of age, man or woman, if such old persons had children or grandchildren. These had license and freedom to use it, as the figures show.[35]

Archaeologist Rosemary A. Joyce notes that Izcalli age-grade rituals introduced children to actions necessary in their adult religious life: singing, dancing, ceremonial drinking, and sacrificial bloodletting. The piercing of the ears was a physical marker that began the process toward the formation of Aztec adulthood.[36] This physical alteration marked a transformation in the children. Anthropologist Inga Clendinnen writes that these Izcalli celebrations immediately preceded the

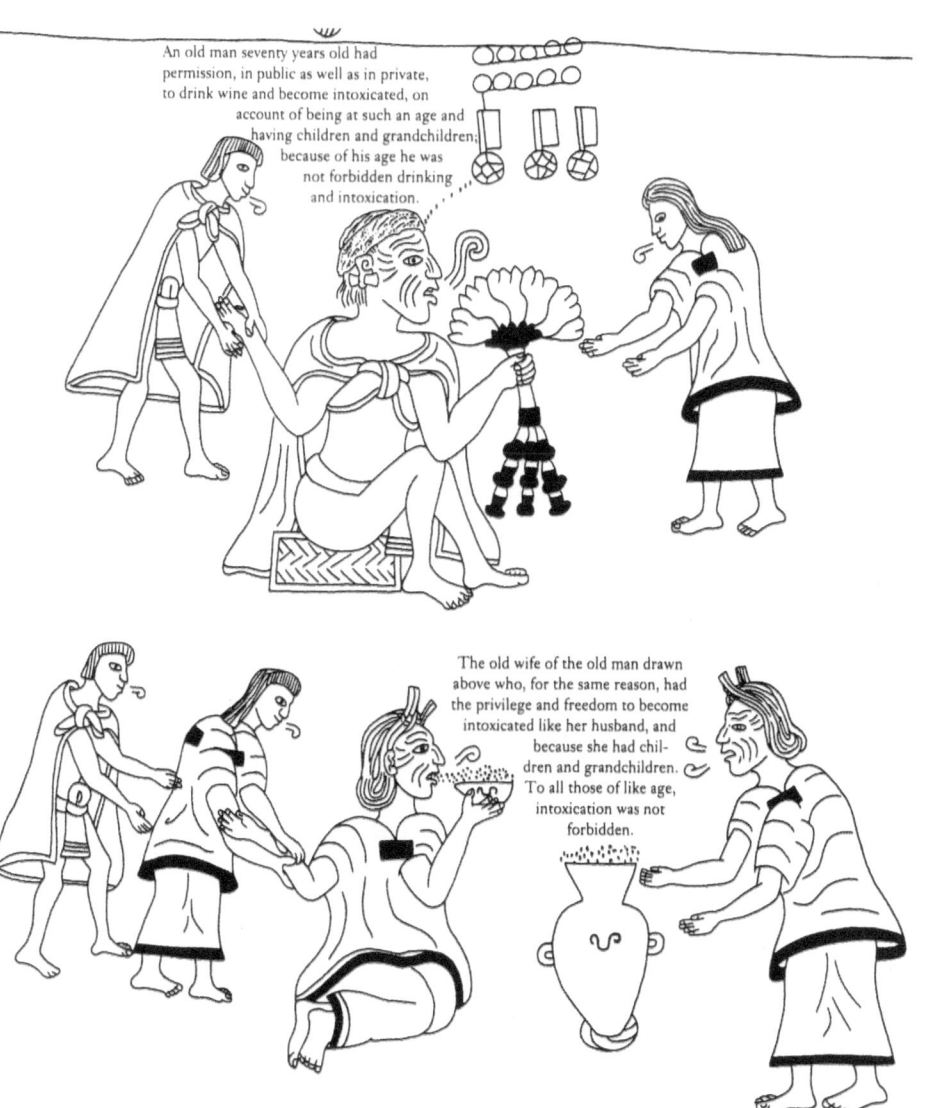

1.7

Drawing of elderly couple with woman drinking pulque, from Berdan and Anawalt, The Essential Codex Mendoza, folio 71r. Courtesy of Dr. Frances F. Berdan.

five unnamed days at the end of the calendar round: "a sinister period out of 'time' and thus beyond ritual."[37] These nameless days, not part of the eighteen 20-day periods of the agricultural cycle, are known as *nemontemi*.[38] According to Clendinnen, these Izcalli rituals and the significant timing move children from the home sphere to the public sphere, specifically introducing the children to the temple ("a place of excitement, glamour and terror"), transforming and altering them forever.[39] This transformation is also evident in the drinking of pulque.

In the Izcalli rituals the boys presented are transformed by being allowed to drink pulque in the ritual. They are also altered by the symbolic "cooking" that they undergo: the aunts and uncles hold them over the fire as they are dedicated to the fire god Xiuhtecuhtli. Food historian Felipe Fernández-Armesto notes that culture begins when "the raw got cooked."[40] The fire not only purifies the children presented but also transforms them into proper members of the society. The "heat" that the children face is also shared by all in the feast. Sahagún's informants note that the food served is also "hot":

> And the sauce of the tamales ... was called "red [chile] sauce." And when the good common folk ate, they sat about sweating, they sat about burning themselves. And the tamales stuffed with greens were indeed hot, gleaming hot.[41]

As in many of the feasting rituals noted, the food served is a metaphor for the rituals performed.

WEDDING CEREMONIES

Another life-cycle event celebrated across class divisions is the wedding. According to Sahagún's informants, when a desire for marriage had been expressed (whether by the parents or by the Aztec youth is not indicated), a young boy's parents notified his *calmecac* (school) leaders and asked for their permission. Part of this process involved a feast in which school leaders offered gifts. Sahagún notes: "Then tamales were prepared, chocolate was ground, sauces were prepared."[42] After the permission of the leaders had been given, the family of the boy discussed which young girl would be requested in marriage.

The Codex Mendoza depicts a noble wedding scene (fig. 1.8). In the lower register the bride is carried from her home by a woman accompanied by a procession of female attendants holding pine torches aloft. In the top register the bride appears in an indoor scene where she is

1.8
Drawing of wedding ceremony, detail from Berdan and Anawalt,
The Essential Codex Mendoza, *folio 61r. Courtesy of Dr. Frances F. Berdan.*

literally "tying the knot" in Aztec fashion: her mantle is tied to that of her husband. Husband and wife are seated on a straw mat: she sits directly on the ground, he on a woven seat. Between them is the hearth of the house, in front of which lies an incense offering.

On either side of the couple are an older man and woman, matchmakers involved in the execution of the marriage. They are identified by the Spanish gloss as *viejo* and *vieja* (old man and old woman)

CEREMONIAL CONSUMPTION IN EVERYDAY LIFE

and are speaking to the younger couple, as is evident in the speech scrolls coming from their mouths. The old woman also gestures with her right hand, probably addressing the younger woman. The elderly matchmakers reappear below this scene, this time seated across from each other. Between them are several food items, including an olla (ceramic vessel) full of pulque (often shown in manuscripts as a vessel with liquid that foams on top), a small pulque drinking cup, a basket full of tamales, and a tripod vessel with turkey meat.[43] The elderly matchmakers are again speaking. As is typical of the scenes in the Codex Mendoza, this wedding scene conflates several different moments of the marriage ceremony and feast. It addresses activities that pertained to the wife, the actual wedding ceremony, and the feast that accompanied the event.

The Codex Mendoza also records, in both text and image, a young man asking permission from his military youth house to marry (fig. 1.9). Boys either became warriors by merit or inherited the profession.[44] When a young boy was born and his military profession was understood, "if he entered the young men's house, [the parents] promised him to it; they prepared drink and food."[45] The parents provided a feast but more importantly offered the child as a gift.

This theme reappears again later in the child's life. Sahagún's informants note that when a boy of fifteen took up arms or when a young man of twenty went to war, feasting and gift reciprocity also occurred. The parents first summoned the seasoned warriors and "gave them to eat and to drink." Additionally, other gifts were given to the experienced soldiers, including "large, cotton capes, or carmine colored breech clouts [*sic*], or capes painted with designs." In return the warriors would guide and protect their children in battle: "The seasoned warriors went taking great care of him . . . And they taught him well how to guard himself with a shield; how one fought . . . and made him see how he might take a captive."[46]

In the Mendoza image (fig. 1.9), the soon to be married youth sits facing five other young men identified as *telpuchtli* (youth leaders).[47] Words are being exchanged, as all six men have speech scrolls emanating from their mouths. Between the young man and his military companions gifts and food are being presented as part of the feast: a large basket filled to the brim with tamales, a turkey in a tripod vessel, and a cacao gourd filled to the top with chocolate. Gifts include a copper axe, perfumes, and two mantles. Behind the young soldier is his soon to be wife, who is spinning; presumably she has cooked the food and is now weaving more mantles for the gift-giving. She works silently

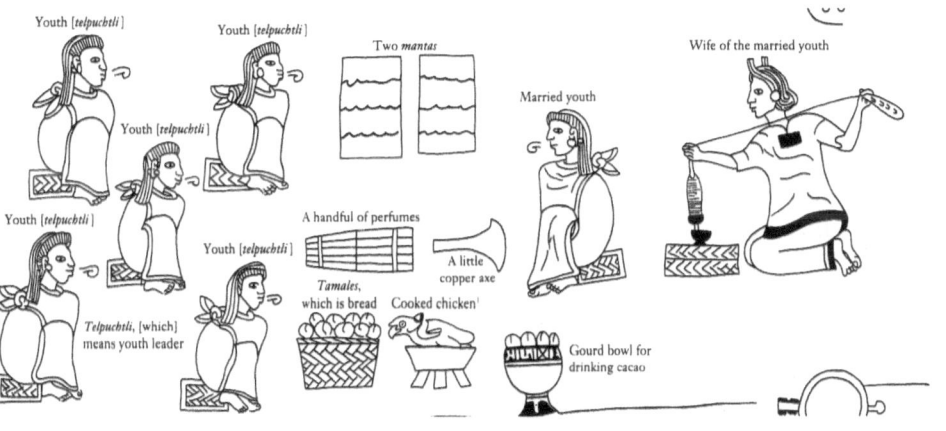

1.9
Drawing of banquet scene, detail from Berdan and Anawalt,
The Essential Codex Mendoza, *folio 68. Courtesy of Dr. Frances F. Berdan.*

as she weaves (no speech scrolls emerge from her mouth), yet she is drawn on a larger scale than any of the other figures, including her husband. The accompanying Spanish text of the Codex Mendoza gives us the reason behind the feast: "And in order to please them and so they will accept his request, he provides them with a banquet offering them good food and drink, and gives them gifts."[48] The feast was not merely an occasion for the youth leaders to say good-bye but rather a demonstration of the complex personal and professional dynamics that occurred in Aztec society. Feasting helped to create a balance in social and political relationships.

FUNERARY CEREMONIES

Several sixteenth-century sources remark on the presence of food at funerary ceremonies. Like other feasting ceremonies already discussed, most of these sources comment on rituals carried out by the wealthier classes. It is difficult to interpret what commoners did at the time of someone's death, but some basic rituals were probably similar to extant descriptions.

Aztec burial rituals corresponded to the way in which a person died. For example, someone who drowned or was struck by lightning was thought to have been chosen by the rain god Tlaloc to die in a water-related death. Instead of being cremated that person was buried.[49] A common thread, however, was the presence of food, drink, gifts, and offerings. Sahagún notes that the deceased was often dressed in

mantles and adorned with paper offerings.[50] Paper offerings were also a component of agricultural rituals, especially those connected with the rain deity Tlaloc.[51] History of religion scholar Philip Arnold observes that paper was also closely connected to food preparation:

> Just as human beings rely on the daily gifts of Tlaloc's body through their consumption of maize and other foodstuffs, paper seems to serve an analogous yet distinct symbolic relationship to food as another processed cultural object important for the sustenance of human and Tlaloc related life.[52]

As an element connected to Tlaloc and the sustenance of life, it makes sense that paper also makes an appearance at the time of death, a point where life was believed to take on a different form.

Sahagún's informants relate that the dead were often given a dog to travel with. The dog was a guide and companion to the land of the dead. It is unclear if a dog was sacrificed, as servants often were,[53] or if the text refers to a substitute image of a dog like the funerary urn discovered at the Templo Mayor in the shape of a dog.[54] The Dominican friar Diego Durán comments on the sacrifice of servants in his *Book of the Gods and Rites*, where he lists the priest or chaplain, chief steward, cupbearer, humpback, and dwarf who accompanied the deceased to the underworld to serve him there. Cooks were also slain at the time of a lord's death. Durán states: "They killed the grinders of corn so that these women might grind and prepare tortillas in the other world."[55] Sahagún's informants, writing on funerary practices for chiefs, note: "Thus they said that they were those who cared for their master, and still made chocolate and prepared food for him. And the men they sent as servants, likewise to care for him in the land of the dead."[56]

The elite dead were also cremated with many material goods that they would use in the afterlife: jewelry of gold, silver, and precious stones; earplugs and bracelets; and fine mantles.[57] While neither Durán nor Sahagún comments on whether or not food was provided for the deceased, we can assume that these types of offerings were made because many Aztec deposits, like those in the Templo Mayor, included numerous ceramic vessels that may have been used for foods, such as special tamales and sauces.

Food and offerings were also important aspects of the banquets held in honor of the dead. "At these funerals [people] ate and drank; and if [the deceased] had been a person of quality, lengths of cloth

were presented to those who had attended the funeral." Durán comments on the great amount of food that was consumed: "everyone . . . eats the host out of house and home."[58] He tells his reader that octli or "wine" was served as well as chocolate, fowl, fruit, seeds, and other foodstuffs.[59] These foods are similar to those in other banquets, such as merchant and wedding celebrations. Like feasting at those events, a funerary banquet would have involved more than just food distribution and eating. Food order, presentation, and gift-giving also would have been important aspects of funerary ceremonies.

OTHER DOMESTIC/HOUSEHOLD CEREMONIES

State rituals often mirror those that were practiced on a domestic level. Sweeping, which was practiced by all Aztec women in a household, was also done by priests and priestesses in temples as well as by gods in myths. The goddess Coatlicue, for example, conceived her son Huitzilopochtli while she was sweeping a temple. The agricultural *veintena* ceremony called Ochpaniztli (Sweeping of the Roads) involved sweeping roads, houses, baths, and courtyards. Scholar Louise Burkhart refers to the mimicking of domestic ritual in temple ritual as "cosmic housekeeping" and notes that "the priests guarded the temple fires, made offerings, prayed, and cleaned; female priests and attendants also spun and wove clothing for the deities and cooked their offerings of food."[60] Sahagún records the offerings that women made in the home to the gods, including burning copal incense, eating the earth, bloodletting, and sweeping.[61]

Archaeologist Michael Smith has also noted that some state religious practices resembled domestic religious ones in their objects and themes, demonstrating continuity between domestic and state religious practices. The Aztec people burned incense in their homes using long-handled censers, which were identical to those used by professional priests in public ceremonies in Tenochtitlan.[62] Other scholars have noted that household ritual activity followed an annual round that paralleled state rituals without actually being a part of them.[63]

Elizabeth Brumfiel notes, however, that state rituals took a different form than household rituals in the use of ceramic figurines. Figurines have been found in domestic archaeological contexts but not in the excavations at the Templo Mayor in Tenochtitlan.[64] Figurines are noteworthy for various reasons. While they are found in household

contexts, they were rarely if ever used within public ceremonies.[65] Scholars have pointed out that figurines are found on house floors, in middens, and occasionally associated with burials.[66]

Figures that have been identified with attributes of Aztec gods such as Xipe Totec or Xochiquetzal might in fact not be deity representations but rather relate to health, curing, and agricultural concerns.[67] Smith suggests that these might not be perceived as gods but rather as "generalized spirits" that are invoked for specific healing or a community concern like having safe drinking water.[68]

The Museo Nacional de Antropología in Mexico City has several clay figurines of cooking paraphernalia: a pitcher, bowl, jug, metate (stone grinder) and comal (flat griddle). They also have a figurine of a woman grinding on a metate (figs. 1.10–1.12). These small objects might have been linked to the everyday, as when the Aztec mother taught her daughter how to grind maize. But it is highly probable that they were also linked to the cosmic realm, for "domestic" activities such as grinding maize on a metate were also associated with the creation of humans by the gods: the earth goddess Cihuacoatl (Woman Snake) helps create humans by grinding maize dough.[69]

Domestic rituals also involved food and cooking. In the appendix to Sahagún's Book 5 (The Omens), the friar lists different indigenous beliefs, many of them involving household rituals and food. He notes that an Aztec woman would breathe on dried grains of maize before cooking them, believing that this would cause the maize not to fear the fire. Women would often pick up maize grains that were found on the floor with reverence, claiming: "Our sustenance suffereth: it lieth weeping. If we should not gather it up, it would accuse us before our lord. It would say: 'O our lord, this vassal picked me not up when I lay scattered upon the ground. Punish him!' Or perhaps we should starve."[70] In both cases maize was regarded as very much alive; the consequences of not giving it due attention were quite severe. The ritual also points to the interconnectedness of humans (in this case women) and food. Women and grain are united by a shared breath, which provides life but is also a precursor to death (by fire). Yet the grain will die (or be cooked) and provide sustenance for the woman. In this simple ritual, a gesture of blowing air mimics the significant reciprocal relationship between humans and the cosmos.

Foods created with maize also functioned as omens. If a woman was making tortillas and they doubled over, this would indicate that she would have a guest. If her husband was out of town, this would mean that he would be coming home soon. Household cooking was

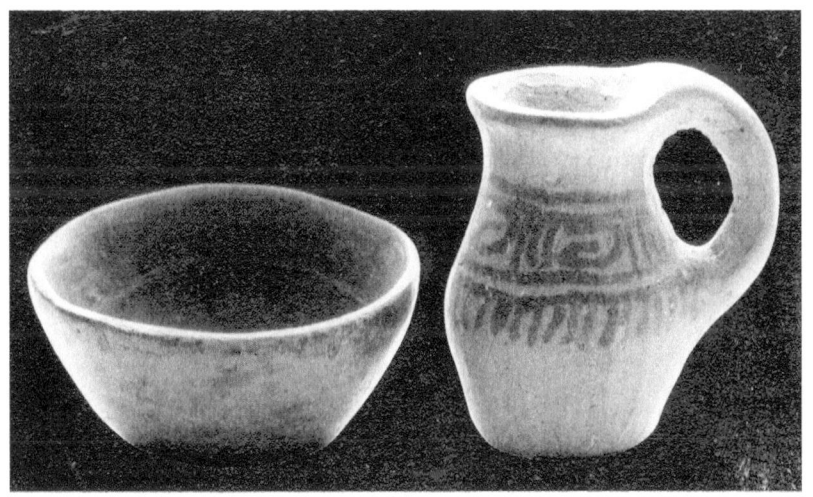

1.10
Figurines of bowl and pitcher, from the Museo Nacional de Antropología, Mexico City, Mexico. Courtesy of the Museo Nacional de Antropología.

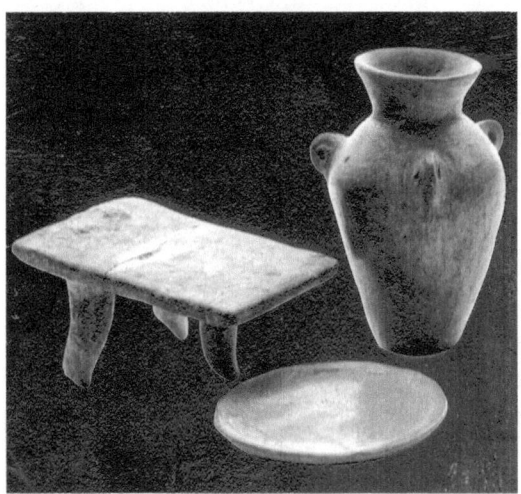

1.11
Figurines of metate, comal, and pitcher, from the Museo Nacional de Antropología, Mexico City, Mexico. Courtesy of the Museo Nacional de Antropología.

1.12
Figurine of a woman with a metate, from the Museo Nacional de Antropología, Mexico City, Mexico. Courtesy of the Museo Nacional de Antropología.

also connected to warfare and enemy captives. A man was admonished not to dip into the cooking pot lest he not capture any captives.[71] A man should not eat tamales stuck to a pot or, again, he would not capture any enemies. Here food is equated to success in warfare. If a woman ate such tamales, she would not bear children.[72] The connection between warfare and the house is also evident in the admonition not to kick the hearth stone: this would make a man slow and unable to move in war.[73]

Cooking utensils were also believed to have some form of cosmic power. If the stone of someone who was grinding broke, this would be seen as a bad omen, indicating that death would befall someone in that household. The fire drilled in a house was also seen as a divinatory tool. If the new fire did not take long to start, it was believed that the household would be a happy one; but if the new fire did not take, then the household would be unhappy.[74]

The hearth was a center of domestic rituals. Sahagún notes that food was offered to the hearth before anything was eaten and pulque was offered before any of it was drunk.[75] Mesoamerica scholars Mary Miller and Karl Taube point out that three-dimensional images of Huehueteotl (Old God), the ancient Mesoamerican fire god, usually turn up in residential quarters rather than in temples, though some were found in the Templo Mayor. Xiuhtecuhtli, the god of terrestrial fire, was also venerated in household shrines. During celebrations in honor of the deity, blood, food, paper, and incense were offered at temple shrines. Sahagún's informants note that the poor would make offerings in "their own fires."[76] For the Aztec people, as for all Mesoamerican peoples, the ordinary and the extraordinary are woven together as part of their worldview.[77] This is especially apparent in rituals performed in the home that were also paralleled by some aspect of state rituals commemorating cosmic events. In these instances the everyday merged with the extraordinary, becoming even more meaningful for the people performing the rituals. The statewide celebration of a New Fire Ceremony falls within this category.

The drilling of a New Fire in the hearth took on cosmic proportions as part of the broader New Fire Ceremony that was celebrated every fifty-two years on the occasion of the coinciding of the 260-day ritual calendar and the 365-day solar calendar. While this was a state ritual, it also had domestic components. During a New Fire Ceremony all pots and cooking ware were destroyed, all fires were extinguished, and the Aztec people awaited the cues of the priests who read the astrological signs to let them know when to rekindle the fires, signifying a new be-

ginning.[78] Fires were first rekindled at the top of a hill on a site called Huixachtlan, now called Cerro de la Estrella, in the southern Basin of Mexico.[79] From there the priests brought the fire to the temple of Huitzilopochtli in the Templo Mayor precinct, which was in the center of the city.[80] The series of fire rekindlings continued as priests and other ceremonial officials went from the main temple lighting fires in other temples, ceremonial precincts, and eventually homes.

The New Fire Ceremony thus included all sectors of society and encompassed both the domestic and ceremonial spaces. On a state level the ceremony recalled the creation of the Fifth Sun and the necessary travel of the sun throughout the year (time) for the regeneration of all living things. The Aztecs believed that they were living in the Fifth "era" or Fifth Sun, with four previous Suns having been created and destroyed before this.[81] In these and other creation myths, fire is often both a destructive and a constructive force, seen in nature over and over again. This notion of regeneration and renewal would have been significant for Aztecs not only during the New Fire Ceremony but every day, as they added leaves and plants to the hearth.

SUMMARY

By no means do the activities described above constitute all examples of Aztec domestic and state-level feasting as noted in sixteenth-century sources. Rather, the preceding discussion is an overview of some of the more prominent ceremonies in which feasting occurred. Similar characteristics are found in both domestic and state-level feasting. Everyday staples, such as maize and beans, as well as special foods like pulque and chocolate were a component of ritual feasting. In addition, other nonfood offerings were given; in the case of a wealthy individual or individuals, this could take the form of jewelry, mantles, and housing. The less wealthy could offer gifts of flowers, dance, or song.

Aztec feasts were an opportunity for the host to display material wealth as well as authority or power within the larger society. A host could also make demands of the guests, asking for food and other items. At the same time, it was the role of the host to provide an abundance of food, entertainment, and offerings. Feasting required a delicate balance between host and guests. The role that food played in these events was therefore crucial in keeping a balance in Aztec society. The role of reciprocity between humans and gods is examined in later chapters.[82] It should be noted here, however, that there is a parallel

narrative in the interactions of host and guests and humans and gods. These "gifts" that are given by the host to the guests are not made without some expectation of a "return," whether it is something concrete like a food item or a mantle or something nontangible such as respect or acknowledgment of power.

Throughout an individual's life, food was a marker of significant events and important changes. In child-naming ceremonies, a special maize dish was served to four small boys who would "call out" the name of the child, introducing him or her not only to the larger society but in essence to the four corners of the universe. As an old person, an Aztec individual would have the right to drink the fermented drink pulque, without any concern about excess. Food was present even in the afterlife: sacrifices for nobles sometimes included cooks as well as food items. In these ceremonies food often served as a metaphor of Mesoamerican cosmic ideologies such as in the serving of "green stone tamales" in Izcalli celebrations.

Food items were also thought to be endowed with special powers. In Book 5 (The Omens) of the *Florentine Codex*, Sahagún's informants record the many beliefs about the ability of food to cause punishment by the gods or to serve as signs and omens. In addition, the tools used in preparing food also had cosmic capabilities. A broken grinding stone was read as an omen of death. Success in drilling a fire in a home foretold a successful household. These everyday activities—drilling a fire in the hearth or grinding maize on the metate—were also connected to cosmic myths of the creation of the Aztec world. Food in Aztec culture thus enveloped the mundane and everyday as well as the extraordinary and cosmic.

CHAPTER 2

FOOD *in* AZTEC PUBLIC RITUAL

The passing and recording of time was significant to the peoples in Mesoamerica. The Aztecs, like many other Mesoamerican groups, had two different calendars that organized their ritual life: the 260-day ritual calendar (*tonalpohualli*) and the 365-day solar calendar (*xihuitl*). The *tonalpohualli* was associated with divinatory activities and the *xihuitl* with agricultural activities; both calendars involved the performing of rituals. The *tonalpohualli* and the *xihuitl* ran concurrently and often "met" on significant time correlations: for example, every fifty-two years.[1] A series of eighteen public ceremonies was connected with the Aztec agricultural cycle and solar calendar. Called *veintenas* by Spanish chroniclers, these ceremonies, each of which lasted twenty days, provided a continuous annual sequence of ritual activities. Mesoamerican scholar Elizabeth Hill Boone has noted that these festivals were large public affairs, and it was the 260-day calendar that spoke most directly to the Aztec people.[2] Food use and feasting were significant aspects of these state-sponsored festivals, as were dancing, singing, gift-giving, and human sacrifices.

THE *Veintena* CEREMONIES

The *veintena* ceremonies are recorded both in painted manuscripts and in textual sources. Sahagún's informants dedicated an entire volume to the topic (Book 2), and other friars such as Diego Durán and Toribio de Motolinía also documented the rituals.[3] Images from such works as the Codex Borbonicus, Codex Telleriano-Remensis, and Codex Magliabechiano (just to name a few of the painted pictorial manuscripts that record the celebrations) also help in visualizing and understanding these ceremonies.[4] When comparing the various written and

pictorial sixteenth-century sources, it is clear that the names and order of the *veintenas*, as well as the activities associated with them, were not uniform throughout central Mexico.⁵ Johanna Broda, for example, notes the differences between Durán's and Sahagún's descriptions of the Tlacaxipehualiztli (Flaying of the Men) ceremony.⁶ In his analysis of the Codex Borbonicus, Christopher Couch points out that the images from the manuscript differ markedly from written accounts.⁷ While records by some colonial writers stress the role of the state and the city center, Couch contends that images from the Borbonicus stress the role of the commoner.⁸ Regional and local *veintena* ceremonies also varied from those in Tenochtitlan and other major centers. For example, Elizabeth Brumfiel has noted that Sahagún's *Primeros memoriales* and *Florentine Codex* differ in their account of rituals in some of the same *veintena* ceremonies, mostly because *Primeros memoriales* was compiled in a provincial town.⁹ These regional differences were also observed by the friars who chronicled the ceremonies. Diego Durán notes:

> In pagan times each of the cities, towns, and villages of New Spain had its own god [worshiped by] the natives. And though [the gods] were revered by all, adored, and their feasts celebrated, [each town] had a special one who served as patron of the place, honored with greater ceremonies and sacrifices.¹⁰

Additionally, scholars have noted that *veintena* celebrations are not just about cyclical time but can also be about specific or linear time. Most recently art historian Catherine DiCesare has effectively shown that the Codex Borbonicus images of the Ochpaniztli (Road Sweeping) celebrations are specific to events that occurred in the years corresponding to 1 Rabbit and 2 Reed. For DiCesare the emphasis on Chicomecoatl in this particular depiction of the Ochpaniztli ceremony is connected to years of famine and hardship (1450 and 1454), respectively.¹¹

As Boone notes,

> Multiple, ongoing, and intermeshing cycles of the calendar created reoccurring junctures in time, so that each action and every human took its place in multiple cycles. As the cycles advanced, new junctures continually came to the fore until the cycles completed their span. Thereafter the same previous junctures reoccurred, already occupied by remembered past events but remaining open to pres-

ent and future actions. These junctures tied those events to the current ones and to those still to be.

She points to the year 1 Rabbit, in which the devastating and widespread famine that occurred historically carried the taint of famine for all future 1 Rabbit years in the Aztec mind.[12]

Allowing for regional and local differences, as well as historical readings, there are many similar factors in the *veintena* ceremonies. The ceremonies were performed throughout the Aztec Empire; each "month" corresponded to a particular deity or deities; the ceremonies revolved around the agricultural calendar; rituals performed were associated with the natural cycle of plant growth and harvest; and food was a significant ritual component of the ceremonies. The importance of food in ceremonial use was already evident to sixteenth-century writers. Diego Durán understood clearly that food was a part of the process in Aztec ritual:

> Petitions were made to the deities, begging for a good, fruitful year full of fortunate events. New foods were eaten, different from everyday fare. This custom of eating different foods on feast days was a ceremonial rite. The people made distinctions among the dishes, and for every feast a new food was prepared—that which was permissible on said festivity.[13]

Food was present in many of the *veintena* ceremonies, especially those celebrating fertility deities, and was often included in several ways. The most common was of course as an offering or consumed as part of a feast. However, as discussed further below, food was also included in Aztec ritual in numerous other ways. This chapter demonstrates that food was a multifaceted element used in a variety of ways in Aztec rites and added to the ceremonies observed. For the Aztecs food was offered; consumed; gathered; used as an added visual element on people, sculptural forms, and architecture; used as a material to make sculptural work; embodied in sculptural form; and even transformed into a weapon or a threat. Finally, abstaining from food (fasting) was also a purposeful activity in ritual.

FOOD AND AESTHETICS

It is often difficult to agree on what is art in our own culture, so trying to define an aesthetic for a society removed not only in location but in

space is almost impossible. Yet there is ample evidence of "art" in Aztec culture. Monumental sculpture, exquisite objects made from feathers, large-scale clay figures, and labor-intensive mosaic works are just a few of the examples that attest to a cultural aesthetic. Defining an Aztec aesthetic has been tackled by numerous Aztec scholars.[14]

Art historian Esther Pasztory notes that the primary purpose of Aztec art was "the communication of ideas about man's place in the cosmos and in human society." This is true of most world art (although the Western canon has shifted the function of art in modern times). Aztecs understood their world with the aid of what they saw. Forms and shapes created understandable concepts. Pasztory points out that "the emblem of the earth monster is not a deity . . . it is the concept of the dark, devouring, or nurturing earth."[15]

Inga Clendinnen remarks that "'art' among humans becomes a collective quest for the really real" but notes that the Aztec artist has purposely chosen a rejection of realism and even the human realm. Instead the Aztec canon stresses a connection to the sacred, which includes nature. For Aztec artists it is not merely a matter of representing something as it is in the natural realm but also of representing how it behaves or functions in their world. Clendinnen notes that the raccoon was visualized not only as a "small squat, cylindrical," creature but also as a "little old woman" because of its human hands and its busy, managing ways.[16]

The search for the "really real" is certainly the focus of the art history of the Western world. The representation of actual likeness is not significant for Mesoamerican people. Proportion, color, and scale can all be manipulated to conceptualize both the sacred and the natural world visually. In fact, Aztec artists, like most in Mesoamerica, choose different styles for different concepts. The clay warrior in his eagle suit looks more "real" or natural than the squatting carved reliefs of the earth lord Tlatecuhtli. This is a conscious decision by the artist to communicate larger cultural ideas. The Aztec audience understands that the warrior is a human being dressed up in his military garb, whereas the squatting figure is visually abstract and confusing because of the multiple concepts associated with Tlatecuhtli: creation, birth, consumption, sacrifice, destruction, duality, and so forth.

Colonial sources also comment on Aztec artists. Durán, for example, notes that a brush was placed in the hands of children whose birth sign indicated that they were going to be painters during the birthing rituals. He also records that the goddess Xochiquetzal (Flower Quetzal), who is associated with pleasure and sometimes excess, was

"the patroness of painters, embroiders, weavers, silversmiths, sculptors, and all those whose profession it was to imitate nature in crafts and in drawing."[17] Sahagún's informants in the *Florentine Codex* note the characteristics of the artisan, the featherworker, the gold worker, the lapidary, the woodworker, and the stonecutter.[18] Skill, design, creativeness, and accomplishment are all necessary to be a good artist.

Pasztory records the various materials used by Aztec artists and comments that these are not randomly selected: materials had not only practical value but symbolic value as well. In Izcalli (Growth or Rebirth) celebrations, deity images were dressed in long robes made out of quetzal feathers and feasting participants were fed "precious green stone" tamales. Both green quetzal feathers and green stones were highly valued materials in the Aztec world but also carried symbolically significant associations with the green and fertile earth. Materials selected by the Aztec artist communicated many complex and varied ideas to the Aztec audience. In her list of materials Pasztory includes the many perishable types of materials such as dough, paper, and resin, which were just as visually and symbolically important as gold, feathers, and wood.[19] To her list I would add seeds and other food items, which were often used as an embellishment to already existing artwork, whether sculpture or architecture.

Sahagún's informants also note that food was used as a visual element in ritual performance: architecture, sculpture, and people were often embellished with food.[20] During the first 20-day period or Atlcahualo (Ceasing of Water), dedicated to Tlaloc and other deities associated with water, child sacrifices being offered to the gods "were adorned, they were ornamented with all valuable things," including items such as green stone necklaces and bracelets, precious feathers, rubber adornments, and a paste of amaranth seeds used to decorate the face.[21] While the text notes luxury items such as feathers and green stone, it also records ephemeral materials that were just as valued: rubber and a paste of amaranth seeds.

Food was also part of the architectural setting and ritual paraphernalia of *veintena* celebrations. In ceremonies honoring Xipe Totec (Our Lord the Flayed One) offering priests adorned themselves quite lavishly; sources note that the costumes included

> quite various arrays: butterfly nets, fish banners, clusters of ear maize, coyote heads made of a paste of amaranth seeds, S-shaped tortillas, thick rolls covered with a dough of amaranth seeds, which they covered on top with toasted maize, and red amaranth (only

it was red feathers), and maize stalks with ears of green or tender maize.²²

Durán also notes food as an embellishment that adds multiple meaning to ritual activities. In recording the sacrifices to Chicomecoatl during the month of Hueytozoztli (Great Vigil) he mentions that one of the female victims was placed on a litter decorated with ears of corn, chiles, and squash.²³ This visual bombardment of food would of course have been understood as a metaphor for the abundance to be received by the sacrifice of the woman. Yet it also adds to the visual saturation of color, forms, and shapes that were constantly shifting throughout the ceremony. We later learn from Durán that this woman (dressed as Chicomecoatl) was eventually taken to a shrine in which a goddess image had been placed. After she was sacrificed, her skin was flayed; the priest conducting the ceremony then wore her flesh (see the discussion below). Here the image of the goddess appears in multiple shifting forms: as a sacrificial victim dressed up as the goddess, as a sculptural form, and then as the reborn deity (now the priest who wears the flayed skin).

Painted images also demonstrate the creative use of food as a multivalent visual element in *veintena* celebrations. Images of the Ochpaniztli celebrations from the Codex Borbonicus feature a female priest wearing the skin of a flayed victim exiting a temple adorned with green stalks and maize of different colors. As in the Chicomecoatl rituals we have multiple symbols of renewal, shifting visual forms, and a multitude of meanings for the ritual participants to perceive. These examples illustrate the diversity and lavishness in the use of food as a visual embellishment. The foods that are most used are (not surprisingly) common food items such as maize, amaranth, chia, chiles, beans, and squash.

Food was also used to make specific deity images connected to *veintena* celebrations. Sahagún's informants note many occasions on which images of deities were created out of dough: "And they also fashioned [images in the form of] mountains . . . they made them all of amaranth seed dough."²⁴ Book 2 of the *Florentine Codex* describes five *veintenas* that include the making of deity images out of food (see the appendix). Durán describes the dough (*tzoalli*) as being "made of amaranth seeds and maize and kneaded with honey."²⁵ Pasztory proposes that these dough images might have predated images made out of wood and clay and perhaps originated in agricultural ritual when

plants were first domesticated in Mesoamerica.26 They were still being made and used in ritual in the sixteenth century, which speaks to their value in Aztec society.

Dough images were often the center of ritual activities. During celebrations in honor of the Aztec solar and patron god Huitzilopochtli (Hummingbird on the Left) Durán notes that images of the god were made from various materials, including wood and food:

> The cloistered virgins of this temple . . . ground a great quantity of amaranth seeds, called *huauhtli*, together with toasted maize. When this had been ground, it was mixed with black maguey sirup [*sic*]. After it was kneaded, an idol was made of that dough . . . Green, blue or white beads were inlaid as his eyes, and his teeth were grains of corn.27

These "cloistered virgins" that Durán mentions in his accounts were specially chosen young girls (age twelve or thirteen) who were dedicated to the service of the god Huitzilopochtli. There were also young boys, roughly the same age, who served the god exclusively. The young girls were responsible for cleaning the temples and cooking the daily meals for Huitzilopochtli; these included "small tortillas fashioned in the manner of hands and feet" or tortillas so light that they resembled "taffy" and "chili stews."28

When describing the attire of both the young girls and boys, Durán also notes that food was part of their costume: "They came along crowned with garlands of toasted, burst corn called *momochitl*. They wore thick garlands of this corn, and around their necks were big necklaces of the same." He also records that the youths who lived in seclusion were called "elocuatecomame." He finds this nonsensical but unwittingly indicates to his reader that the Aztecs connected this word to "elotl," a reference to both the smooth heads of the children when they entered the service of Huitzilopochtli and "ear of corn."29 While this might not have made sense to the friar, the Aztec audience participating in these rituals understood that the children in the service of the gods were themselves transformed into living maize: they were not only dressed with maize but in their service to Huitzilopochtli were transformed into this essential grain.

During Hueytozoztli *tzoalli* was used to make an image of Chicomecoatl. Sources note that she was placed "in the courtyard of her pyramid; and before her they offered all kinds of maize, and all kinds

of beans, and all kinds of *chía*."³⁰ Here the dough image *becomes* the deity: she is placed in the deity's sacred space and venerated as the god. Dough images were also transformed into sacrificial offerings, often standing in for the deity impersonators (who later were to be sacrificed) and other sacrificial victims.

In the month of Xocotlhuetzi (Xocotl Falls) in honor of the fire god Xiuhtecuhtli a dough image was used to represent this god and eventually was "sacrificed." These dough sacrifices were just as important in ritual as other forms of sacrificial offerings, often being "eaten" by participants as flesh:

> And when they revived, then they climbed down; they came bringing the amaranth seed [image] which they had captured. They took it with them to their homes, for it was in truth their captive. They ate it. They offered it to each of their kin and to those of the neighborhood; they ate it all.³¹

During rituals in honor of Huitzilopochtli dough was used to create many "bones." These food sculptures were then used by the young boys in service to the god in a ritual dance. Along with the boys, deity impersonators danced and chanted around the bones and "with this, [the dough] was considered blessed and consecrated as the flesh and bones of the god Huitzilopochtli."³² Again, through ritual use food becomes flesh—not only of the sacrificial victims, but in this case of the gods themselves.

Food items were rendered by Aztec artists in a wide range of materials. Aztec stone workers made huge sculptures of cacti, squash, and pumpkin out of different stones; some scholars suggest that these huge food items were permanently on display in temples.³³ Sculptures of frogs, birds, rabbits, fish, and grasshoppers have managed to survive the destruction of the conquest period. There are also images of people holding foods, such as the sculpture of a man with a cacao pod (fig. 2.1). The work, which is currently at the Brooklyn Museum of Art in New York, is slightly over two feet in height. The male figure holds a disproportionately large pod: with his right hand he grasps the stem, while with his left he balances the weight of the giant fruit. His serene face still has traces of the red and white pigment used to paint the volcanic stone. Here the cacao pod is transformed into a monumental food. Its large size denotes its significance.

Cacao was a specialty item in the Mesoamerican world. It was

2.1
Figure of a man holding a cacao pod, from the Brooklyn Museum of Art, Brooklyn, New York. Courtesy of the Brooklyn Museum.

highly esteemed not only for the tasty beverage that could be made from it but for the value of the seeds themselves, which were used as currency throughout Mesoamerica.[34] For the Aztecs drinking chocolate was the privilege of a select few: lords, nobles, warriors, and the class of merchants known as *pochteca*—in short, individuals of some wealth.[35] Sahagún's informants are very specific about this, noting: "The common folk, the needy did not drink it."[36]

While other Mesoamerican people like the Mayas grew the cacao tree in *cenotes* (sinkholes),[37] the dry land and cool climate of central Mexico was not conducive to its cultivation. The Aztecs acquired cacao through either trade or tribute. Durán notes that the Aztecs received cacao seeds in "vast amounts" and lists Xoconochco, on the southern Pacific coast, as one of the conquered provinces that provided them.[38]

2.2
Serpent fragment with maize cobs, from the Museo Nacional de Antropología, Mexico City. Author's own photo.

But both the tree and the drink had a symbolic meaning for the Aztec people. Sahagún's Book 6 (Rhetoric and Moral Philosophy) of the *Florentine Codex* records: "This saying was said of cacao, because it was precious . . . The heart, the blood are to be feared."[39] While the exact meaning of this statement remains obscure for the modern reader, Sahagún's informants make clear cacao's connection to blood (and hence life) in Aztec thought and thus its significance in ritual.

The collection at the Museo Nacional de Antropología in Mexico City also has examples of figures holding food. In the Mexica gallery you will find a female figure carrying a load of maize on her back. She seems to be overpowered by the weight of the maize. As in the case of the figure holding the cacao pod, the artist emphasizes the size and weight of the plant rather than the size of the person. Of particular interest in this gallery is a fragment of a rattlesnake with six maize cobs embedded in the design (fig. 2.2). The sculptural fragment complements what is documented in textual sources: food is used as a decorative and artistic element in *veintena* ceremonies. Yet it is much more than a matter of aesthetics. In the serpent fragment the viewer gets a doubly potent symbol of renewal (serpent and maize) and of course would understand the reference to the corn goddess, Chicomecoatl, one of the most important agricultural figures in Aztec cosmology.

Maize was certainly the superfood of the Americas and thus was part of both the mundane and everyday as well as the extraordinary and sacred. Aztec mothers followed strict rules when feeding their children maize tortillas, as seen in folios 58r to 60r of the Codex Mendoza.[40] As the child grew, so did the required intake of tortillas. At age three, children received half a tortilla; from ages four to five they received a full tortilla; from ages six to twelve they received one and a half tortillas; their entry into the teenage years was marked by two whole tortillas. In preparing meals with maize, Aztec cooks also followed specific procedures. Sahagún's informants note that Aztec cooks would

often breathe on maize kernels before putting them into the fire in order to prepare the grains for the flame.[41]

In fact the good cook in Aztec society, who was highly regarded in Aztec culture, was defined as someone who had the ability to make maize dishes. Sahagún's informants note that good cooks make tortillas and tamales of every kind. Book 10 (The People) of the *Florentine Codex* describes some of the virtues of the good cook: it is not just a matter of having "good drink, good food"; her character is also scrutinized. She must be "honest, discreet, and prudent." The bad cook is "dishonest, detestable, nauseating, offensive to others . . . crude."[42]

No discussion of aesthetics and food would be complete, of course, without commenting on food presentation. Numerous sixteenth-century written sources document the lavishness of royal consumption. Book 8 (Kings and Lords) of Sahagún's *Florentine Codex* lists the various foods available to the lords of Tenochtitlan, and some of the descriptions make the mouth water. Among the dishes prepared were "[t]amales made of maize flowers with ground amaranth seed and cherries added; tortillas of green maize or of tender maize; tamales stuffed with amaranth greens; tortillas made with honey, or with tuna cactus fruit."[43] While many of these were staple items available to commoners, the more delicate ways in which maize and amaranth were prepared set them apart from everyday foods. Other dishes that were probably not available to commoners included "lobster with red chili, tomatoes, and ground squash seeds."[44]

Bernal Díaz del Castillo commented on the manner in which the ruler of Tenochtitlan was served:

> His cooks had more than thirty styles of dishes made according to their fashion and usage, and they put them on small low clay braziers so that they would not get cold . . . if it was cold they made him a fire of glowing coals made from the bark of certain trees . . . the odor of the bark . . . was most fragrant . . . they put the tablecloths of white fabric . . . They served him on Cholula pottery, some red and some black. . . . and from time to time they brought him some cups of fine gold, with a certain drink made of cacao.[45]

Sahagún's informants also remark on serving of cacao to Moctezuhma:

> The ruler was served his chocolate, with which he finished [his repast]—green, made of tender cacao; honeyed chocolate made

with ground-up dried flowers—with green vanilla pods; bright red chocolate; orange-colored chocolate; rose-colored chocolate; black chocolate; white chocolate.[46]

Aztec lords drank *tlaquetzalli*, a beverage made from fine chocolate.[47] The above description probably reflects the different types of chocolate prepared for the ruler rather than a survey of what was drunk at one sitting. Notice again the mention of the colors that chocolate came in. It is obvious that the Aztecs were very fond not only of exquisite tastes but of beautiful presentation as well.

OFFERING, GATHERING, AND CONSUMING FOOD IN RITUAL

Food is gathered, offered, or consumed in every *veintena* noted by Sahagún's informants in Book 2 of the *Florentine Codex*. These three activities were important parts of the ritual component of Aztec *veintena* ceremonies. During the fourteenth month, called Quecholli (Precious Feather), observed in honor of Mixcoatl (Cloud Serpent, god of the hunt), a great hunt was part of the ritual process. Sahagún's informants note that after spending five days performing auto-sacrifices and making arrows, "all forthwith broke fast and set out for the country and formed a great wing, wherewith they surrounded many animals—deer, rabbit, and other animals."[48] According to his informants, the fasting was done "for the deer" so that it would be a successful hunt. In the Aztec capital of Tenochtitlan those successful in capturing a deer or a coyote were rewarded by the ruler Moctezuhma with a cape displaying feathered edging.[49]

Hunting was also an important component in celebrations dedicated to the fire god Xiuhtecuhtli. During Izcalli Aztec boys and young men hunted for ten days, capturing all kinds of land and water animals.[50] These in turn were handed over to the priests, who cooked them in a large fire. The hunt provided animals for offerings as well as feasting. Indeed the textual recordings of the *veintenas* contain many descriptions of consumption: "that night they ate and drank, and all made merry"; "[e]verywhere there was eating, there was celebration of the feast"; and "[t]here was eating; the feast day was observed." It also includes mouth-watering descriptions of what was prepared and served: "tamales stuffed with greens"; "fruit tamales, and stews"; and "turkey hen."[51]

These mundane (albeit delightful) descriptions do not lessen the im-

portance of food as an aspect of rituals performed during the agricultural cycle. Offerings were often embedded with symbolism, and rites mirrored and emphasized Aztec ideology. Durán records food offerings during celebrations in honor of the ancient god Quetzalcoatl and clearly links them with religious practice:

> On his day in the temple the gift which the common people offered to this false god consisted of breads and fowl, some of the latter alive, others cooked. Those already cooked were [presented] in this manner: in woven containers of dry cornstalks, all interlaced. This did not lack its symbolism, since it indicated the dryness of the season. On top of those small containers, or plates, they placed tamales as large as fat melons. These tamales are the native bread. Upon the tamales were placed large pieces of cooked hen or male turkeys. An enormous offering of these was made before the altar of the idol.[52]

The woven containers made of dry corn stalks would have acted as a visual reminder of the need for the earth to produce (and the dependence on water) and a sharp contrast to the abundant foods being offered. Other feasting descriptions reflect the importance of order and audience participation. Durán notes that some of the more exquisite food offerings in festivities related to Tlaloc were those presented by Moctezuhma and other leaders invited to the ceremony:

> Then was brought forth the sumptuous food which had been prepared for each king [to offer the god]: turkeys and their hens and game with a number of different kinds of bread. Moteczoma himself, acting as a steward, entered the chamber where the idol stood, and his great men aided him in the serving of the food. The rest of the chamber was filled to bursting with stews of fowl and game, many small baskets of various breads, and gourds of chocolate. Everything was beautifully prepared and cooked, and there was such abundance in the room that some of it had to be left outside.[53]

After this great offering the other leaders, with the help of their assistants, "fed" the deity as well. Everyone present later gathered for a feast, but Durán notes that this was in another area, "since they could not eat" where the food offerings were made,[54] creating a clear distinction between the food offered to the god and the food that could be consumed.

Offering food to the deities was a necessary part of the reciprocity in

Aztec thought. During the celebrations of Hueytozoztli, for example, food was offered to an image of Chicomecoatl. Sahagún writes that offerings included maize of every color and of every growth stage, all types of beans, chia of various kinds, and different amaranth seeds. He notes that these offerings were given to the deity because the Aztec believed that "she is our sustenance, that is to say, indeed truly she is our flesh, our livelihood; through her we live; she is our strength. If she were not, we should indeed die of hunger."[55] Aztec men and women could not live without the food provided by the gods, so they had to offer food to the gods in return.

Rituals underlining the reciprocal nature of the relationship between the gods and the Aztec people are best described in Durán's account of celebrations in honor of the god Tezcatlipoca. The friar notes in his writings that certain women had dedicated themselves to the god and came to "fulfill the vow they had made: that of giving food to Tezcatlipoca. Then they prepared the food neatly and with great care—an amazing variety of rich dishes and different breads!" Later in the celebrations participants "placed a finger on the ground, smearing it with earth, whereupon they placed it within their mouths and ate the earth which stuck to their fingers."[56]

Feeding the gods (deity impersonators, stone or wooden sculptures, or dough images) was a meaningful component of *veintena* celebrations. In rituals in honor of Tezcatlipoca participants fed the deity but were fully cognizant of their own dependence on what the earth provided and the cyclical nature of this relationship: they could not feed the gods if they did not have food from the earth, and they would not get food from the earth if they did not feed the gods. The ritual of eating the earth would have reminded participants of their often volatile relationship to nature (earth) and their dependence on the acts of the gods. The ritual was often part of the *veintena* ceremonies, as described in numerous sixteenth-century sources. In rituals in honor of Huitzilopochtli, for example, ceremonial partakers also touched the earth and then brought dirt to their mouths.[57] This ritual, which was done in the very public *veintena* celebrations, also was done in the private sphere of the home. Sahagún writes that they touched the ground and then the mouth, "perhaps before the devil, or else in front of the hearth."[58]

In other ceremonies the flesh and bones of the gods were "eaten." In rituals pertaining to Huitzilopochtli, Durán notes, "[a]ll received it [the flesh] with such reverence, awe, and joy that truly it was a thing of wonder! The people claimed that they had eaten the flesh and the

bones of the gods, though they were unworthy."⁵⁹ Again, this ritual consumption points to the intimate connection between earth and humans and of course the necessary intervention of the gods for sustenance. Here it is the flesh, or in this case dough, of the god Huitzilopochtli that acted as a reminder of the Aztec people's dependence on the gods.

THE OMINOUS SIDE: FOOD AS A WEAPON OR THREAT

Food is often complexly used in *veintena* celebrations. One of the most unusual uses of food is in the month of Izcalli, when the principal priest makes a small cake of cornmeal and waits for a footprint to appear on the dough as a sign of the arrival of the gods: "All night long the principal priest watched, and came and went many times to see when he would descry the print." When the footprint finally "appeared" and the god's foot crumbled the cornmeal cake, the head priest made the announcement and music was played to spread the news. Then the people "all offered them balls of dough." Food was also offered at the various pyramids and shrines; and finally the feasting could begin, with "the old men and the old women, who drank wine."⁶⁰

Sahagún's description of Etzalcualiztli (Eating of Etzalli), a *veintena* dedicated to the rain gods, highlights the strict rules regarding the consumption and handling of the celebration's special foods and sauces:

> And if someone were to exchange his sauce with someone else, they detained him because of it, they seized him because of it; he was seized because of it. And when food was eaten, no one let a drop of the sauce fall there on the ground where the sauces had been placed. If anyone spilt a little sauce, for all this he was detained; there was punishing.⁶¹

Diego Durán also comments on the severe penalties for food mishandling. He notes that strict rules pertaining to consumption were followed during *veintena* celebrations in honor of Huitzilopochtli:

> It was a solemn rule in all the land that no one eat anything but *tzoalli* with honey; this was the dough with which the idol was formed, it had to be eaten at dawn . . . It was considered an ill omen, a sacrilege, to drink anything after having eaten that food, until the ceremonies and sacrifices had terminated . . . Young people . . . were told: "Do

not drink, for you have eaten *tzoalli*. The wrath of the god might fall upon you and you would die!"[62]

When food offerings were made during Etzalcualiztli celebrations, Sahagún's informants note: "Very cautiously, very gently, very warily he placed them. If he made one of them roll [four maize dough balls], he was seized because of it." In some cases, instead of the four maize dough balls, a person would offer four large tomatoes or four green chiles. But no matter what the food offering, the priest watched the activities closely to make sure that no food was rolled or moved inappropriately: if it was, this person would be punished or "marked." This threatening aspect of food use in Aztec ritual is repeated throughout *veintena* recordings. The Etzalcualiztli celebrations continue with dancing and singing. Yet here too there is an underlying danger: "They danced the *etzalli* dance ... And as they kept on dancing they chanted: 'When I do, when I do, [give] me a little of thy *etzalli*. If thou givest me none, I shall break a hole into thy house.'"[63]

This text helps us to understand why food becomes a threat in certain *veintena* ceremonies. It clearly points to the reciprocal nature between giving and receiving in Aztec thought and the balance needed in that precarious relationship. Some form of violence (even death) could occur if this relationship was not balanced. Sahagún's informants also note the violence that occurs in some *veintena* celebrations, specifically in connection to food. In discussing Ochpaniztli rituals they note:

> Then came forth the Chicomecoatl [priests] . . . they came forth from the temples. They strewed seeds [of maize] . . . they each scattered on the people the seeds . . . As if there were stealing, as if there were scratching up, gathering up, there indeed continued brawling over it.[64]

In discussing this Ochpaniztli festival as related in the Codex Borbonicus and Sahagún's Book 2, Catherine DiCesare connects this "stealing" of food with Aztec creation myths in which the god Quetzalcoatl steals maize and all forms of food from the Food Mountain.[65] Ominous food rituals during Etzalcualiztli also echo creation myths; here the number four is certainly identifiable as a cosmic force and the foods presented are also significant: chiles, tomatoes, and of course maize (foods retrieved from the Food Mountain). But in addition to referring to the creative forces, it is certain that these violent uses of food also refer to the destruction that occurs in these cosmic tales. In

Aztec myth four previous "suns" or eras ended with some form of destruction; the Aztecs of sixteenth-century Mexico believed that they were living in the fifth era.[66] Thus in the Aztec mind there could be no creation without previous destruction.

In other *veintena* celebrations food is used as a threat to keep some form of social control. During Hueytecuihuitl (Great Feast Day of the Lords) food was provided to the poor for several days; tamales and atoles were given to those who had nothing to eat. Yet this was done with great order: a certain amount was provided for each individual. If any person was found taking more than his share "they struck him repeatedly, leaving marks on him with a cord made of reeds" or "they repeatedly struck him with green canes; they whacked him."[67]

Food was also a threat when it mimicked sacrificial activities. During the *veintena* Atlcahualo, sacrificial victims were gathered for the gladiatorial sacrifices to take place in the following 20-day period of Tlacaxipehualiztli (Flaying of the Men). These victims were brought to a temple, where the priests psychologically tortured them by "killing" them with food:

> There they intimated to them how they were to die; they tore out their hearts; yet they were only putting them to the test. It was with the use of tortillas of ground corn which had not been softened with lime, or "Yopi"-tortillas, that they tore their hearts from them.[68]

With hardened tortillas the priests mimicked the sacrifice to take place; victims were symbolically killed with food. It should also be noted that Mexican scholars Alfonso Caso and Ignacio Bernal have identified the god Xipe Totec with the Zapotec god Yopi, and therefore these deadly tortillas are "Xipe-Totec" tortillas.[69]

FOOD AND SACRIFICE

The *veintena* Tlacaxipehualiztli has received much comment from sixteenth-century chroniclers because of the intense level of human sacrifice that was part of the various rituals performed. Sahagún's informants note that "it was the time when all the captives died, all those taken, all those who were made captive, the men, the women, all the children."[70] Any research on consumption and ritual would be lacking if Aztec human sacrifice was not part of the discussion.

Tlacaxipehualiztli began with the sacrifice of enemy warriors who had been captured.[71] They were sacrificed on top of the temple of Hui-

tzilopochtli, the god associated with the sun, war, and renewal. The hearts of the victims were extracted and placed in a vessel called a *cuauhxicalli* (eagle gourd); many intricately carved examples of these vessels still survive in stone. The bodies of the captives were then thrown down the temple steps, where they were removed by other priests who flayed the skins of the victims. These skins were later worn by the captors, who engaged in mock battles. Davíd Carrasco proposes that the exchange between captors and captives, a literal *transfer* of flesh, was perceived by the Aztec audience as a metamorphosis of power that animated their material world as well as their very own bodies.[72] Keep in mind that we have seen this very same activity, however, in other rites occurring with images made from dough; thus food and flesh are interchangeable. The exchange was necessary to empower the rituals performed in the ceremony, making them meaningful sacred offerings to the gods for their continual provisions of sustenance.

Food was emphasized from the very beginning of Tlacaxipehualiztli celebrations. Sahagún's informants state that the day before the sacrifice took place the hair of the captives was cut and placed in the hearth and the participants fasted.[73] Here the omission of food was an important part of the ritual and perhaps symbolized an actual separation between the everyday and the extraordinary set of days to follow. The connection between the captives and the hearth is also interesting, perhaps reminiscent of the daily offerings that common Aztecs would have performed in the home, and highlights the blurred line between the sacred/profane and the public/domestic spheres.

When the captives were taken to the homes of the captors to be divided and eaten, the text emphasizes that the captor himself could not eat the flesh of the captive; only his family and relatives could partake of the special meal. The captor became the captive and hence the offering as well (a transference of offerings). A stew called *tlacatlaolli*, made from dried maize, was specifically prepared for the event; each family member ate some of the stew, and into each serving "went a piece of the flesh of the captive."[74] According to Aztec belief, these sacrifices were necessary to maintain the balance between the gods and people, to keep the giving and receiving in order. In eating the flesh of the sacrificed victim the Aztec man and woman intertwined themselves within that cosmic plan.

The stew of maize made sense on many levels. As one of the primary staples for the Aztecs, it was eaten on a daily basis and throughout the day. What could the Aztecs be more grateful for than receiving this basic substance from the gods? The growth of the plant, indeed of all

the foods that they harvested, depended on the sun; it is only fitting that maize would appear in a ceremony that honored the solar and war god Huitzilopochtli as well as Xipe Totec, another god associated with the sun and renewal. To the Aztec mind, all three had enormous control over the continuation of life.

The connection between flesh and food became even more apparent when the captor wore the skins of the victims. The Flaying of the Men ceremony was concerned with renewal: the skinning of victims and the wearing of the skins was a potent visual metaphor for growth and rebirth. After performing the mock battles, the warriors went from home to home threatening and frightening the common people. They were rewarded with offerings of food and other goods, such as turkey hens or cotton mantles (currency for the Aztecs).[75] Carrasco has noted that these rituals transformed the entire city of Tenochtitlan into a battlefield in which the sacrificed bodies nourished the sun as well as those that participated in the sacred meals: all absorbed the spirit or "soul" of the offerings.[76] Renewal was cosmic. The *veintenas*, however, were most concerned with agricultural rites. Hence renewal would have been seen as a tangible goal: a bountiful harvest. As people performed the Flaying of the Men rituals, cosmic renewal was intertwined with agricultural renewal. It is noteworthy to mention again that the rituals using dough images or other foods mimic those in which sacrifice appears.

The flesh of the captives also played another role. Sahagún's informants note:

> And the captor kept [the captive's] skin for himself; he went lending it to others. For twenty days there was begging in it; it was passed from one to another; it was worn all day. He who wore it customarily gave the captor all that was given [him], all that was gathered. Afterwards [the captor] divided up, distributed [the gifts] among [all of] them. Thus he made use of his skin.[77]

The flesh of the sacrificed victim was not only a symbolic tool for receiving food from the gods but a very real way to get food from the participants. Human flesh became the necessary exchange item for food. It was no longer an abstract idea but a physical activity in which the audience participated.

Aztec warriors also sacrificed enemy captives on the gladiatorial stone. Tied to a sacrificial stone, with a "weapon" of feathers instead of the usual obsidian-bladed club, the captive had to fight off four

fully equipped Aztec warriors. As in the sacrifices at Huitzilopochtli's temple, the defeated captive's heart was removed and offered to the sun god. He was later skinned as well. Food was connected to the gladiatorial sacrifices in various ways, as in the earlier sacrifices. Before the victim was led to the gladiatorial stone, he was made to drink pulque: "they gave him pulque, and the captive raised the pulque four times in dedication, and afterwards drank it with a long hollow cane."[78]

It is curious that in the discussions of some rituals connected to the pulque gods, Sahagún's informants illustrate the priests drinking with a long hollow tube from a vessel in the form of a rabbit. Sahagún's informants also refer to the rope that was tied from the center of the stone to the waist of the captive as the "sustenance" rope.[79] The name evokes the umbilical cord and the connection between a mother who gives sustenance to her child. It also mimics the interdependent relationship between the Aztec and their deities. In this instance, the rope acts as a visual connection between the captive and his impending death, destruction, and subsequent renewal. This association would not have been lost on the Aztec audience, who saw time as cyclical, with one event needing to end in order for another to begin again. Many of the other rituals in the Flaying of the Men ceremony also reiterate this relationship: the sacrifices on the temple tops and gladiatorial stone, the captives and their captors (who "provide" the food for the gods as well as the participants), and especially the flesh of the victims that is literally used as an exchange for food or other valuables.

The images that depict cannibalism are fascinating. It is certainly understandable why such an act has been so controversial in the scholarly literature.[80] Food historian Felipe Fernández-Armesto notes that cannibalism "normally" occurs in the context of war. This makes sense in the Flaying of the Men ceremony: Huitzilopochtli is the god of war and the captured warriors make the bulk of the sacrificial victims. But Fernández-Armesto also notes that cannibalism is "a form of divine communion," the moment when "food is re-interpreted as more than a bodily sustenance."[81] This communion involving transformation of food is certainly evident in the rituals described by Sahagún and others: food becomes flesh, flesh becomes food, and both the gods and people consume during the celebrations. This exchange is part of the communion between the Aztec people and their gods.

In the sixteenth-century pictorial manuscript Codex Magliabechiano the ceremony in honor of the god of death Mictlantecuhtli depicts several participants sitting around three vessels containing a human leg, an arm, and a head as they face the god of death in his

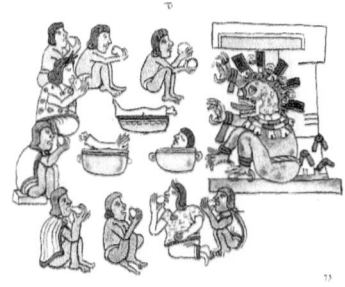

2.3
Celebration in honor of Mictlantecuhtli, from the Codex Magliabechiano. Courtesy of Akademische Druck- u. Verlagsanstalt.

temple (fig. 2.3). The participants are all eating. The figure closest to Mictlantecuhtli has two round objects outlined in red, and it could be surmised that they are all partaking of the flesh that has been offered. But only the two round objects outlined in red are being offered to the death god; everyone else is holding a round object outlined in black. These objects could very well be maize dough balls, with only Mictlantecuhtli receiving the actual flesh.

FASTING (OR NO FOOD) IN *VEINTENA* RITUALS

Abstaining from food could be just as significant as consuming food in Aztec *veintena* rituals. Fasting is mentioned in seven of the eighteen ceremonies recorded in Book 2 of Sahagún's *Florentine Codex* (see the appendix). It is highly probable that fasting occurred in all of the *veintena* celebrations as a separation between ordinary and sacred time. The friar Diego Durán mentions some of the different individuals who fasted. For example, during celebrations in honor of the god Tezcatlipoca, his priests "fasted ten, five, or seven days continuously before the main feasts" and were called "those who do penance" and "they who fast." In other feasts it was the duty of everyone to fast: "all the people of the city had to fast so strictly and rigorously that not even children or the ailing were allowed to break the fast." Durán cannot hide his admiration at the way the indigenous people were so faithful to their strict fasting rituals: "This fast was kept with a great deal more rigor and care than Lent and fast days are kept."[82]

Fasting also marks a difference between individuals: those who perform this act and those who do not. Continuing his account of the Tezcatlipoca priests, Durán writes:

> The priests and the ministers who had fasted five days in a row, who had eaten only once a day, who had lived separate from their wives

during those five days, who had not left the temple, who had been flogging themselves with the ropes we have mentioned—they were the ones who had bled themselves and made themselves martyrs to the devil!

Here the priests and ministers are separated spiritually and physically from their everyday life and space, performing auto-sacrifices that would heighten the effects of fasting on the body. The account continues:

Then was brought out the food that by this time was as eagerly desired as salvation itself. The men gorged themselves with that "divine nourishment," as it was called. No one was permitted to partake of this food except these dignitaries; this rule was observed with such rigor and fear that no one dared eat even though he saw the food there, even though he was famished.[83]

While the priests and ministers break their fasts through feasting, they are still separate from those who did not perform the fasting rituals. In this account the priests, the ministers, and the audience experience hunger, yet only the hunger of those who self-imposed it through rituals gets satiated.

Rites connected to Chicomecoatl are particularly helpful in understanding the role of fasting in *veintena* ceremonies. Sources comment that a great festival occurred a week before celebrations in honor of the deity were supposed to begin: "because of the fasting expected in the near future, the people drank and ate meat dishes, together with other things, until they were filled." After this feasting a fast took place, "with great . . . rigor and care."[84]

Then a young girl was selected and dressed as the deity image and was placed in and tied to a litter:

Finely decorated with strings of ears of corn, chili, replete with all types of grains . . . Inside and out, this chamber had been decorated and made green with numerous strings of ears of corn, chili peppers, squash, flowers, and all kinds of seed. It was a most remarkable, a most ornate thing to see.

The deity impersonator was carried in the litter in a procession to the temple of Huitzilopochtli. "Then she was carried to the chamber of

the wooden goddess who she represented, where she was untied from the litter. She was made to stand on the ears of corn and vegetables which had been offered up in the room." Durán notes that throughout this period participants were still fasting:

> I have been assured that they became so weak because of the terrible eight-day fast that for another eight days they were not themselves, nor were they satisfied with eating. Many became gravely ill, and the lives of many pregnant women were in danger.[85]

While the deity impersonator was in the chamber she was given blood offerings from the audience (it is difficult to decipher exactly who provided the blood, although Durán notes that they were both young and old) and eventually was led to a priest who decapitated her and flayed her skin. Another priest then put on her flayed flesh and thus took on the role of deity impersonator.

Throughout the ceremonies to Chicomecoatl there is a back and forth—a balance and a tension—between hunger and abundance. Visually, participants are overwhelmed by the quantity of foods available; the deity impersonator wears food as part of her costume, is carried in a litter that is brimming with different types of foods, and is placed in a chamber that is also decorated with food. She then becomes the perfect symbol of fertility herself, being killed and "reborn" through the priest who wears her skin. The audience goes from stages of gorging, hunger, and back to feasting. Even Durán notes that this relationship with food can be dangerous and deadly. The tension reflected in food rituals (abundance/abstaining) reflects the duality of Aztec thought and certainly aspects of Chicomecoatl herself. The goddess was known to cause "harm ... in barren years, when the seeds froze, when there was want and famine," but also "granted an abundant and fertile year."[86] During celebrations in honor of the deity food and ritual mirror the precarious relationship between nature and humans.

Fasting during *veintena* rituals also mimics Aztec creation accounts in which the gods fast before a sacred action of creation.[87] Just as food can be a reminder of both creation and destruction, no food or fasting also would have been a reminder to the Aztec audience of the precarious relationship between humans and the cosmos. Images of famine and food destruction are quite frequent in *veintena* pictorial accounts. One of the most poignant is a section of folio 32r from the Codex Telleriano Remensis (fig. 2.4) that depicts two men and one woman

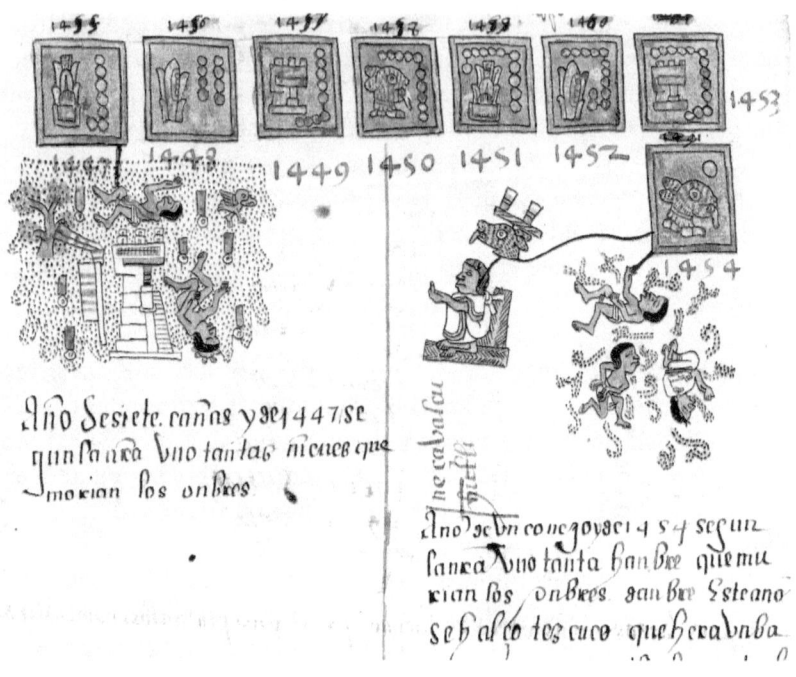

2.4
*Detail of folio 32r of the Codex Telleriano-Remensis.
Courtesy of Bibliothèque National de France.*

slowly starving to death if not dead already. This particular image corresponds to the great famine of 1454, in which many people died; the annotation to the image is "there was such a great famine that men died of hunger."[88]

SUMMARY

Sixteenth-century chroniclers of *veintena* celebrations already understood how important food was during these ceremonies. Durán, for example, notes: "I believe that the special food eaten on each feast was consumed in order to assure that this type of food [would not] be wanting at any time."[89] Food was certainly a metaphor for a good harvest and abundance. Yet a closer study of food use in *veintena* celebrations reveals a much more complex and multilayered symbolism. One of the primary functions of food is to serve as a parallel to mythical accounts: food helped the Aztec audience become an active part of cosmic stories. Most notably, *veintenas* that demanded a great deal of fast-

ing, such as celebrations to Chicomecoatl, highlighted activities and rites in accounts of cosmic creation and destruction. *Veintenas* in which food use became dangerous and threatening also highlighted cosmic connections. For example, food was related to the cosmos and the four cardinal directions during Etzalcualiztli celebrations, which included the use of offerings of four maize balls, four chiles, or four tomatoes. In their association with the cardinal directions and as offerings to the gods, these staples were transformed into cosmic foods. But if these offerings were handled inappropriately they became a metaphor for cosmic destruction. The participants felt the very physical effects of such destruction, in this case possible bodily harm.

Food was also used in tangible ways that assisted in religious transformation during ritual activities. Food was an added visual element, often being a part of the costume of priests, captives, or other participants. Items such as squash, maize, and chia were part of the architectural element of *veintena* celebrations, used to decorate temples, shrines, and litters that carried deity impersonators. Food was also represented in various media by Aztec artists. Figures such as a man holding a larger-than-life cacao pod (fig. 2.1) or a feathered serpent fragment with maize cobs (fig. 2.2) might have been placed in these food-decorated temples or shrines.

Seeds were used to make deity images. Amaranth dough, for example, was used to create entire god effigies or deity "bones" that were used in ritual activities. In many cases these dough images or fragments were ritually sacrificed and then consumed, transferring their power to those who ate them. Food use was also prevalent in *veintenas* that featured human sacrifices: victims abstained from food, consumed special foods or drinks, and were sometimes themselves made into a potent meal.

While these examples illustrate the intricate ways in which foods were used throughout celebrations, some *veintenas* highlight the most common use of food: as an offering and as a meal. However, neither of these two acts is simple. The foods offered were often basic staples that become superfoods through rituals. And while the Aztecs participating in a *veintena* feast would have enjoyed their meals, they would also have been keenly aware of the transformative power of consumption, perhaps even recalling some of the myths in which their worlds were created and destroyed through food and eating (see chapter 3).

CHAPTER 3

AZTEC MYTHS, COSMOVISION, *and* FOOD

In the anonymous work the Legend of the Suns, the author recounts how each era or "sun" came into being.[1] The account is significant in understanding the Aztecs' conception of their place in the universe; they believed they were living in the fifth era or Fifth Sun and that four previous eras had been created and consequently destroyed. The Fifth Sun, the time in which they were living, would eventually also be destroyed. The role of food and consumption is crucial to the narrative of both creation and destruction of the cosmos. In each of the periods a cosmic destruction (and consequent creation) takes place through eating and the transformation of humans into animals and/or foodstuff.

In the First Sun jaguars ate the inhabitants and destroyed the world. In the Second Sun people were turned into monkeys and then the world was destroyed by wind. In the Third Sun the inhabitants were transformed into turkeys and the world was destroyed by fire. And finally in the Fourth Sun the people were transformed into fish and the earth was destroyed by water.[2] As with many world myths of creation the four elements appear as characters of creation and/or destruction: earth, wind, fire, and water. In each of the periods the author points out what the inhabitants ate, using the phrase "That was their food" four times for emphasis. And what did they eat?: 7 Straw, 12 Snake, 7 Flint, 4 Flower—calendrical names for unidentified early foods that most scholars believe to be wild seeds or primitive grains.[3]

Diego Durán's recording of Aztec cosmic origins also contains the transformation of key figures into animals or foodstuff. The god Xolotl (Dog or Twin) transforms himself into three different foods: maize, maguey, and a salamander.[4] Two of the transformations, maize and maguey, are food items with a high level of ritual significance. While maize was an everyday staple, it was also a part of sacred celebrations and was often used in rituals that involved sacrifice.[5] The juice of the

maguey, used to make the specialty drink pulque, was also consumed in ritual and associated with various deities.[6] Unlike maize, pulque was not an everyday food item but was often used in special domestic and religious rituals. Maize and maguey also appear as specific food items first brought to the Aztec people by the gods.[7]

Book 11 (Earthly Things) of the *Florentine Codex* describes the *axolotl* (salamander) as "boneless . . . good, fine, edible, savory: what one deserves."[8] Both Sahagún and his informants seem to have appreciated this tasty food item. While not much else is known about the cooking of the salamander or its use in ritual functions, it must have had some importance to the Aztec audience, because it appears with two other sacred food items. Xolotl's transformation into three different foods probably would also have been highly significant to them. Transformation would have been understood as a process of both the supernatural and natural realms and often, as in the case of Xolotl, a wonderful blending of the two.

Transformation similarly plays a significant role in the stages of food. Food substances are always changing: they constantly move through different stages, from raw material to prepared meals. The cycle of a grain growing from a seed in the ground into a plant that in turn is harvested and prepared in various ways is a powerful example of a food's ability to transform and be transformed from one state to another. Mexican scholar Enrique Florescano, writing on the agricultural practices of Mesoamerican peoples, notes:

> This entrance of the seed into the heart of the earth and its prodigious rebirth in the form of a life-giving producing plant was a cycle that also implied sacrifice. In order for the plant and the corn husk to germinate each year in the fall, each spring a part of the previous harvest, planting seeds, had to be sacrificed to the earth, where they would suffer underground the process of decomposition and transformation which transformed the buried seed into a nutritious, revitalized fruit.[9]

In addition to seeing food growth as part of the sacrificial process, the Aztec people would likewise have been aware of their catalytic involvement in food's transformation from raw material into cooked or prepared foodstuffs, especially for their basic staples. Maize, for example, needed constant human intervention, from cultivation to consumption.[10]

In examining ritual celebrations dedicated to Tlaloc, scholar Philip

Arnold has commented that "food was articulated as an agent of transformation in these ritual descriptions. It was through its inherent quality of articulating the reciprocity necessary for human life that food became the most meaningful element in these festivals and their primary objective" (see also chapter 2 in this book).[11] In certain *veintena* celebrations the consumption of specific foods transformed the identity of the ritual participant. For example, children who consume pulque are transformed into adults and participating members of Aztec society in Izcalli (Growth or Rebirth) celebrations. Furthermore, abstaining from food is also an agent of transformation in ritual. Fasting participants in rituals in honor of Chicomecoatl are rewarded with a stunning feast and go from being hungry to being satiated. Food as an agent of transformation is expressed in Aztec creation myths as well.

Indeed in these creation stories food is the catalyst in the transformation. Without these items of consumption the various suns or universes could not have existed. Scholar Kay Almere Read believes that the myths of the different suns in the Legend of the Suns are about cosmic transformations:

> This myth about the first four suns is a story about cosmic beginnings resulting from cosmic endings. It is a story about multiple transformations. Each sun's life span is carefully counted out. Then each sun has its own unique inhabitants who live in unique houses and eat their own particular food.[12]

I agree with Read that the myths are about cosmic transformations, but I would also stress that food is a key element in the creation myths of the Legend of the Suns and the myths recorded by Durán because of its own *transformative* nature. Food is transformed through its natural growing cycle as well as when it is prepared and consumed by humans.[13] Read does point out, however, that consumption is one of the ways in which transformation occurs in these narratives.[14] In the creation myths transformation occurs through food consumption. Eating, while part of the everyday, becomes the action leading to the creation and destruction of the cosmos.

A third agent of transformation in the creation stories is the act of cooking. Continuing with the account of the Fourth Sun in the Legend of the Suns, the god Tezcatlipoca (Smoking Mirror) informs the primordial couple, identified as Tata and Nene, that they must hide in a large hollowed-out cypress tree and each consume one corn kernel.[15] After the deluge they come out of the log, see a fish, and decide

to drill a "New Fire" and cook the fish. The gods become angry and cut off the heads of the primordial couple and then transform them into dogs, which incidentally often were cooked and consumed in Aztec society. In the story maize appears for the first time (now fully identified without a calendrical name), yet the primordial couple do not get to enjoy the new food for long because they transgressed by drilling a fire without the permission of the gods. In this account the cooking fire is too sacred for humans to handle; the fire needs to be drilled by the gods first.

The discovery of maize and other foods also takes on cosmic proportions in the Legend of the Suns.[16] After creating humanity and the earth, the gods wondered what humans would eat. The task of finding food fell on the god Quetzalcoatl (Quetzal Feather Serpent), who observed an ant retrieving a kernel of maize from "Food Mountain." Quetzalcoatl reached this mythic site after transforming himself into a black ant, following the ant inside the mountain, and successfully acquiring maize. The text tells us that he and the ant "carry it out together."[17]

But acquiring this basic staple was not enough. While the gods were pleased with the maize kernels and distributed them to the people, Quetzalcoatl was determined to take the entire mountain of food. When his plan proved unsuccessful, he sought help from the other deities. The god Nanahuatl, who in another myth becomes the sun, helps Quetzalcoatl by striking the Food Mountain with lightning. To assist him the gods also summoned the rain gods (Tlaloques), who represent the four cardinal directions and are associated with the directional colors: blue, white, yellow, and red.[18] The successful acquisition of the Food Mountain brought with it a host of goods: maize of all colors, in addition to beans, amaranth, and chia.

Quetzalcoatl is a prominent figure in the creation of the Aztec world; in addition to acquiring food he also is responsible for organizing time and space. His name alludes to the green of the quetzal bird's feathers and the serpent, two powerful symbols of rebirth and renewal. Florescano notes:

> In Mesoamerica, the bird and the serpent are symbolic representations of two regions significant to religious and cosmological thought: heaven and earth. In Mesoamerican symbolism, this double entity is a synthesis of opposites: it conjugates the destructive and germinal powers of the earth (the serpent) with the fertile and ordering forces of the heavens (the bird).[19]

This netherworld, an ill-defined area, is described as "the inside of the earth, the great mouth that absorbs human beings, plants and stars." As Florescano indicates, "The dreadful risk of this insatiable mouth is that it can devour the products of the earth and the sky and refuse to return them."[20] So the other side of creation is always destruction. This is not only evident in myths such as the Legend of the Suns, in which each Sun or era is created and then destroyed, but in rituals that include dough images shaped like mountains.[21] The Aztec ritual participants ate or destroyed the Mountain of Sustenance, yet they would always need it. Philip Arnold notes that these images are both the victims of sacrifice and the embodiment of sustenance.[22] Florescano writes about the role of sacrifice in Aztec creation myths. The Mountain of Sustenance is located in the netherworld, where both food and humans are born. The netherworld is also the place where the fecundity of the universe exists, and all this is produced or acquired by sacrifice.[23]

The foods named in this cosmic event from the Legend of the Suns were basic staples that the Aztecs consumed on an everyday basis as well as during special ritual activities. The Legend of the Suns thus demonstrates the merging of the ordinary with the sacred. It takes a cosmic event and the participation of the gods to acquire basic staples. The mythic account continues with the creation of the Fifth Sun, the time when the Aztec man and woman lived: "We who live today [have] this one, it's our sun." Nanahuatl (the sun) has to be sacrificed at the "spirit oven," a fire pit often illustrated in Aztec pictorial manuscripts as the *tlecuilitl* (a cooking fire with three stones), the basic means of cooking in the hearth of Aztec homes. Before this happens, however, he does several significant things: (1) he fasts, (2) he ritually bathes, and (3) he performs auto-sacrifice.[24]

As mentioned earlier, abstaining from food is just as transformative as consuming food in the creation myths. In the Legend of the Suns cosmic events occur through both eating and *not* eating. In Aztec ritual fasting, ritual bathing, and auto-sacrifice are often preludes to commemorating an important rite and are present in both private and public celebrations.[25] Fasting is significant in ritual because it points to a pause in time, a separation that distinguishes regular time from sacred time. In the story Nanahuatl accepts his fate and begins to prepare himself for the sacred events to take place by abstaining from food. Here again the sacred (fasting, sacrifice, bathing) merges with the ordinary (a fire pit) and a transformation (a simple fire pit becomes a spirit oven).

Other sources also use the metaphor of the *tlecuilitl* in their narrative of cosmic creation. For example, in Book 7 (The Sun, Moon, and Stars and the Binding of the Years) of the *Florentine Codex*, Sahagún notes that the gods Tecuiciztecatl (God of the Moon) and Nanahuatzin create a fire in the hearth then jump into it and become the sun and the moon, respectively.[26] Again, transformation is significant in this myth. Sahagún's informants also note that before their magical transformation into the sun and moon Tecuiciztecatl and Nanahuatzin "performed penance for four nights."[27] Read points out that the Nahuatl word *mahceua* (often translated as "penance") may be one of the most difficult words to translate because of its many nuances; she believes that a more accurate translation in this passage would be "merit," since Aztec rituals were not acts of atonement, as the word "penance" would lead us to conclude.[28] "Merit" is a noteworthy translation: while a modern audience would associate the word with deserving a reward (often rightfully earned), an older definition of the word is simply something due: whether a reward *or* a punishment. In a religious context merit is associated with the performance of rituals in order to receive a reward, which is certainly part of the Aztec interpretation: Sahagún's informants note that this "penance" included offerings, auto-sacrifices, and adornments.[29] In Aztec culture food was often used as an offering and as part of the costume of both gods and humans.[30] Fasting was also part of the rituals performed by both Tecuiciztecatl and Nanahuatzin before their cosmic transformation; "Then they began now to do penance. They fasted four days — both Tecuiciztecatl [and Nanahuatzin]." Here the absence of consumption (fasting) is the catalyst for cosmic transformation. In Aztec rituals, as demonstrated throughout the recording of both private and public celebrations, fasting is a prelude to commemorating a significant rite.[31] In this myth abstaining from food becomes a ritual in itself. The Aztec people thus mimic this divine action when performing both domestic and state rituals.

Food abstinence is also significant in the Aztec myths of the destruction of the Fifth Sun as recorded in the Legend of the Suns: "They say the sun that exists today was born in 13 Reed [751], and it was then that light came, and it dawned. Movement Sun, which exists today, has the day sign 4 Movement, and this sun is the fifth that there is. In its time there will be earthquakes, famine."[32]

Earthquakes and famine mark the destruction of the Fifth Sun, also called 4 Ollin (Movement). Both earthquakes and famine are dynamic examples of catastrophic ends. While the role that food plays has been

examined in the creation of the cosmos, it now needs to be considered in its connection with the destruction of the cosmos. Here the *absence* of food marks the destruction of the Fifth Sun. Famine disrupts the fabric of society: activities that constitute part of daily events become increasingly difficult to maintain; activities that make up ritual life cease to exist. The physicality of both earthquakes and famine drastically alter the human body. In discussing the extreme effects of famine on the body, Peter Farb and George Armelago detail its debilitating stages:

> It produces diarrhea and other disturbances of the digestive tract; hypertension and eventual collapse of the circulatory system; a sharp decrease in the intake of oxygen by the respiratory system; a decrease in strength and control over limb movements governed by the neuromuscular system; and increasing vulnerability to changes in temperature as the thermoregulatory system fails.[33]

The Aztec people would thus have felt the cosmic end of the Fifth Sun in a very direct and corporeal way. Through the absence of food the end of the cosmic realm became more than an abstract concept; it became something palpable and personal. The destructive changes in the body would echo the destruction taking place in the larger universe.

Most sixteenth-century historical texts on the Aztecs mention famines, which are also depicted in pictorial histories. Durán's *History* includes an image of the great Aztec ruler Moctezuhma Ilhuicamina (ruled 144–468) overseeing his officials as they distribute goods and foods during a famine. He sits on a throne in the center of the painting, while to his right and left two dignitaries dispense clothes and food. In front of Moctezuhma are more mantles, baskets, and vessels with foodstuffs. The huddled bodies of the poor frame the ruler and his aides. The poor either reach out to take the goods or sit quietly waiting to receive them. The accompanying text states that before the ruler intervened: "People became faint and walked about shriveled and skinny due to the famine they suffered. Others became ill, having eaten things bad for the health. Others in their despair abandoned their city, homes, wives, and children, and departed toward more fertile lands to seek salvation."[34]

Had it not been for the foodstuffs in the royal storehouses the people would have perished. Performing ritual abstinence from food would re-create these historical and cosmic events for the Aztecs.

FOOD AND MIGRATION STORIES

The sixteenth-century mestizo writer Hernando Alvarado Tezozomoc's *Crónica mexicana* records the story of the Nahua people: their first entry into the Basin of Mexico in the thirteenth century, their settlement of Tenochtitlan on islands in Lake Tezcoco about 1325, and their systematic rise to power and control in central Mexico in the fifteenth and sixteenth centuries. Crucial to the beginnings of the Aztecs (or Mexicas at this point) in their new homeland were the seeds or foods that they brought with them: maize, beans, chia, and amaranth.[35] These foods continued to play an important role in Aztec culture and were the very same items that the Aztec state would later require in tribute from conquered provinces.[36]

Food appears frequently in migration accounts, also being present at the foundation of Aztec history. In the pictorial manuscripts that illustrate food, such as Codex Azcatitlan and Codex Boturini, food, food preparation, and food consumption are not only symbols for survival and success but metaphors for continuity of culture and religion.[37] As the Mexicas moved from one location to the next, they were able to acquire and prepare the necessary foods that allowed them to survive and forge their cultural identity, which included specific everyday foods and their uses in ritual. Migration accounts that illustrate food help establish the Aztecs as the chosen group in central Mexico to thrive more than other cultural groups. Food, or a lack of it, helps in reading this success.

The Codex Azcatitlan refers to food very early in the migration account. According to folio 4, during the years 1169 and 1170 the Aztecs stopped at a desert-like location, whose flora included succulents and cacti such as the nopal.[38] The inclusion of the nopal plant in the image is essential. In Book 11 (Earthly Things) of the *Florentine Codex*, Sahagún's informants list the different types of tunas (cactus fruits), their particular tastes, and some of the ways in which they were cooked.[39] In addition to being an important food item, the nopal fruit became an emblem of Tenochitlan, which literally translates to "place of the fruit of the cactus,"[40] and an icon of Aztec identity. According to Aztec myth, the Mexicas would find their home when they came across the sign of an eagle perched on a cactus.[41] The inclusion of the nopal fruit in the Codex Azcatitlan image foreshadows the success of the Aztecs in their new home.

The rest spot depicted proved to be a good place for a temporary home, as indicated by several houses and temples drawn in the center

of the page. In the midst of these buildings a kneeling woman grinds maize on a rectangular metate (stone grinder). Its appearance among the temples and homes indicates stability in the everyday, cultural, and religious life of the Aztecs. As they moved around the Basin of Mexico in search of a permanent homeland, they were able to bring with them this basic staple, which was not only important in daily meals but also became a significant part of ritual activities.

The Codex Azcatitlan illustrates another metate at a moment of great tension in the Aztec migration account. Folio 11 (fig. 3.1) depicts a point in the migration story where the Aztecs were in the service of the Colhuas of Colhuacan, an already settled group in the Basin of Mexico at this time.[42] On behalf of this group they waged war against the people of Xochimilco in the southern Basin of Mexico. The scene on the lower right-hand side shows the two groups battling as the Aztecs try to cross a river to safety. A woman holding a child crosses the river, while on the other bank another woman and child, the sacred bundle of the Aztec patron deity Huitzilopochtli, and several vessels appear.[43] Above and to the right of a soldier holding a spear and shield is a metate illustrated in profile. The image makes clear what is important to the survival of the Aztecs as a people: their women and children, their god, and their ability to sustain themselves, especially with maize. More than just being necessary for basic survival, these items were crucial for cultural and religious continuity.

Another pictorial migration account, the Codex Boturini, also known as *La tira de peregrinación*, uses food to signify those chosen by Huitzilopochtli to migrate southward and those who were not. At this critical point in the story, two distinct groups are depicted to the right of the broken tree: the first enjoys a meal with food-laden vessels lying around, while the second weeps as it listens to Huitzilopochtli (fig. 3.2). Above these groups, and beneath symbols of the migrating bands, two men engage in conversation, with scrolls at their mouths to indicate speech. One of the men looks toward the ground while tears stream down his face, as behind him two footprints move off the page. Huitzilopochtli has clearly made a selection. The artist depicts the god atop a temple as he looks at the chosen group celebrating its selection with food. His bundle, however, is no longer in the temple when he speaks to the crying group that has not been chosen. The tears, lack of a deity bundle, and lack of celebratory food reflect this group's exclusion.[44]

The acquisition as well as the production of food is important in the stories told in Codex Azcatitlan and Codex Boturini. Codex Botu-

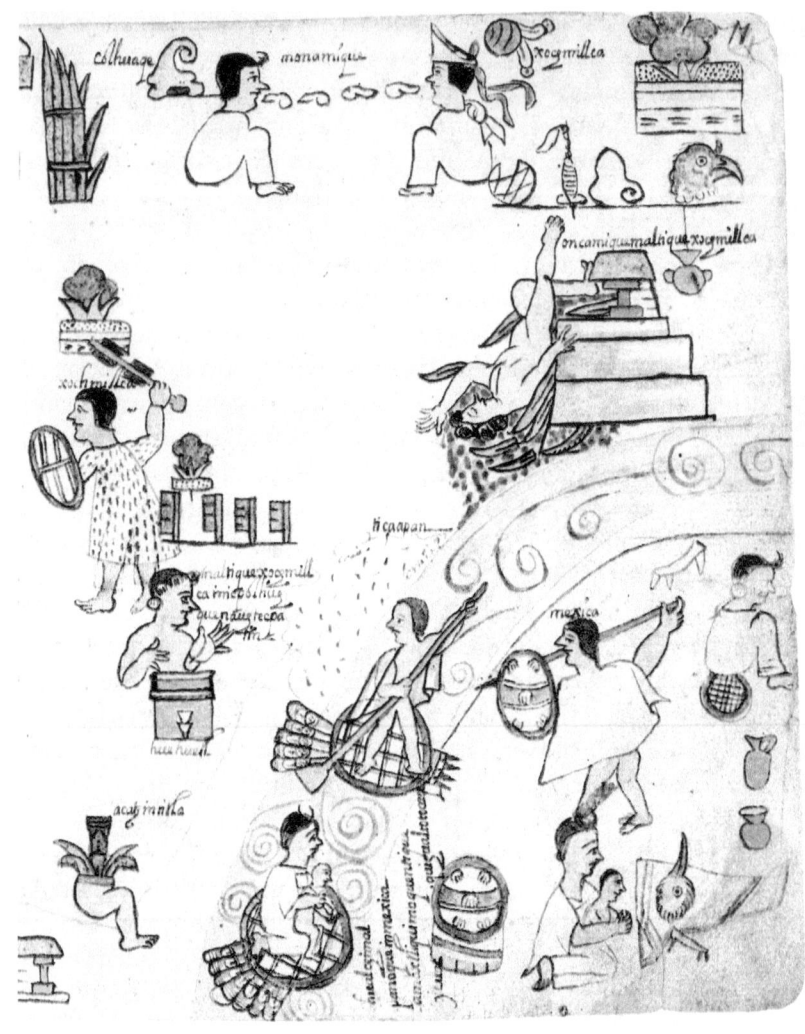

3.1
*Migration scene, detail from the Codex Azcatitlan, folio 11.
Courtesy of Bibliothèque National de France.*

rini illustrates the production of pulque (fig. 3.3).[45] At the top left a figure draws liquid from a maguey plant, using a stick to pierce the center or "heart" of the plant; he proceeds to suck the juice stored in the plant through the hollow stick. This juice was then fermented to make pulque. Directly above this figure is another man with a bowl in his hand and a larger vessel at his feet; he is enjoying the tasty drink. The scene depicts the Aztecs learning how to make pulque from the

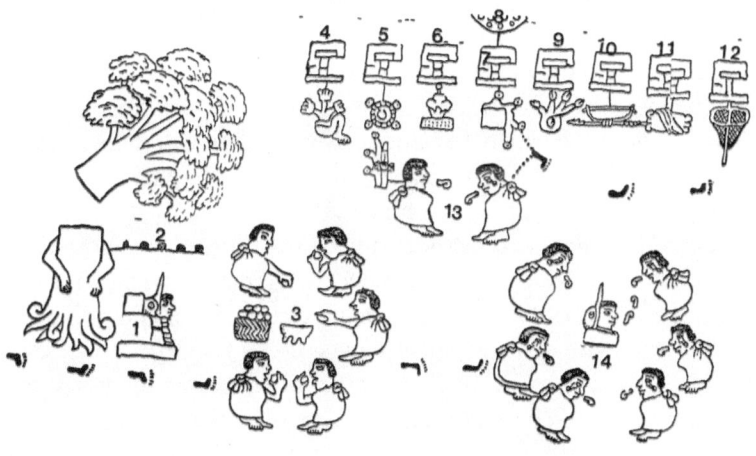

3.2
Migration scene: detail with Huitzilopochtli choosing a group to continue the migration, from the Codex Boturini. Courtesy of the Museo Nacional de Antropología.

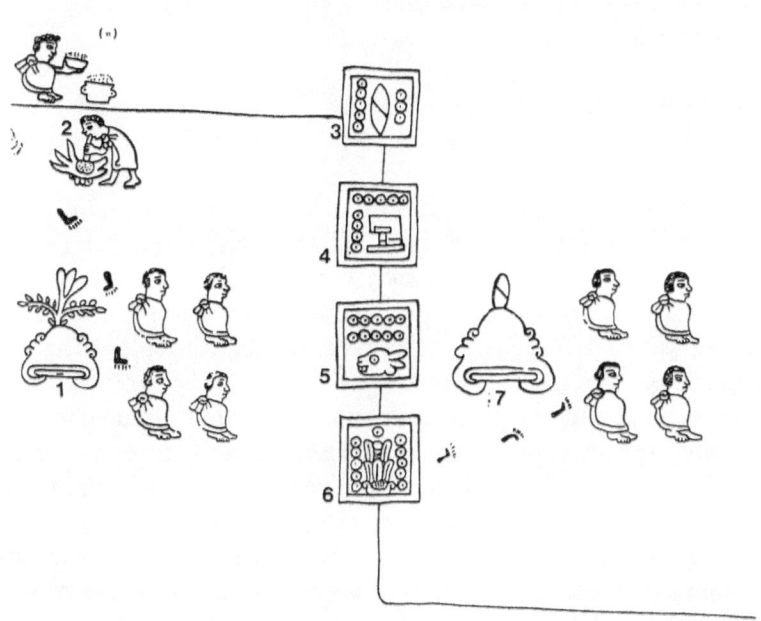

3.3
Migration scene: detail of the harvesting of the maguey juice, from the Codex Boturini. Courtesy of the Museo Nacional de Antropología.

people of Chalco, another group in the southern Basin of Mexico.[46] Like the previous scene with Huitzilopochtli, the depiction of food reflects security and the progress being made by the Aztecs, well on their way to becoming a coherent and settled group. The drinking of pulque in Aztec society eventually became highly regulated, and intoxication was severely punished.[47] Like maize, pulque was associated with many deities and was used in a ritual context.[48]

Codex Azcatitlan also depicts the acquisition of new sources of food. A detail of folio 12v-13 depicts the Aztecs hunting in a lake, capturing an array of birds and fish using canoes, nets, and poles. This scene indicates the acquisition of new skills as they moved through central Mexico as well as the development of possible religious practices. The Aztecs celebrated a series of agricultural ceremonies during the year that Spanish chroniclers referred to as *veintenas*.[49] An important aspect of many *veintenas* was the capture or acquisition of food. For example, Quecholli, the *veintena* celebrating the god of the hunt, Mixcoatl, included a great hunt in honor of the deity.[50] As the Aztecs went from location to location in the Basin of Mexico, the acquisition and production of food began to shape them into the people that would control the area.

FOOD AND POLITICS

The Aztec island capital of Tenochtitlan faced some of the same problems that face many urban cities of today: overcrowding and limited resources. Tenochtitlan's population was believed to be about 200,000 at the time of the Spanish conquest, with an overall population in the Basin of Mexico between 1 million and 2.65 million people.[51] The production of food in this area would not have been sufficient to deal with these masses. Food was produced in the city and in its immediate surrounding areas through various production methods, most noticeably chinampas (artificially constructed gardens), yet they would not have been enough to sustain the needs of such a large population.[52]

Food was constantly brought into the city through various means, including by foot and canoe. *Tlamenes* (foot carriers) were heavily used in Tenochtitlan and throughout the Aztec Empire. While these foot carriers were essential in transporting goods, the use of canoes (*acalli*) was also crucial. Historian Ross Hassig notes that canoe traffic "economically linked the entire lake system of the Valley [Basin] of Mexico."[53] This statement highlights the interdependence between

the city and surrounding areas. While the flow of goods was predominantly into the city and consisted primarily of foodstuffs, the city also served as a market for surrounding areas. Canoe trade thus flowed in both directions.

The marketplace (*tianquiztli*) was vital for the distribution of foodstuffs. Many European chroniclers comment on the Aztec market, including conquistador Bernal Díaz del Castillo, who writes of his reaction upon seeing the great marketplace at Tlatelolco: "we were astounded at the number of people and the quantity of merchandise that it contained, and at the good order and control that was maintained, for we had never seen such a thing before."[54] He also describes the incredible range of goods that were sold at the market and the vast numbers of people who came to sell and buy.[55] The impression that the market made on Europeans is also evident in the many descriptions of marketplaces and vendors in works by Sahagún and other early sixteenth-century authors. Indigenous artists depicted the market because it was a major meeting place for the indigenous population. Durán notes the importance of the market to the Aztec Empire, mentioning that attendance at the market was required for all Aztecs.[56] This enforcement of attendance by the Aztec state would have created the necessary numbers for market sales. In addition, and perhaps more significantly, the marketplace would have been a place for all Aztecs to merge daily activities with the purchasing of food and items for ritual ceremonies.

The location of the market was linked to city planning and growth. Díaz del Castillo remarks that the market contained administrative buildings associated with market activities, which probably included places to assess quality and price control.[57] Durán mentions the role of market administrators as well as the market architecture, noting that it included a court where disputes could be heard and settled.[58] Hassig comments that important markets were often adjacent to the residence of rulers, indicating a conjunction of the economic and the political.[59] As the Aztec Empire grew, the tribute system that the state had set in place was inadequate to guarantee enough foods; the city depended extensively on the market system.[60]

Religious ideology also played a role in the Aztec economy. Hassig observes that the day would begin and end at the market of Tenochtitlan with the sounding of the drum from the temple of Quetzalcoatl.[61] Markets were organized by the Mesoamerican calendar, taking place either daily or every five, nine, thirteen, or twenty days. He connects these market cycles to religious concepts involving the calendar, asso-

ciating thirteen with the Lords of the Day cycle and nine with the Lords of the Night cycle.[62] This cyclical recurrence of the market days appears in images painted by indigenous artists. A view of a market in Durán's *Book of the Gods* illustrates it as circular; among the goods being sold are clothing, foodstuffs, and slaves. In the center of the marketplace is a smaller circular form, identified by Durán as a *momoztli* or "roadside shrine or a pillory block." The friar records that food was offered on these shrines: "thus in that small shrine where the idol of the market stood were offered ears of corn, chili, tomatoes, fruit, and other vegetables, seeds, and breads—in sum, everything sold in the *tianguiz*."[63]

The religious, political, and economic thus merge in Aztec thought and culture, and food played a dynamic role in this interaction. The inclusion of food in migration and origin accounts helped transform the ordinary act of eating into an extraordinary activity that played a role in the construction and destruction of the cosmos. Food as a source was necessary both for the everyday and for special occasions. Basic daily staples such as maize and beans and elite goods such as chocolate were part of the trade and market system. The Aztecs specifically targeted areas to control that would allow them access to the foods they desired.[64] The leaders' ability to acquire the foodstuffs needed for basic functions and ritual activities was also necessary for the economic and political success of the empire. Nothing is more telling than a story in the *Annals of Cuahtitlan* regarding the fall of the legendary city of Tollan.[65] It relates that the Toltecs and their leader Huemac played a game against the rain gods. The game took on cosmic significance when the Tlalocs lost and in retaliation decided to give the Toltec leader "the shuck in which the green ear grows" instead of the promised quetzal feathers and jade. Annoyed, Huemac refused the gift. The dispute came to a head when the Tlalocs became angry and announced that they would hide their "jades" and make the Toltecs suffer for four years.[66]

The text then reads:

> So then it snowed, the snow fell knee deep, and the crops were destroyed. It was in Tecuilhuitl [June or July] that it snowed. Except that in Tollan, where there was intense heat, all the trees, the prickly pears, and the magueys dried up, and all the stones broke apart and were shattered by the heat. . . . And when the four years of hunger had passed, the tlalocs appeared in Chapoltepec, where the water is. And milk corn—food—is rising to the surface.[67]

The story continues with the gods requesting human sacrifices. Unfortunately, the Toltecs could not deliver these and the city fell. Another group, the Aztecs, rose to the occasion and delivered the necessary sacrifices. Johanna Broda points out the connections among sacrifice, the mythical fall of the Toltecs, and the rise of the Aztecs.[68] The role that food plays in the story should not be overlooked. Huemac's scorn of the gods' (meager) offering led to four years of famine, which in turn led to the collapse of the Toltec Empire. While the Toltecs cemented their fall with the inability to make appropriate human sacrifices, the Aztecs sacrificed a woman. But they also *fasted* for the sacrificial victim for four days, and here the absence of food parallels the four years of famine suffered by the Toltecs. Because it was a voluntary act, it became a powerful offering that helped the Aztecs become the dominant group in the Basin of Mexico.

SUMMARY

Migration accounts illustrate the key role that food played in establishing the Aztecs as the dominant group in the Basin of Mexico. The anonymous artists of the Codex Boturini and Codex Azcatitlan use the preparation and acquisition of food as symbols of success. In the Codex Azcatitlan a stone metate used for the daily grinding of maize is transformed into a mark of victory as the Aztecs fight against the people of Xochimilco in the southern Basin of Mexico. Food acquisition is also transformed into an icon of victory. In the Codex Boturini the Aztecs are shown learning how to make pulque, the highly valued drink used in ritual. With this knowledge in hand, they are no longer a group merely wandering the lands: they have achieved both cultural and religious continuity.

Food and its acquisition are also relevant to Aztec origin myths. In the Legend of the Suns the god Quetzalcoatl acquires food by transforming himself into an ant and following another ant into Food Mountain. His foray brings the Aztec people maize, beans, amaranth, and chia, foods that are significant to both daily meals and sacred celebrations. But food is much more than a metaphor for cultural and religious success in these origin accounts. The cooking and consumption of food are agents of transformation in Aztec primordial creation accounts. In Sahagún's narrative the deity Xolotl transforms himself into three different food items necessary to the Aztec people. The consumption of food is also the catalyst for change in accounts of the cre-

ation and destruction of the five Aztec "suns" or eras as recorded in the Legend of the Suns. In another creation account the gods Nanahuatzin and Tecuiciztecatl jump into an oven and become the sun and the moon.

Destruction is just as significant in the narratives of creation. Likewise, having no food or abstaining from consumption is sometimes just as transformative as having food. In the Legend of the Suns the god Nanahuatl, who is identified as the sun in this account, has to be "cooked" or sacrificed. But before this he performs several significant ritual activities, one of which is fasting. Fasting is often a ritual performed in both private and public ceremonies and is not just a marker of different states of being (hungry versus satiated, ritual participant versus ritual observer) but also a marker of different spaces (sacred versus everyday). Food can change from seed to plant and from raw material to prepared meal; additionally, it alters the body and mind when consumed. Equally, in the creation accounts of the Aztec people, the consumption (or not) and cooking of food serve as a catalyst for transforming time, space, gods, and the Aztec people.

CHAPTER 4

FOOD *and* RITUAL
after the CONQUEST

Food was exchanged rather quickly after European contact. By as early as 1493 maize, a word that comes from the Amerindian Tainos, may have reached Europe with Columbus's return from the Caribbean. By 1525 maize was already being grown in both Portugal and Spain. By 1565 chile peppers were common in Spanish gardens.[1] In examining food after the conquest, historian Alfred Crosby notes:

> The great advantage of the American food plants is that they make different demands of soils, weather, and cultivation than Old World crops, and are different in the growing seasons in which they make these demands. In many cases the American crops do not compete with Old World crops but complement them.[2]

The New World plants enabled the Old World farmers to produce food from soils that before contact were considered useless.

FOOD AT THE TIME OF CONQUEST

Food played a vital role from the very beginning of the meeting of the Old and New Worlds. In Book 12 (The Conquest) of the *Florentine Codex* Bernardino de Sahagún's informants observe that one of the first encounters between Spaniards and Aztecs featured an exchange of food. The Aztec ruler Moctezuhma II ordered several of his messengers to investigate the stories of strange men reaching the east coast. Upon seeing the Spaniards and hearing their guns, the messengers were fearful and fainted. Both the text and the corresponding image describe Hernando Cortés's men trying to revive the messengers with wine and food (fig. 4.1). When describing the Spanish food to the ruler

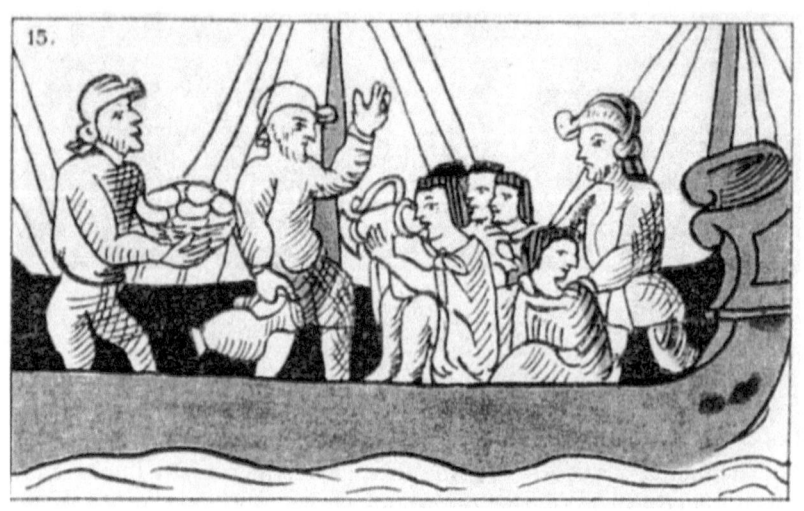

4.1

Spaniards give wine and food to Moctezuhma's messengers, from Sahagún's Florentine Codex, *Book 12, figure 15. Courtesy of the University of Utah Press.*

Moctezuhma, they noted that "their food was like fasting food," not suitable for feeding guests.³

Later on in the conquest story the Aztec ruler ordered that food be given to the Spaniards. Although the Europeans were horrified that some of the food was soaked in blood (as is befitting for the food of gods), they did eat what was offered:

> They ate white tortillas, maize kernels, eggs, turkey hens, and all manner of fruit—custard apple, mamey, yellow sapota, black sapota, sweet potato, manioc, white sweet potato, yellow sweet potato, colored sweet potato, *jícama*, plum, *jobo*, guava, *cuajilote*, avocado, acacia [bean], *tejocote*, American cherry, tuna cactus fruit, mulberry, white cactus fruit, yellow cactus fruit, whitish-red cactus fruit, *pitahaya*, water *pitahaya*.⁴

FOOD AFTER THE CONQUEST

When the Spaniards finally conquered the Aztecs in 1521, they kept the tribute system in place, demanding the same foods and goods from the conquered provinces. During the first years of Spanish rule, the Indi-

ans paid tribute in food to *encomenderos* (conquistadors who became the trustees of the indigenous population), thus playing a critical role in the food economy of what they named New Spain.[5] Tribute items included corn, fowl, eggs, fruits, vegetables, fish, honey, and chocolate, among other foods. The household of Cortés, for example, was given fifteen loads of maize, eighty baskets containing twenty tortillas each, ten native fowls, two Castillian fowls, two rabbits, ten quails, three doves, fruit, salt, chiles, and firewood on a weekly basis. Eventually, with the increase in the Spanish population and the decrease in the indigenous population, tribute became insufficient as a means of supplying food to the city. By the middle of the sixteenth century the system had begun to fall apart.[6]

Soon after the conquest the Spanish imported all things European into the new settlements established in Mexico. The success of New Spain was due in part to Spanish efforts to transform an unknown New World into a familiar Old World. Beef, cows, sheep, goats, pigs, and chickens, along with all types of fruits and plants, were brought over to establish a staple European food supply.[7] Sahagún's artists illustrate some of the first Old World animals that they saw, including horses, pigs, sheep, goats, and cattle (fig. 4.2). By 1600 all the most important food plants of the Old World were being cultivated in the Americas.[8] Of great importance to Europeans were olive oil, wine, and bread. Wine and olive oil were difficult to produce in New Spain, however. Grapes did not grow so readily and the olive tree preferred the warmer climates of places like Chile and Peru.[9] Constant shortages occurred, so the government of New Spain had to keep a tight hold over distribution. Wheat was a different matter. The Spanish were able to satisfy their demand for wheat by using the indigenous population for forced labor in order to cultivate this grain.[10] And while the Spanish were eating their familiar fare, the Indians continued to eat their usual foods.

During the early colonial period (ca. 1521–1600) many food restrictions were placed on the indigenous population, prohibiting them from gaining control of European foods and animals. Indians were also restricted when it came to producing and selling food. On May 9, 1527, the government of New Spain prohibited Indians from buying and selling Spanish goods. On June 12, 1553, they were forbidden to trade, slaughter, or sell pigs.[11] As Coe notes, food restrictions increased as the Spanish and Indian cultures began to mix and often had very little to do with food or drink.[12] Rather, the restrictions were an attempt to keep the Indian and Spanish worlds separated and

4.2
Spaniards bringing supplies and animals on land, from Sahagún's Florentine Codex, *Book 12, figure 1. Courtesy of the University of Utah Press.*

ordered, with Indians eating only New World foods and Spanish eating Old World foods. This separation was about class and social structure rather than about the foods themselves or about taste.

An example is the response to wheat and maize by both Indians and Spaniards. Maize, identified as an indigenous food, was not highly valued by the Spaniards. In 1597 the botanist John Gerard described maize as being "of hard and evil digestion, a more convenient food for swine than for men."[13] Spanish consumption of bread served to underscore the difference between the European and the maize and potato–

eating Indians. When given a choice between wheat and maize, Indians continued to value their indigenous staple. When the Spaniards tried to integrate wheat into the diet of the indigenous population, the effort was not as successful as they had hoped that it would be. In fact the Mexican population resisted wheat more than their counterparts in South America did. While taste certainly played a part in the choice, other factors must be considered as well. As Arnold Bauer notes, from the Indians' point of view wheat seemed inferior to maize, as maize yielded up to ten times more than wheat when measured in proportion to seed.[14] It also took less labor and time to produce roughly the same amount of grains. But perhaps the strongest reason for the Indians' preference for maize was its continued importance in their cultural and religious lives.[15] As noted throughout this book, maize was a sacred and profane food: eaten daily by the Aztec people, it became an extraordinary food in ritual performance.

Another tactic used by the government of New Spain to keep indigenous and European foods (and people) separate was placing restrictions on Indian markets. Indian markets outside of Mexico City were only allowed to sell indigenous foods: tortillas, corn flour, tamales, and local fruits.[16] Spaniards and blacks were prohibited from buying in Indian markets.[17] By the close of the sixteenth century Indian markets, and commerce in general, were in the hands of the Spanish authorities.[18]

Images from Sahagún's *Florentine Codex* help illustrate the separation that occurred during the early colonial period. In Book 10 (The People) his informants list the various meats sold by the meat seller. Along with the meat from local animals, they include "the meat of the Castilian [animals] — chickens, cattle, pigs, sheep, goats."[19] The corresponding image depicts two men dressed in European clothing with a scale between them (fig. 4.3). While the text does not identify the meat seller as European, it is obvious to the viewer that both seller and buyer are non-Indian. Sahagún's artists also illustrate the wheat seller. The image shows two men with a scale between them. One man carries a bag over his shoulder as the other walks to the scale in the center of the image. Behind the wheat seller are several other bags presumably full of wheat. As in the image of the meat seller and buyer, both men are clearly identified as Spaniards by their European dress.

The seller of tamales (fig. 4.4), while identified as a male in the text, is an indigenous woman. She sells a broad range of tamales; maize tamales filled with beans or fish and cooked with chiles and many more. While the flour seller is not illustrated by Sahagún's artists, he is in-

4.3
Meat seller, from Sahagún's Florentine Codex, *Book 10, figure 134.
Courtesy of the University of Utah Press.*

4.4
Tamale seller, from Sahagún's Florentine Codex, *Book 10, figure 127.
Courtesy of the University of Utah Press.*

cluded in the text: "The seller of Castilian flour . . . sells finely ground, very finely ground, well ground, very well done." The bad seller of flour "increases it with ground maize."[20] The indigenous staple is not only inferior to European food; it could also debase and corrupt it.

CHANGES IN PRE-HISPANIC PATTERNS AND INTRODUCTION OF NEW FOODS

The attempt to keep Indian and Spanish lives separate was not very successful; eventually both people and food began integrating. One simple reason for the merging of foods was the fluctuation in avail-

ability and pricing of European goods. Poorer Spaniards, unable to acquire bread on a regular basis, ate maize prepared in gruels and breads.[21] Substitution was caused by economic necessity.

An important influence in the integration of food and people was the role of the Indian woman and her presence in the Spanish home. There were few Spanish women among the early immigrants to Mexico. Several hundred arrived in 1535 and 1536 when New Spain reached the status of viceroyalty, but there were never enough to match the numbers of male Spanish settlers.[22] While the most-common marriage pattern involved members of the same ethnicity, occupational group, and social stratum, poorer Spaniards often married Indian women and richer ones often took them as concubines.[23] Some Spaniards specifically sought out high-ranking indigenous women as wives to create profitable alliances.[24] Many Spanish homes had an Indian presence in the kitchen. It is not too difficult to imagine beans, maize, avocados, and potatoes being cooked and eaten along with beef, milk, cheese, oranges, and bananas.

Another significant venue for the mixing of cuisines was the New World convent, where young girls from good families were educated. The first convent in Mexico City, Nuestra Señora de la Concepción, had been established by 1540.[25] Nearly sixty convents were founded in colonial Mexico between 1550 and 1811.[26] In addition to teaching reading, writing, and religious doctrine, many convents also offered classes in sewing, embroidering, painting, and cooking. Convents also served as experimental locations for New World crops and hybrid cuisines. For example, the popular Mexican dish mole poblano, with its mixture of Old and New World ingredients (such as cinnamon and chiles), is believed to have originated in a convent kitchen.[27] There are many different stories about where mole poblano originated, but the first recorded mole recipes come from *Novisimo arte de cocina o escenlente colección de las mejores recetas* by C. Alejandro Valdés in 1831.[28] Valdés credits Sor Juana de la Asunción from the St. Dominic convent in Puebla de los Angeles (present-day Puebla) with accidentally coming up with the recipe.[29]

Perhaps the biggest influence in the mixing of Old and New World foods and cuisines came from the new creole and mestizo groups that were used to eating both types of food.[30] While the indigenous population declined dramatically during the sixteenth century, the mixed-ancestry population grew in numbers, allowing for the continued blending of cultures and cuisines.[31] Much of this mixing was simply substitution out of necessity. For example, when wine was difficult

to attain and creoles could not afford the steep prices, they may have chosen to adopt the indigenous pulque or drink *aguardiente* (distilled sugarcane liquor).[32] Both were seen as cheap substitutes. In other cases the mixing of Old and New World foods was about taste. Cooks in the markets began selling European and indigenous fruits side by side along with prepared foods that combined products from both continents, such as quesadillas, which used the Indians' tortillas with the cheese produced from European cattle.[33] Food historian Jeffrey Pilcher comments on the ingenuity of colonial cooks:

> Colonial cooks, in attempting to re-create European foods, actually developed a highly innovative culinary repertoire. Forced to use native ingredients such as chiles and low-status European ones like pork fat, they improvised dishes that were both delicious and distinct from those eaten in the peninsula. Yet they tried valiantly to maintain ties to the homeland and, in particular, demanded the European staff of life, wheat bread. Native Americans reacted in a similar manner to the gastronomic encounter by incorporating Old World plants and animals to their diet whenever convenient.[34]

In the ingredient borrowing from one culture to another, chocolate stands out as one of the items most quickly appropriated by Europeans. During pre-Hispanic times chocolate was consumed by the elite and used as currency (it was the item in the market barter system that had the highest value). After the Spanish conquest chocolate retained its importance among the indigenous population and became significant for the Spaniards as well. The Spanish conquistador Bernal Díaz del Castillo records the feast hosted by the viceroy Antonio de Mendoza and Hernando Cortés (who was already the Marqués del Valle) in 1538, upon the announcement that Charles V from Spain and Francis I from France had signed a peace agreement.[35] Of all the foods served at the feasts, two Mesoamerican foods stand out: "chocolate" and "fruit from the land."[36] Unfortunately he does not specify which native fruit or fruits were eaten.

The province of Xoconusco, along the southern Pacific coast in Chiapas, was the dominant producer of cacao trees during pre-Hispanic times. After contact with Europeans the area was severely affected by a drop in its indigenous population, a decline significant enough to hinder chocolate production. The Spaniards then acquired chocolate from other places, including Guatemala and El Salvador.[37]

Unlike the indigenous population, Europeans drank chocolate hot, regularly sweetened with sugar, and produced a froth by beating the drink with an instrument called a *molinillo*.[38] In some monasteries friars drank chocolate twice daily, once in the morning and again in the afternoon.[39] Pilcher believes that chocolate might have been a more popular beverage than alcohol; he cites a story recorded by Thomas Gage, an English priest who was in Mexico in the seventeenth century:

> Gage . . . described the women of Chiapas as being so addicted to chocolate that they drank it during Mass. When threats failed to stop this practice, the bishop excommunicated the offenders; to which the women responded ironically by poisoning his cup of chocolate. Fray Francisco Ortiz went before the Holy Office of the Inquisition, in 1650, on charges of consuming chocolate before Mass.[40]

The irony in chocolate's history is that it was transformed into a European food once it was included in the European diet. While it was considered inappropriate for Spaniards to eat native foods, chocolate was relegated to another class and became a drink with a European social status.[41]

FOOD RITUALS AFTER THE CONQUEST

Food continued to be important to the ritual life of the indigenous population of Mexico after the conquest. Although friars such as Motolinía claimed very early on after contact that idolatry had been wiped out, others, such as Sahagún, felt that much work had to be done in order to eliminate indigenous religious belief. The character of Aztec religion, with its emphasis on gods associated with the natural and supernatural world, made it difficult for friars fully to eradicate indigenous beliefs. A Christian God was easily perceived as one of many gods, and Christ's death could certainly have been interpreted as a kind of "debt-payment" to the gods.[42] The private sphere of the Indian was also very difficult for the friars to penetrate.[43] Additionally, the more rural a population was, the less likely it was to accept state legislation.

Rites of passage ceremonies, such as funerals and weddings, were occasions in which food still played a vital role in the social and religious life of the indigenous population. Friars such as Diego Durán were often troubled by foods that they saw for sale in the Indian markets because they were aware of the ritual significance of these foods.

Upon seeing several hundred dogs for sale, for example, the friar inquired about them and was very troubled by the answer: "For fiestas, weddings, and baptisms." He writes:

> I was deeply distressed, for I knew that in olden times the little dogs had been a special sacrifice to the gods and that they were eaten afterward. I was even more distressed on seeing that in each village beef and mutton were being sold and that for a *real* one may buy more beef than [the meat of] two dogs, and yet [the latter] are still eaten.[44]

Durán understood that the choice of meat was not a mere matter of taste or availability; it reflected an intended ritual use. The friar was also aware of special dates associated with celebrations and routinely checked the Aztec calendars for any correlations between indigenous dates or names and those chosen to celebrate a Christian saint or feast. When approached by an Indian who requested Saint Luke as a patron saint, he refers to the indigenous calendars and notes: "It was then that I saw clearly that he had asked for the Feast of Saint Luke because it fell on the day and sign of House." Durán made the connection between the man's calendrical name, Calli or House, and the day of the feast of Saint Luke. The friar was also troubled by the lavish spending necessary to host a festival. He was aware of the requirements of indigenous religious festivals, that the host gave freely of food and offerings to his guests after a propitious date was chosen and the proper foods were offered. Durán was particularly upset to encounter an Indian who had been begging: after having gathered enough money he offered a fiesta, inviting the whole town and spending everything he had.[45] When Durán confronted him and reprehended him for such foolishness, the man responded simply and wisely: "Father, do not be astonished; we are still *nepantla*."[46] *Nepantla* (in the middle) is definitely the state of being or place for the indigenous population after European contact. Some might argue that they have never left that place.

Friar Motolinía also notes the use of food in Christian rituals but does not seem to have been as dismayed as Durán was. He records that the Feast of the Apostles was celebrated by the Indians, who often brought offerings for their dead: "Some offer maize, others mantles, others food, bread, chickens, and in the place of wine, they offer chocolate."[47] Of particular significance in the list of offerings are maize and cacao, two foods that were offered and prepared in pre-Hispanic religious rituals. Maize in particular had a special place in Aztec cuisine,

both at daily meals and as sacred offerings. During the celebration of Ochpaniztli (Road Sweeping) in honor of the earth mother Toci and the maize goddesses, maize was offered as a gift, a costume adornment for the deity impersonator, and a decorative element in the festival.[48] Cacao, available only to individuals of some social standing (merchants and the nobility), was another food associated with religious celebrations. It played an important role in the Aztec worldview because it was often equated both with the heart and with blood, two offerings considered to be essential for the continuation of the cosmos.[49]

Agricultural ceremonies also continued after the conquest. The writings of Hernando Ruiz de Alarcón (completed in 1629) are useful in studying the postconquest survival of food rituals. Of great concern to the priest was the use of *huauhtli* (amaranth). He notes that amaranth was used to make everyday meals such as a cold gruel to drink and buns that were "cooked in the manner of tortillas." But what disturbed him was the harvesting of the seed and the celebration that followed:

> From the first that they gather, [when it has been] ground well and made into dough, they fashion some idols in human form, about a quarter of a yard in size. For the day on which they form them, they prepare a great deal of their wine. When the idols have been made and baked, they put them in their chapels as if they were setting up some images. Placing candles and incense for them, they offer to them amid bouquets the wine prepared for the dedication.[50]

Ruiz de Alarcón goes on to describe the festivities that were held, which featured singing, playing music, and much drinking. He notes: "the owners of the little idols keep them carefully for the next day, during which all those in the festival gather together in the said chapel and divide the little idols into pieces like relics, which are eaten among all of them."[51] Amaranth was similarly used during preconquest celebrations to make dough images of Chicomecoatl, Huitzilopochtli, the fire god Xiuhtecuhtli, and the mountain gods.[52] These images were often broken into pieces and eaten as symbolic sharing of the "flesh" of the deity. Pilcher has noted that friars issued a ban against the cultivation of amaranth because of its religious significance.[53] Amaranth use thus declined because the early friars, keen on ending idolatry, limited the growing and harvesting of the seeds. However, it has survived its persecution and is still widely used in Mexico, principally in the preparation of a popular sweet called *alegría* (literally, joy or happiness).[54]

Ruiz de Alarcón also records the many spells and chants associated with the fertility of important foods such as maguey and maize. Of the maguey spell he notes: "In the spell they ask—in metaphorical terms—that crying, sweating, and streaming take place, meaning that there be a great amount of maguey-sap so that their harvest might be more abundant." He comments that maize spells were said for the planting and storing of the seed. Other foods such as squashes and sweet potatoes also had spells associated with them. In some cases, the tools used for harvesting received special chants so that they might work more efficiently.[55] During pre-Hispanic celebrations of Etzalcualiztli in honor of the rain gods, a ritual performance using agricultural implements such as hoes, sharp sticks for sowing, and other tools had also been carried out. The tools were placed on altars in the home and honored for their role in harvesting. Durán notes that "the objects were revered and thanked for their help in the fields and on the road. Food and pulque were offered to them, together with the dish eaten on this day."[56]

Some of the chants recorded by Ruiz de Alarcón recall deity names and epithets: "Please bring yourself forth, Priest whose sign is 1 Water, For now the priests have arrived, Now I have come to leave the priest, Precious prince 7 Serpent, Let us go, For here is Basket of Our Sustenance."[57] This chant used for the planting of maize seeds makes reference to "7 Serpent," the calendric name for Chicomecoatl, the goddess of maize. It also refers to the food as "Our Sustenance," another phrase used by Sahagún's informants, who called the goddess of maize the "representative of . . . men's sustenance."[58]

The maguey plant posed another concern for Ruiz de Alarcón, who reports:

> When they are to go to transplant the maguey plants . . . they prepare themselves with tobacco as if it were a guardian angel or an angel of God, to which they entrust the task. Next they get a sharpened stick, with which they are to dig up the small maguey plants, and they begin casting a spell on the said stick, advising it to carry out its task well.[59]

As noted earlier, the maguey plant was used to make the fermented beverage pulque, consumed in pre-Hispanic times in religious rituals and associated with various deities. The drinking of pulque also became a moral issue for Spanish clerics, who often criticized the Indians'

drinking as detrimental to the spirit, a concern as disturbing to the church as pulque's pre-Hispanic ritual associations.[60] Pulque increased as a problem for the poorer Spanish social classes as well; unable to afford wine, they drank pulque and *aguardiente* instead.[61]

Pulque's roots in New Spain continued to be strong. In 1662 Mexico City experienced a food shortage that caused riots. The public attacked and set fire to the National Palace, the Municipal Council of the Spaniards, and the market stands in the main plaza. While the buildings were burning, the crowds yelled "Death to the Viceroy," "Death to the Magistrate," and "Long live Pulque." When the riots ended, the viceroy at the time, the count of Galves, took measures to restore the food supply in the city and forbade the importation and sale of pulque, on which he laid full blame for the riots.[62]

In addition to the textual descriptions and images in works by the friars Durán and Sahagún, painted images from early colonial monasteries also help to understand how foods continued to be used in rituals after the conquest. In the sixteenth-century Augustinian monastery in Malinalco, in the Toluca Valley, several of the surviving painted murals depict foods among other subjects. Malinalco was an important center prior to the arrival of the Spaniards. It was a tributary province of the Triple Alliance and was predominantly responsible for providing clothing but also foodstuffs. The four food items given to the Aztec capital were one bin each of chia, maize, beans, and amaranth.[63] Two of those, maize and amaranth, were highly significant in ritual use. In addition to providing important goods to the city of Tenochtitlan, Malinalco was also essential to the ritual life of the Aztecs. During 1501 and 1515 a circular temple was cut from the living rock (Temple I).[64] The entrance to the interior was accessed through a series of narrow steps and the open "mouth" of a giant serpent. Inside the small temple was a circular bench with one jaguar and two eagle sculptures carved from the stone as seats. A third eagle seat was positioned in the middle of the room, while in the center of the various seats a deep hole was cut into the ground. Richard Townsend notes that the four seats correspond to various military offices that were replicated on the local level. In addition to being a site concerned with state affairs, Temple I was also a location where warrior sacred rituals took place. The hole in the center was most likely an offering place for sacrifices and for blood offerings made to the earth. In Townsend's words, "This was a ritual place for offerings to the 'heart of the earth' or 'the heart of the mountain,' the location of the earth's life force."[65] As the select few walked

up the narrow stairs and through the open mouth of the serpent, they would have been reminded of their role in continuing the cycle of life on earth.[66]

With the advent of the Spaniards, Malinalco continued to be important in matters of both religion and government. During the early colonial period Malinalco served (and still does) as the *cabecera* (principal town) for the area.[67] Recognizing the ritual significance of the site, Spanish authorities quickly set about a church building program. Some of these churches were massive. Monasteries were often built in *cabeceras* because, in addition to being establishments to educate the indigenous people and to keep them under control, they also served as a place for the Spanish population to seek refuge in the event of a rebellion.[68] The monastery at Malinalco, dating to roughly 1560, was staffed by the mendicant Augustinian order.[69]

The fertile lands of the Toluca Valley continued to be important to the daily life of both the Spanish and indigenous population. Native crops such as maize and sweet potato as well as introduced foods such as sugarcane, apples, and bananas were cultivated. It is thus not surprising that foods, plants, and animals are depicted in the painted murals of the convent at Malinalco. While the church was built around 1560, the murals were not painted until after 1571 by numerous artists.[70] The more thoroughly trained painters were given the responsibility for the walls, with apprentices relegated to secondary areas, details in the frescoes, and the vault paintings.[71]

The overall theme of the painted murals was that of a garden, an "earthly paradise," which Peterson notes went beyond the walls of the cloister garden to include the entire monastic complex and even the Christian church.[72] Cloisters of European monasteries consisted of a corridor surrounding a central garden. The living quarters of the friars at the monasteries were usually on the second floor. While the cloister was traditionally reserved for the friars' use in Europe, art historian Samuel Edgerton contends that in colonial New Spain, and certainly at Malinalco, these corridors were used to host processional functions. He observes that the painted murals at Malinalco were a backdrop to the actions taking place in the corridors, rather than being an Indian representation of an earthly paradise. He interprets the mix of Old and New World icons as the choice not only of indigenous artists but also of the Augustinian friars, who were very well aware of their meanings.[73] The images at Malinalco are complex because they were created by an indigenous population for an indigenous audience, but within a

European and Christian framework. The reading or interpretation of the images must have varied from individual to individual.

Various preconquest foods are represented in the Malinalco scenes, but it is difficult to ascertain if these foods were associated with their preconquest meanings or indicated a new postcontact association. In any case they were still very much associated with ritual. One image that is repeated several times is a monkey on a cacao tree. During pre-Hispanic times spider monkeys, notorious for stealing cacao pods, were sometimes depicted on vessels for chocolate. Monkeys also had an important role in Aztec thought: they were considered to be precursors of humans and as such were thought to have creative powers.[74] Cacao pods and chocolate were also equated with the heart and blood, because both were containers of valuable liquids.[75] In European thought, however, the monkey usually had negative associations. Peterson points out that from the twelfth century on the ape was the symbol of a sinner. Monkeys and apes appeared to parody human actions, so it was believed that they represented people in a state of depravity.[76] By the sixteenth century the ape and its apple diet were directly linked to the Christian idea of the fall of humankind. Peterson believes that it is in this context that they appear at Malinalco, where the murals also include many images of apple trees. The monkey is depicted twice in the garden frescoes at Malinalco (east cloister wall). Both times it is dangling not from an apple tree but rather from a Mesoamerican tree, the cacao plant. Clearly the indigenous association was not forgotten.

The sapote tree also appears at Malinalco and had religious pre-Hispanic associations. "Sapote" comes from the Nahuatl word *azpotl* (soft), and the sapote fruit is indeed large and oval with soft flesh.[77] Like the cacao plant, the sapote tree also played a role in pre-Hispanic ceremonies. In describing the rituals performed during Tlacaxipehualiztli (Flaying of the Men) in honor of Xipe Totec Durán notes the offerings presented to the deity: "They gave bunches of ears of corn... They were offered there and had to be placed upon green leaves from the sapota tree."[78] The sapote fruit was also enjoyed at regular meals. Sahagún's informants noted that it was "good, fine, sweet."[79] In Malinalco the tree appears in the east wall of the garden frescoes. Peterson and Edgerton agree that its inclusion was intended to represent the biblical Tree of Knowledge.[80] Sapote trees were part of the lush garden at Itztapalapa in the southern Basin of Mexico, which Bernal Díaz del Castillo describes as "like things never dreamed of."[81] The precon-

quest image that accompanies Sahagún's text certainly illustrates the abundance of both flora and fauna. The trees are heavy with fruits, the small pond is full of fish, and numerous birds surround the edges of the pond. The landscape is filled with diverse trees and plants, many eaten on a daily basis (such as maize and tomatoes) as well as used in ritual. The sapote tree is dominant in the picture plane, located in the upper left-hand corner of the square pond. Undoubtedly the sapote tree at Malinalco was interpreted by indigenous viewers as having both old and new ritual associations.

SUMMARY

While the exact meaning of the native trees depicted in the garden murals at Malinalco eludes definitive interpretation, food use in indigenous rituals certainly continued after the conquest. Sixteenth-century friars such as Durán noted the continued use of native foods in wedding and baptism ceremonies as well as in other types of celebrations.[82] Like many pre-Hispanic rituals, these postcontact ceremonies included not only eating special meals but also sacrificing various animals.

Some pre-Hispanic foods never lost their religious significance. Maize, for example, retained its indigenous religious as well as cultural importance. During the seventeenth century the priest Ruiz de Alarcón recorded various chants or prayers that were said for the planting and harvesting of special plants, including maguey and maize.[83] In fact maize continues to be used in rituals in rural areas in many parts of Mexico, where the Eucharist ritual is performed not with wheat wafers but with maize ones.[84] During the early colonial period some pre-Hispanic foods continued to be preferred for specific rituals. While the indigenous population eventually had access to plenty of new meats, such as pork and beef, Durán notes that they preferred to use dog meat for ritual offerings.[85]

The advent of Christianity brought a new set of ceremonies in which food use in rituals continued. Motolinía records a Feast of the Apostle celebration that included offerings not only of maize but also of bread and chickens.[86] It is not surprising that some European foods would be absorbed into ritual ceremonies. The garden murals at Malinalco provided the indigenous audience with depictions of lush and fertile lands in which the sapote and cacao tree could be newly interpreted in a Christian context and used in hybrid rituals.

EPILOGUE

SOME FINAL THOUGHTS *on* FOOD

From the beginning of their history food was essential to the Aztecs for their survival and the formation of their identity. According to the remaining migration pictorial manuscripts, as the Aztecs moved into and around in the Basin of Mexico and converted themselves from a nomadic band to the dominant group in central Mexico, the images reflect how food was used as a symbol for this transformation. In Codex Azcatitlan, for example, the Aztecs stop at a location that is full of succulents and other edible vegetation. One such plant was the nopal cactus, which would eventually become a symbol of their capital city Tenochtitlan (Place of the Prickly Pear Cactus on a Stone) but in this account also serves as a foreshadowing of their future greatness.

In another migration account, the Codex Boturini, food appears at a point of tension in the story, when the Aztec patron god Huitzilopochtli chooses between groups in the migrating band, selecting one that would continue the migration under his guidance.[1] One group weeps with sadness, as the chosen group (the Mexicas) eats from bowls laden with food. In both manuscripts food is a symbol of success in the transformation of the nomadic group into a people who would preside over a tribute empire in the Basin of Mexico and beyond. From the very beginning of Aztec myth and history, food was an important aspect of migration stories. As the Aztecs settled and began their imperialistic expansion in the fifteenth century, foodstuffs became intertwined with their rise to power: they are chosen, become more civilized, and even win wars by their ability to obtain food for their sustenance and for their rituals.

The notion of transformation is further explored in Aztec origin accounts. In origin myths such as the Legend of the Suns and "Histoyre du Mechique," food plays a role in the alternating destruction and con-

struction of the cosmos.² In the Legend of the Suns each cosmic era or "Sun" is marked by the consumption of a particular food, which becomes a catalyst for cosmic change. Sometimes it is the absence of food (or fasting) that leads to cosmic transformation. In Book 7 (The Sun, Moon, and Stars and the Binding of the Years) of Sahagún's *Florentine Codex*, the gods Tecuiciztecatl and Nanahuatzin only become the sun and the moon after abstaining from food for four days.³ Here it is the absence of food that marks a cosmic change.

Why food? Food is critical on a fundamental human level; simply put, we would not be able to exist without nourishment for our bodies. The basic act of eating takes on a cosmic relevance in Aztec myths of the construction (and destruction) of the universe. The connection between consumption and the continued existence of the human body becomes a metaphor for the continuation of the world. Food transforms, engenders transformation, and can be transformed. For example, the seed that is planted grows into the plant that is harvested. Consumption is also a transformative act. When someone eats, the body is replenished with necessary fuel and continues to grow and live. Food is also transformed by humans. The seed that is planted and later harvested becomes the grain that is ground, made into dough, and prepared in numerous ways. It is not surprising, then, that the Aztecs chose food as a dynamic symbol in their migration and origin accounts as well as in the many rituals that they celebrated throughout the year.

The transformative power of food is often highlighted in the rituals that the Aztecs performed. This is apparent in the annual series of *veintena* ceremonies, which were dedicated to specific gods and organized around the agricultural cycle within the 365-day solar calendar. The Aztecs associated specific gods with food, such as Mayahuel, the goddess of pulque, but they also associated the regenerative powers necessary for food growth with other deities such as Tlaloc, the rain god, and Huitzilopochtli, who was not only their patron god but also a solar deity. Additionally, they associated various gods with the acquisition of food—Quetzalcoatl, Tezcatlipoca, and Tlatecuhtli all had a role in bringing food to humanity.

Veintena rituals used food in various ways: to decorate temples, participants, sculpture, and living representatives of deities; to feed the gods, participants, and observers; and to mark a special time or moment in the ceremony. In addition to using food in these tangible ways, some *veintenas* used food in more esoteric ways. For example, during Ochpaniztli (The Sweeping) maize was offered as maize ker-

5.1
(Above) Abstract representation of maize deity in the Ochpaniztli ceremony, from the Codex Magliabechiano. Courtesy of Akademische Druck- u. Verlagsanstalt.

5.2
(Left) Maize altar, from the Museo Nacional de Antropología, Mexico City, Mexico. Author's own photo.

nels, dough balls, and tortillas (fig. 5.1). These offerings emphasize the transformation of food and illustrate a cycle of continuous change. This metaphor would have been significant for the Aztec audience, which would connect food with the power of cosmic transformation and continuity. Through their rituals they would reenact cosmic creation and destruction.

The choice of foods in these ceremonies is important. Staples such as maize, beans, chia, and amaranth appear in some of the most sacred of the *veintenas*. The Aztecs depended on these foods daily for their physical existence and transformed them into symbols necessary for continued cosmic existence. In rituals these everyday foods became sacred.[4] Amaranth was used in various *veintena* celebrations to form deity images; these images were transformed into the gods, venerated as such, and often consumed. The amaranth dough was transformed into sacred flesh through the rituals performed. In addition to ritual performance, Aztec art reiterated these food-related ideologies visually. For example, a huge stone block from the collection at the Museo Nacional de Antropología in Mexico City depicts four large maize cobs in relief on each side (fig. 5.2). This work has been interpreted as an altar and probably served as a receptacle for various offerings to the gods, thus allowing participants to connect with the spiritual realm. Here the maize cobs would not be associated with the tortillas that

were eaten on a daily basis but rather be seen as a sacred food connected to the gods and the cosmic realm.

Rituals involving food continued after contact with the Spanish. Chapter 4, which investigates the ways food was used in the early colonial period (ca. 1521–1600), reveals that some practices reflect a pre-Hispanic connection, others a European one, and still others a link to both. We are struck by how strong Indian traditions related to food continue to be in Mexico from ancient to modern times. Although many contemporary uses of food in Mexico reflect a fusion with European culture, food use and consumption are still intimately connected to the pre-Hispanic past.

The use of food in contemporary indigenous ritual has been documented by several scholars. In some indigenous rural communities in Mexico, a maize wafer serves as the host during the Catholic ritual of communion.[5] Anthropologist Alan Sandstrom has noted the continuing importance of maize to the spiritual and ritual life of Nahuas living in Amatlán, a remote village in the tropical region of northern Veracruz.[6] Of particular significance is the use of maize kernels in divination. The contemporary rituals recorded by Sandstrom resonate with the domestic ones performed by the ancient Aztecs. The appendix to Book 5 (The Omens) of Sahagún's *Florentine Codex*, for example, records the various ways in which food was used in rituals that took place in the home. Dishes made with maize often functioned as omens. For example, a tortilla doubled over could have various possible interpretations, such as a visit from a surprise guest or the return of a spouse.[7]

Sandstrom also documents how Nahua spiritual specialists use maize, as well as coins or small pre-Hispanic axes and carved pieces of green stone, to restore harmony in the human world. People in Amatlán still recognize the importance of the sacred nature of the earth; they view it as both male and female, akin to the Aztec conception and representation of the earth deity Tlaltecuhtli.[8]

The reciprocal relationship between the earth and humanity is still a concern of contemporary indigenous groups in Mexico. Anthropologist Tim Knab, who has worked with the Nahuas of San Miguel in the Sierra de Puebla, records a contemporary prayer:

> We live HERE on the earth
> > We are all fruits of the earth
> > The earth sustains us

> We grow here, on the earth and lower
> And when we die we wither in the earth
> We are ALL FRUITS of the earth
> We eat of the earth
> Then the earth eats us.[9]

This prayer emphasizes the interdependency of the earth, its bounty, and humanity. The earth provides the necessary foodstuffs for human beings to sustain themselves and thus grow and live; yet when they die they return or give back to the earth, so the cycle can begin again. The prayer is also remarkably similar to the "earth-eating" ritual described by Sahagún's informants, in which participants touch the earth and then bring their hands to their mouth, again emphasizing the reciprocal relationship between earth and the Aztec people.[10]

Knab notes many other prayers to the earth, some of which include references to food preparation as well. For example, one prayer includes "those who eat the earth, who heat the earth."[11] There are prayers that echo the sacred relationship between humans and cosmos and the role of food in that communion. For example: "*Talocan* you nourish us as a mother. *Talocan* you nourish us as a father. *Tlaloc* you are our tortilla mother. *Tlaloc* you are our tortilla father." "You, Sir, lord of *talocan*, Speaker of *talocan*, all officials of *talocan*, you Ma'am, Mistress of *talocan*, Mistress of the waters, Mistress of death, here I will give you, I will offer to you your food, your sustenance."[12] For the people of San Martín Zinacapan, in Mexico's Sierra Norte de Puebla, gods and people still feed one another and need each other for the exchange of food.

During the fifteenth and sixteenth centuries human sacrifice was a major component of many of the *veintena* ceremonies and often a metaphor for that reciprocal relationship.[13] Sacrifices were considered a form of "debt-payment" and were performed to keep a cosmic balance. The Aztecs offered to the gods the most precious substance available, human hearts and blood, so that they could continue receiving the bounty of the earth. This concept of feeding the gods in return for their feeding humanity was also communicated in Aztec ritual through the use of food. Book 2 (The Ceremonies) of Sahagún's *Florentine Codex* records the ritual use of amaranth, often used to stand in for the gods as well as sacrificial victims. These dough sacrifices were just as significant as other forms of sacrificial offerings, often being "eaten" by participants as the flesh of the god or the sacrificial victim.[14]

In some *veintenas* food was transformed into a sacrificial weapon: for example, during the month of Atlcahualo (Ceasing of Water) captured victims were symbolically killed with hardened tortillas before they were physically sacrificed.[15]

Aztec myths highlight this reciprocal relationship between people and the cosmos. A myth in the Legend of the Suns section of the sixteenth-century Codex Chimalpopoca credits the god Quetzalcoatl with the initial discovery of maize and bringing it to the people.[16] In addition to Quetzalcoatl's feat of obtaining maize for humanity, another myth from the sixteenth century in the "Histoyre du Mechique" illustrates his role in the birth of the maguey plant.[17] In this myth Quetzalcoatl and Mayahuel, the goddess of maguey, are hiding from the *tzitzimime* (the constellations and planets that transformed themselves into forces of darkness).[18] The two deities change themselves into branches of a tree, but the *tzitzimime* are not fooled and tear Mayahuel to shreds. When Quetzalcoatl buries her remains, the first maguey plant sprouts from her body. Mayahuel's sacrifice is thus necessary for the generation of the maguey plant. This story is one of many mythic examples where deity sacrifice is required in order to gain foodstuffs, most notably plant life. In the two stories Quetzalcoatl is involved in the attainment of two of the most important foods, maguey and maize. While both of these were certainly used on a daily level, they were also used in rituals throughout the year.

Quetzalcoatl, along with the god Tezcatlipoca, is identified in another myth in the "Histoyre du Mechique" as being responsible for the creation of the earth and by extension all things on it.[19] The myth recounts that there was no earth in the very beginning of time, just a large crocodilian creature floating in space and water. Transforming themselves into serpents, the gods tear apart the creature, called Tlaltecuhtli (Earth Monster or Lord), to create the earth. From half of her body they create the heavens, from the other half the earth. Like the myth of Mayahuel, this demonstrates that in Aztec belief sacrifice is necessary for the creation of plant life and, more specifically, food.

The myth continues as all the other gods, distressed at the dismemberment of the creature, decide to console her. The text notes:

> and they ordered from her body all the necessary fruits needed by men to live. To do that, from her hair they created trees and flowers and grasses; and from her skin, young grass and young flowers; from her eyes, pools and fountains and small caves; from her mouth, rivers and large caves; from her nose, valleys and mountains.[20]

This account is a meaningful version of the origin of the earth, because it illustrates the Aztec concept of the interconnections among all living things and the correlation of the gods, the earth, and food. Everything is cyclical: through the death or the sacrifice of the gods, life (in the form of the earth and the food produced by it) is attainable. The myths of Quetzalcoatl and Tezcatlipoca bridge the space between the everyday and the sacred as well. They help to create the ideology of the everyday as sacred. The merging of sacred acts (such as human sacrifice) with everyday foods reinforced this philosophy in Aztec culture.

Perhaps one of the most visible examples of the continued role of food in contemporary ritual is Day of the Dead celebrations in Mexico.[21] The holiday climaxes on November 2, the Christian feast of All Souls, which is dedicated to the departed souls of relatives. People welcome their dead relatives back into the earthly realm by setting up altars in their homes and at grave sites. Part of the ceremony consists of adorning shrines and graves with flowers and food. Food appears throughout the celebration, most notably in sugar confections in the shape of skulls but also in offerings of food to the dead that include specially prepared meals, chocolate beverages, and sweets. While the celebration is not specific to the Nahuas, the various rituals involved certainly parallel preconquest Aztec ceremonies for the dead.

For the Aztecs of sixteenth-century Mexico, food enveloped their natural world as well as their spiritual world, two realms that often converged. In their everyday existence food marked important moments of their lives: child-naming ceremonies announcing the birth of a child; marriage; and death. Gender, age, and status were also denoted by consumption. The nobility, men, and the old ate and drank different things from the common class, women, and the young. In creation accounts food was first obtained for humans by the gods and in essence food is inherently sacred because it was given as a gift. Creation and origin myths used food as a metaphor for cosmic and political transformation, and rituals echoed these ideas in art and performance. Food thus distinguished the Aztec people from other groups in the area and shaped their spiritual and physical world.

APPENDIX
SAHAGÚN'S *Florentine Codex*, BOOK 2

Veintena	Major deities	Food	Fasting	Dough images	Painted images
Atlcahualo (Ceasing of Water)	Tlaloc, Chalchiuhtlicue (Jade Her Skirt) Quetzalcoatl (Quetzal Feather Serpent)	amaranth seeds, tortillas			
Tlacaxipehualiztli (Flaying of Men)	Xipe Totec (Flayed Our Lord)	tlacatlaolli (dried maize stew), pulque, tortillas of uncooked maize, tamales of wild amaranth seeds, turkey hens	yes		#1–12
Tozoztontli (Small Vigil)	Tlaloc, Coatlicue (Serpent Her Skirt)	food served (not specified)			
Hueytozoztli (Great Vigil)	Centeotl (Maize Cob Lord)	white atole, atole made of maize softened with lime, *aquetzalli* (atole made with fruit), hard baked frog, pinole with beans, toasted maize, maize of various colors, beans, amaranth, chia, quail	yes		#13–14

Veintena	Major deities	Food	Fasting	Dough images	Painted images
Toxcatli (Dry Thing)	Tezcatlipoca (Smoking Mirror) Titlacauan (We His Slave)	tamales made with fruit, tamales softened with lime, bean and cornmeal cakes, tamales of coarse white flour, tamales rolled up in amaranth seed dough, quail, other (not specified)	yes	Huitzilopochtli	#15–21
Etzalcualiztli (Eating of Etzalli)	Rain Gods	*etzalli* (cooked maize and beans), maize balls, green chiles	yes		#22–23
Tecuilhuitontli (Small Feast Day of the Lords)	Huixtociuatl (Lady of Salt)	pulque			#24–25
Hueytecuihuitl (Great Feast of the Lords)	Xilonen (Young Maize Ear Doll)	pinole sweetened with honey, atole, tamales made with maize, tamales made with fruit, tamales made with blossoms, tamales with twisted ends, cane of green corn, cooked amaranth greens, pulque; feeding of the poor for seven or eight days	yes		#26–28
Tlaxochimaco (Giving of Flowers)	Huitzilopochtli (Hummingbird on the Left)	tamales, turkey hens, dogs, pulque			#29
Xocotlhuetzi (Xocotl Falls)	Xiuhtecuhtli (Turquoise Lord)	food served (not specified)		Xiuhtecuhtli	
Ochpaniztli (Road Sweeping)	Teteo Innan (Gods Their Mother)	maize and squash beans			#30
Teotleco (Arrival of the Gods)	Huitzilopochtli (Hummingbird on the Left) Xiuhtecuhtli (Turquoise Lord)	dried grains of maize, ears of maize, toasted maize, maize dough balls, pulque			

APPENDIX

Veintena	Major deities	Food	Fasting	Dough images	Painted images
Tepeihuitl (Hill Feast Day)	Rain Gods	pulque		Mountains	
Quecholli (Precious Feather)	Mixcoatl (Cloud Serpent)	great hunt: deer, coyotes, rabbits, other food and drink (not specified)	yes		
Panquetzaliztli (Raising of the Banners)	Huitzilopochtli (Hummingbird on the Left)	tamales of amaranth seeds, pulque, chocolate, meat, other food (not specified)	yes	Huitzilopochtli	#31–32
Atemoztli (Descent of Water)	Rain Gods	small tamales, sauces, chocolate, pulque, other food (not specified)		Mountains	
Tititl (Contraction)	Illamatecuhtli (Old Mother) Tonan (Our Mother) Cozcamiauh (Necklace of Corn Flowers)	maize balls			#33
Izcalli (Growth or Rebirth)	Xiuhtecuhtli (Fire God)	tamales with stuffed greens with shrimp sauce, pulque, tortillas from uncooked ground maize, capture of animals (such as birds, salamanders, fish, and frogs)			#34

NOTES

PREFACE

1. Maurice Godelier, *The Enigma of the Gift*, 122.
2. Ptolemy Tompkins, *This Tree Grows Out of Hell: Mesoamerica and the Search for the Magical Body*, 35.

INTRODUCTION

1. Of the many helpful surveys on Mesoamerican cultures, I recommend Mary Ellen Miller, *The Art of Mesoamerica: From Olmec to Aztec*.
2. For further information, see Alfredo López Austin, "Aztecs." The term "Nahua" is often used to denote Nahuatl-speaking peoples, and scholars often use it to describe these peoples after the Spanish conquest. See Michael E. Smith, *The Aztecs*, 4. For clarity and continuity I use the term "Aztec" throughout this book.
3. Elizabeth Hill Boone, "Migration Histories as Ritual Performance," 143.
4. Ross Hassig, "The Collision of Two Worlds," 94.
5. Michael E. Smith, "The Aztec Empire," 121.
6. Enrique Florescano, *The Myth of Quetzalcoatl*, 166.
7. Particularly useful is Miller, *The Art of Mesoamerica*, especially the images on 203–212.
8. I use the term "colonial" to refer to the process of colonization of one dominant group by another. It should be noted that Mexico was never a colony of Spain, but a viceroyalty.
9. Chapter 4 and the epilogue provide a summary.
10. Fray Bernardino de Sahagún, *Florentine Codex: General History of the Things of New Spain*. The *Florentine Codex* is an encyclopedic work on Aztec culture and religion organized by the Franciscan friar Bernardino de Sahagún, who used Nahua informants to gather information. The finished product is a bilingual work in Spanish and Nahuatl, the native language of the Aztecs, including painted images. Donald Robertson has proposed that Sahagún's prototype was most probably the thirteenth-century *De Proprietatibus Rerum* by Bartholomaeus

Anglicus, because it follows the medieval manuscript in its organization of topics, the Divine, the Human, and the Mundane: Donald Robertson, "The Manuscripts of Sahagún," 170.

11. Diego Durán, *Book of the Gods and Rites and The Ancient Calendar*.

12. Felipe Fernández-Armesto, *Food: A History*, 34.

13. John Bierhorst, trans., *History and Mythology of the Aztecs: The Codex Chimalpopoca*, 142–144. I am using the English version of the Legend of the Suns as published in *Codex Chimalpopoca*, although there are numerous other translations, including Ángel M. Garibay's *Teogonía e historia de los mexicanos: Tres opúsculos del siglo XVI*. For a solid but brief description of the origin of the text, see John Bierhorst, "Introduction," in *History and Mythology of the Aztecs*, 1–16. For references to other editions and translations, see Roberto Moreno de los Arcos, "Los cinco soles cosmogónicos."

14. Durán, *Book of the Gods and Rites and The Ancient Calendar*, 222.

15. Garibay, *Teogonía e historia de los mexicanos*, 108.

16. Sahagún, *Florentine Codex*, Book 2 (The Ceremonies).

17. Michael E. Smith, "Domestic Ritual at Aztec Provincial Sites in Morelos"; and Boone, "Migration Histories as Ritual Performance."

18. Miguel León-Portilla, "Metaphysical and Theological Ideas of the Nahuas."

19. This is discussed further in chapter 2.

20. Davíd Carrasco, *Religions of Mesoamerica: Cosmovision and Ceremonial Centers*, 12.

21. Ferdinand Anders, Maarten Jansen, and Luis Reyes García, eds., *El libro del Ciuacoatl: Homenaje para el año del fuego nuevo, Códice Borbónico*. The Codex Borbonicus is an early postconquest pictorial manuscript made up of four different sections. The first section is a divinatory almanac. The second section deals with the Lords of the Night, depicted in association with the 52-year cycle. The third section (the one most used in this study) treats the *veintenas*, especially the agricultural ceremonies. The fourth and final section deals with a 52-year cycle and the New Fire Ceremony. See Christopher Couch, "History, Description and Dating of the Manuscript."

22. Ferdinand Anders, Maarten Jansen, Luis Reyes García, eds., *Libro de la vida: Texto explicativo del llamado Códice Magliabechiano*. The pictorial manuscript was done postcontact for a European audience: space is set aside for Spanish glosses to explain the scenes depicted. The entire manuscript deals with the ritual calendar and annual ceremonies. Eloise Quiñones Keber, *Codex Telleriano-Remensis: Ritual, Divination, and History in a Pictorial Aztec Manuscript*.

23. Alfredo Pérez Bolde, *Interpretación del Códice Boturini*; *Codex Azcatitlan*.

24. Fray Toribio de Motolinía, *Historia de los indios de la Nueva España*.

25. Hernando Alvarado Tezozomoc, *Crónica mexicana, escrita hacia el año de 1598*.

26. D. W. Mcpheeters, "An Unknown Early Sixteenth-Century Codex of the Crónica Mexicana of Hernando Alvarado Tezozomoc," 506–507.

27. H. B. Nicholson, "Fray Bernardino de Sahagún: A Spanish Missionary in New Spain, 1529–1590." In addition to the *Florentine Codex*, Sahagún and his team of indigenous collaborators produced the *Primeros Memoriales by Fray Bernardino de Sahagún: Paleography of Nahuatl Text and English Translation*.

28. The following works are just a small sample of the literature on Sahagún's

works: Ellen T. Baird, *The Drawings of Sahagún's Primeros Memoriales: Structure and Style*; Miguel León-Portilla, *Bernardino de Sahagún: First Anthropologist*; J. Jorge Klor de Alva, H. B. Nicholson, and Eloise Quiñones Keber, *The Work of Bernardino de Sahagún, Pioneer Ethnographer of Sixteenth-Century Aztec Mexico*; Eloise Quiñones Keber, ed., *Representing Aztec Ritual: Performance, Text, and Image in the Work of Sahagún*.

29. The city of Tetzcoco, home of the Acolhua people, formed the Triple Alliance about 1430, with Tenochtitlan and Tlacopan. After the conquest it continued to be an important center.

30. Fernando Horcasitas and Doris Heyden, "Fray Diego Durán: His Life and Works," 4–5 (the exact date of his coming to Mexico is unknown), 12–47.

31. For a solid discussion on Benavente Motolinía, see Georges Baudot, "Fray Toribio de Benavente Motolinía."

32. Michael D. Coe and Gordon Whittaker, trans. and eds., *Aztec Sorcerers in Seventeenth Century Mexico: The Treatise on Superstitions by Hernando Ruiz de Alarcón*, 1.

33. The term "colonial" is used throughout this manuscript, but it should be noted that Mexico was never a true colony of Spain but a viceroyalty. Mark A. Burkholder with Suzanne Hiles, "An Empire beyond Compare."

34. Alfredo López Austin, *Cuerpo humano e ideología: Las concepciones de los antiguos nahuas*; Miguel León-Portilla, *Aztec Thought and Culture*; Johanna Broda, "Astronomy, Cosmovision, and Ideology in Pre-Hispanic Mesoamerica"; Doris Heyden, "Dryness before the Rains: Toxcatl and Tezcatlipoca."

35. Quiñones Keber, *Representing Aztec Ritual*.

36. Johanna Broda and Félix Báez-Jorge, eds., *Cosmovisión, ritual e identidad de los pueblos indígenas de México*.

37. Smith, "Domestic Ritual at Aztec Provincial Sites in Morelos," 95–96. He notes the aid of scholar Leonardo López Luján in suggesting this approach (114, note 3).

38. Ibid., 96. Additionally, he notes the difficulties in studying Aztec ritual within the framework of the "great/little tradition" and the "dominant ideology": ibid., 93–95.

39. Brian Hayden, "Fabulous Feasts: A Prolegomenon to the Importance of Feasting," 23–24. Hayden notes that Northwest Coast feasting is an exception.

40. Michael Dietler and Brian Hayden, eds., *Feasts: Archaeological and Ethnographic Perspectives on Food, Politics, and Power*.

41. Janet Long-Solís and Luis Alberto Vargas, *Food Culture in Mexico*.

42. Kay Almere Read, *Time and Sacrifice in the Aztec Cosmos*; Smith, "Domestic Ritual at Aztec Provincial Sites in Morelos."

43. Elizabeth M. Brumfiel, "Meaning by Design: Ceramics, Feasting and the Figured Worlds in Postclassic Mexico"; Yólotl González Torres, "El banquete como forma ritual."

44. Edward E. Calneck, "Settlement Patterns and Chinampa Agriculture at Tenochtitlan," 104.

45. Bernard R. Ortiz de Montellano, *Aztec Medicine, Health and Nutrition*, 78.

46. Teresa Rojas Rabiela, "Chinampa Agriculture," 1:200.

47. Calneck, "Settlement Patterns and Chinampa Agriculture at Tenochtitlan," 114. Other authors have a different view. Hassig believes that the grid pattern of

the chinampas indicates centralized planning: Ross Hassig, *Trade, Tribute, and Transportation: The Sixteenth-Century Political Economy of the Valley of Mexico*, 29.

48. Calneck, "Settlement Patterns and Chinampa Agriculture at Tenochtitlan," 112, 114.

49. Daniel K. Early, "The Renaissance of Amaranth," 19.

50. Ortiz de Montellano, *Aztec Medicine, Health and Nutrition*, 95.

51. Hassig, *Trade, Tribute, and Transportation*, 53.

52. Coe, *America's First Cuisines*, 89. Coe notes that the Spanish called the wickerwork containers that held between 8,000 and 10,000 bushels *troxes*.

53. Diego Durán, *The History of the Indies of New Spain*, 205.

54. Susan Kellogg, "The Social Organization of Households among the Tenochca Mexica before and after the Conquest," 212.

55. For a discussion of the history of the Aztecs in the Basin of Mexico, see Michael E. Smith, "The Rise of Aztec Civilization."

56. *Codex Chimalpopoca* (Legend of the Suns); Garibay, *Teogonía e historia de los mexicanos* ("Leyenda de los soles," "Histoyre du Mechique," and "Historia de los mexicanos por sus pinturas").

57. *Codex Azcatitlan*; Pérez Bolde, *Interpretación del Códice Boturini*.

CHAPTER 1. CEREMONIAL CONSUMPTION IN EVERYDAY LIFE

1. Louise M. Burkhart, "Mexica Women on the Home Front: Housework and Religion in Aztec Mexico," 31–32.

2. Sahagún, *Florentine Codex*, Books 4–5, 113; Frances F. Berdan and Patricia Rieff Anawalt, eds., *The Essential Codex Mendoza*, 118.

3. See Michael Dietler, "Theorizing the Feast: Rituals of Consumption, Commensal Politics and Power in African Contexts," 65.

4. I expand on the definition provided by Polly Weissner, "Of Feasting and Value: Enga Feasts in a Historical Perspective (Papua New Guinea)," 116–117. Specifically, most of the primary sources detailing Aztec ritual (such as Sahagún and Durán) note the abundance of offerings, foods, and other items in feasts.

5. Sahagún, *Florentine Codex*, Books 4–5, 122.

6. Diego Durán, *The History of the Indies of New Spain*, 319.

7. Ibid., 322.

8. Inga Clendinnen, *Aztecs: An Interpretation*, 38.

9. Anthropologist Michael Dietler has argued that all feasts are inherently political: "Theorizing the Feast," 77. While some Aztec feasts were overtly political in nature, such as those having to do with state-level religious and ruler ceremonies, others were less so, such as domestic feasts and merchant banquets. The inherent nature of a feast does indeed allow for the construction of politics. A feast brings people together, promoting the creation and maintenance of political or social relationships or both. As Dietler notes, a feast is often a device for legitimizing status differences, with the manipulation of food consumption emphasizing these differences (84, 88).

10. Sahagún, *Florentine Codex*, Books 4–5, 119.

11. Brian Hayden, "Fabulous Feasts: A Prolegomenon to the Importance of Feasting," 36.

12. Dietler, "Theorizing the Feast," 70.
13. Sahagún, *Florentine Codex*, Books 4–5, 117, 121.
14. Davíd Carrasco, "The New Fire Ceremony and the Binding of the Years: Tenochtitlan's Fearful Symmetry," 105, 106.
15. Sahagún, *Florentine Codex*, Book 9, 34.
16. The term "baptism" was applied because the celebration involved the bathing of the child in a basin in a manner similar to the Christian baptism of a child. In any case, the word "baptism" as used by Sahagún's informants does not reflect the Western/Christian notion of the term.
17. Sahagún, *Florentine Codex*, Book 9, 33, Books 4–5, 113.
18. Ibid., Book 6, 205.
19. Ibid., Books 4–5, 113, 114.
20. Berdan and Anawalt, *The Essential Codex Mendoza*, 147.
21. Ibid., 148; Sahagún, *Florentine Codex*, Book 6, 201, 205.
22. Sahagún, *Florentine Codex*, Books 4–5, 123.
23. Ibid., 121.
24. Ibid., 122.
25. Ibid., 118.
26. Berdan and Anawalt identify a similar image in the *Codex Mendoza* as a flower bouquet: *The Essential Codex Mendoza*, 228.
27. Coe, *America's First Cuisines*, 109. Coe quotes Sahagún, *Florentine Codex*, Books 4–5, 118. While it is possible that chocolate was only available to men, not enough information remains to make a claim with certainty.
28. González Torres, "El banquete como forma ritual," 119. The author uses Sahagún as her source, noting that not all members of the Aztec family ate together.
29. The following discussion comes from Sahagún, *Florentine Codex*, Book 2, chapter 30.
30. Ibid., 159, 160.
31. Esther Pasztory, *Aztec Art*, 250, 278.
32. Sahagún, *Florentine Codex*, Book 9, 33.
33. Ibid., Book 2, 164–165.
34. *Metl* is associated with a female deity, Mayahuel. Pulque is connected with a group of gods referred to as the Centzon Totochtin (400 rabbits), in reference to the drunkenness that it could cause.
35. English translation from Berdan and Anawalt, *The Essential Codex Mendoza*, 146.
36. Rosemary A. Joyce, "Girling the Girl and Boying the Boy: The Production of Adulthood in Ancient Mesoamerica," 477.
37. Clendinnen, *Aztecs: An Interpretation*, 191.
38. Sahagún writes: "And when the twenty [days] of Izcalli had passed, thereupon were established the five days of Nemontemi or Nenontemi. They belonged nowhere. And the Nemontemi were indeed feared; they were held in awe": *Florentine Codex*, Book 2, 162.
39. Clendinnen, *Aztecs: An Interpretation*, 191.
40. Fernández-Armesto, *Food: A History*, 5.
41. Sahagún, *Florentine Codex*, Book 2, 160.
42. Ibid., Book 6, 127.

43. While the Spanish gloss identifies the tamales and turkey simply as *comida* (food), these two items are represented in similar fashion in other Aztec pictorial manuscripts. Berdan and Anawalt, *The Essential Codex Mendoza*, 168–169. The pulque jar and drinking vessel can be identified by a U-shaped symbol, which represents the nose ornament (*yacameztli*) of the pulque gods. For a thorough discussion on this symbol and its iconography, see Patricia Rieff Anawalt, "Rabbits, Pulque, and Drunkenness: A Study of Ambivalence in Aztec Society," 22–25.

44. For a detailed description of the military life cycle, see Ross Hassig, *Aztec Warfare: Imperial Expansion and Political Control*, chapter 3.

45. Sahagún, *Florentine Codex*, Book 3, 49.

46. Ibid., Book 8, 72.

47. Berdan and Anawalt, *The Essential Codex Mendoza*, 141.

48. English translation from ibid., 140.

49. For an overview of some of these funerary practices, see León-Portilla, *Aztec Thought and Culture*, 124–133.

50. Fray Bernardino de Sahagún, *Historia general de las cosas de Nueva España*, 1:328.

51. For more on paper offerings and pre-Hispanic uses, see Philip P. Arnold, "Paper Rituals and the Mexican Landscape."

52. Ibid., 232.

53. Sahagún, *Historia general de las cosas de Nueva España*, 1:329, 330.

54. The Templo Mayor in Tenochtitlan was considered the *axis mundi* of the Aztec Empire. It was perceived as the meeting point of heaven, earth, and the underworld; the main center in the political, economic, and religious sense; the location where Aztec rulers emphasized their power and legitimacy to rule; the place where tribute was deposited and monuments were erected; and the backdrop for the activities of the state, including the cycle of *veintena* ceremonies. See Johanna Broda, Davíd Carrasco, and Eduardo Matos Moctezuma, *The Great Temple of Tenochtitlan: Center and Periphery in the Aztec World*, 5.

55. Durán, *Book of the Gods and Rites and The Ancient Calendar*, 122.

56. Sahagún, *Florentine Codex*, Book 3, 43.

57. Durán, *Book of the Gods and Rites and The Ancient Calendar*, 122.

58. Ibid., 151.

59. Ibid., 310, 442.

60. Burkhart, "Mexica Women on the Home Front," 32, 34, 35.

61. As noted in ibid., 39–40; the source is *Primeros Memoriales by Fray Bernardino de Sahagún*.

62. Smith, "Domestic Ritual at Aztec Provincial Sites in Morelos," 93.

63. Elizabeth M. Brumfiel, "Aztec Hearts and Minds: Religion and the State in the Aztec Empire," 301.

64. Elizabeth M. Brumfiel, "Figurines and the Aztec State: Testing the Effectiveness of Ideological Domination," 146–147.

65. Smith, "Domestic Ritual at Aztec Provincial Sites in Morelos," 93.

66. Elizabeth M. Brumfiel and Lisa Overholtzer, "Alien Bodies, Everyday People and Hollow Spaces: Embodiment, Figurines and Social Discourse in Postclassic Mexico," 302.

67. Smith, "Domestic Ritual at Aztec Provincial Sites in Morelos," 106–107.

68. As noted in Cecilia F. Klein and Naoli Victoria Lona, "Sex in the City:

A Comparison of Aztec Ceramic Figurines to Copa Figurines from the Temple Mayor," 350–351.

69. Bierhorst, *History and Mythology of the Aztecs*, 146.
70. Sahagún, *Florentine Codex*, Books 4–5, 184.
71. Ibid., 187–188, 185.
72. Ibid.; see also Burkhart, "Mexica Women on the Home Front," 41–45.
73. Sahagún, *Florentine Codex*, Books 4–5, 187.
74. Ibid., 194.
75. Ibid., Book 2, 195. The Dominican friar Diego Durán also notes food offerings made at domestic shrines: *Book of the Gods and Rites and The Ancient Calendar*, 463.
76. Mary Miller and Karl Taube, *An Illustrated Dictionary of the Gods and Symbols of Ancient Mexico and the Maya*, 92, 87.
77. Read, *Time and Sacrifice in the Aztec Cosmos*, 41–42.
78. Sahagún, *Florentine Codex*, Book 7, 25–32.
79. Ferdinand Anders, Maarten Jansen, and Luis Reyes García with Gabina Aurora Pérez Jiménez, *El libro de Tezcatlipoca, señor del tiempo: Libro explicativo del llamado Códice Fejérváry-Mayer*, 35.
80. Sahagún, *Florentine Codex*, Book 7, 25–32.
81. This is discussed further in chapter 3.
82. Chapters 2 and 3.

CHAPTER 2. FOOD IN AZTEC PUBLIC RITUAL

1. For more on calendars in Mesoamerica, see Elizabeth Hill Boone, "Time, the Ritual Calendar, and Divination"; and Eloise Quiñones Keber, "The Annual Ritual Calendar."
2. Boone, "Time, the Ritual Calendar, and Divination," 17.
3. Sahagún, *Florentine Codex*, Book 2; Durán, *Book of the Gods and Rites and The Ancient Calendar*; Fray Toribio de Motolinía, *Historia de los indios de la Nueva España*.
4. Anders, Jansen, and Reyes García, *El libro del Ciuacoatl*; Quiñones Keber, *Codex Telleriano-Remensis*; Anders, Jansen, and Reyes García, *Libro de la vida*.
5. Quiñones Keber, *Codex Telleriano-Remensis*, 135.
6. Johanna Broda de Casas, "Tlacaxipehualiztli: A Reconstruction of an Aztec Calendar Festival from 16th Century Sources," 205–209.
7. Christopher Couch, *The Festival Cycle of the Aztec Codex Borbonicus*, 38–40.
8. As Couch has noted, other accounts of Tlacaxipehualiztli stress the gladiatorial sacrifices and the rituals performed by the warrior class, while the Codex Borbonicus shows commoners dressed in white maguey capes: ibid., 38.
9. Brumfiel, "Aztec Hearts and Minds," 285–286.
10. Durán, *Book of the Gods and Rites and The Ancient Calendar*, 128.
11. Catherine R. DiCesare, *Sweeping the Way: Divine Transformation in the Aztec Festival of Ochpaniztli*, 137–140.
12. Boone, "Time, the Ritual Calendar, and Divination," 13.
13. Durán, *Book of the Gods and Rites and The Ancient Calendar*, 414.
14. I am only including two scholars out of many in this discussion.

15. Pasztory, *Aztec Art*, 71, 81.
16. Clendinnen, *Aztecs: An Interpretation*, 215, 226, 230–231.
17. Durán, *Book of the Gods and Rites and The Ancient Calendar*, 124, 239 (quotation).
18. Sahagún, *Florentine Codex*, Book 10, 25–28.
19. Pasztory, *Aztec Art*, 71, 78–79.
20. The following examples are from Sahagún, *Florentine Codex*, Book 2.
21. Ibid., 44.
22. Ibid., 55.
23. Durán, *Book of the Gods and Rites and The Ancient Calendar*, 224.
24. Sahagún, *Florentine Codex*, Book 2, 121.
25. Durán, *Book of the Gods and Rites and The Ancient Calendar*, 80.
26. Pasztory, *Aztec Art*, 78.
27. Durán, *Book of the Gods and Rites and The Ancient Calendar*, 86.
28. For a more detailed account of these young adults, see ibid., 83–86.
29. Ibid., 82, 86.
30. Sahagún, *Florentine Codex*, Book 2, 7.
31. Ibid., 18, 147.
32. Durán, *Book of the Gods and Rites and The Ancient Calendar*, 88–89.
33. H. B. Nicholson, and Eloise Quiñones Keber, *Art of Aztec Mexico: Treasures of Tenochtitlan*, 113. The authors also note that these sculptures were originally thought to be temple offerings.
34. This unit of currency was so efficient that it continued in use after the Spaniards took over Aztec trade routes. Numerous postcontact sources record the complaints of Spaniards on the incredible ability of the indigenous people to create convincing counterfeit cacao beans, a practice that was already in place at the time of the Aztecs. This was no small task when we consider the unique size and shapes of individual pods.
35. Coe and Coe, *The True History of Chocolate*, 93.
36. Sahagún, *Florentine Codex*, Book 6, 256.
37. Mary Miller and Simon Martin, *Courtly Art of the Ancient Maya*, 63.
38. Durán, *Book of the Gods and Rites and The Ancient Calendar*, 203.
39. Sahagún, *Florentine Codex*, Book 6, 256.
40. Berdan and Anawalt, *The Essential Codex Mendoza*.
41. Sahagún, *Florentine Codex*, Books 4–5, 184.
42. Ibid., Book 10, 53.
43. Ibid., Book 8, 38. While the English translation of Sahagún's work uses the word "cherries," this fruit was not indigenous to the Americas, originally coming from Europe and Asia. Andrew Mariani, "Cherries."
44. Sahagún, *Florentine Codex*, Book 8, 38.
45. As quoted in Coe, *America's First Cuisines*, 74–75.
46. Sahagún, *Florentine Codex*, Book 8, 39.
47. Coe and Coe, *The True History of Chocolate*, 87.
48. Sahagún, *Florentine Codex*, Book 2, 25.
49. Ibid., 134, 137.
50. Ibid., 33.
51. Ibid., 2, 21, 115, 132, 159.

52. Durán, *Book of the Gods and Rites and The Ancient Calendar*, 136. In his accounts of rituals Durán mistakenly calls food made from maize "bread."
53. Ibid., 158.
54. Ibid., 159.
55. Sahagún, *Florentine Codex*, Book 2, 64–65.
56. Durán, *Book of the Gods and Rites and The Ancient Calendar*, 101, 105.
57. Ibid., 87.
58. Sahagún, *Florentine Codex*, Book 2, 195.
59. Durán, *Book of the Gods and Rites and The Ancient Calendar*, 95.
60. Sahagún, *Florentine Codex*, Book 2, 21, 21–22, 128.
61. Ibid., 83.
62. Durán, *Book of the Gods and Rites and The Ancient Calendar*, 94.
63. Sahagún, *Florentine Codex*, Book 2, 80, 84.
64. Ibid., 124.
65. DiCesare, *Sweeping the Way*, 150. This myth in the Legend of the Suns is discussed further in chapter 3.
66. This is also in the Legend of the Suns and is discussed further in chapter 3.
67. Sahagún, *Florentine Codex*, Book 2, 96–107 (quotations on 96, 97).
68. Ibid., Book 2, 45.
69. Caso and Bernal quoted in Miller and Taube, *An Illustrated Dictionary of the Gods and Symbols of Ancient Mexico and the Maya*, 188.
70. Sahagún, *Florentine Codex*, Book 2, 47.
71. The following information is from Sahagún, *Florentine Codex*, Book 2, 47–56.
72. Davíd Carrasco, "Give Me Some Skin: The Charisma of the Aztec Warrior," 146. In this essay Carrasco demonstrates the connection between war and renewal in the Tlacaxipehualiztli ceremony.
73. Sahagún, *Florentine Codex*, Book 2, 47.
74. Ibid., 49 (quotation), 54.
75. Ibid., 50.
76. Carrasco, "Give Me Some Skin," 148.
77. Sahagún, *Florentine Codex*, Book 2, 54.
78. Ibid., 52.
79. Ibid.
80. Most notable are Michael Harner, "The Ecological Basis for Aztec Sacrifice"; and Bernard R. Ortiz de Montellano, "Aztec Cannibalism: An Ecological Necessity?"
81. Fernández-Armesto, *Food: A History*, 33.
82. Durán, *Book of the Gods and Rites and The Ancient Calendar*, 121, 188, 223.
83. Ibid., 106.
84. Ibid., 223. The account of Chicomecoatl celebrations comes from ibid., chapter 14.
85. Ibid., 223–224, 225–226. Durán notes that there was no temple of Chicomecoatl per se, simply a chamber with her shrine.
86. Ibid., 222.
87. See chapter 1 of this book.
88. Quiñones-Keber, *Codex Telleriano-Remensis*, 217. Many sixteenth-century

writers record this great famine; see Durán, *The History of the Indies of New Spain*, chapter 2.

89. Durán, *Book of the Gods and Rites and The Ancient Calendar*, 466.

CHAPTER 3. AZTEC MYTHS, COSMOVISION, AND FOOD

1. While the author of the work has never been identified, John Bierhorst postulates that both the author and the document are Aztec: *History and Mythology of the Aztecs*, 7.

2. Legend of the Suns in ibid., 14–44.

3. Ibid., 142n3.

4. Durán, *Book of the Gods and Rites and The Ancient Calendar*, 222. The Codex Telleriano-Remensis identifies Xolotl as "lord of twins and all things that were born conjoined": Quiñones Keber, *Codex Telleriano-Remensis*, 266.

5. See chapters 1 and 2 in this book.

6. Maguey was associated with the goddess Mayahuel and the 400 "rabbits" or pulque gods. Miller and Taube, *An Illustrated Dictionary of the Gods and Symbols of Ancient Mexico and the Maya*, 138.

7. Enrique Florescano, *The Myth of Quetzalcoatl*, 53. He is using the Legend of the Suns and "Histoyre du Mechique" as his sources.

8. Sahagún, *Florentine Codex*, Book 11, 64.

9. Florescano, *The Myth of Quetzalcoatl*, 82–83.

10. Sissel Johannessen and Christine A. Hastorf, "Becoming Corn Eaters," 443.

11. Arnold, *Eating Landscape*, 159.

12. Read, *Time and Sacrifice in the Aztec Cosmos*, 69.

13. Food consumption and food transformation have been examined by various scholars, but I would like to note several works that are specifically relevant to this study. Claude Lévi-Strauss, *The Raw and the Cooked*, notes the importance of cooking as a symbol of the social and cultural. Cooked food becomes a multidimensional metaphor for a society's level of sophistication (8–43). Mary Douglas, *Purity and Danger: An Analysis of Concepts of Pollution and Taboo*, examines food consumption as a ritual that creates boundaries (specifically important is her chapter 3). A more recent work that echoes and further examines food consumption in this light is Hayden, "Fabulous Feasts," 2–4, which notes the ways in which consumption not only establishes necessary boundaries but also creates a balance within that society.

14. Read, *Time and Sacrifice in the Aztec Cosmos*, 73.

15. Bierhorst, *History and Mythology of the Aztecs*, 143–144.

16. Ibid., 146–147.

17. Ibid., 147.

18. Ibid.

19. Florescano, *The Myth of Quetzalcoatl*, 1 (quotation), 52.

20. Ibid., 63.

21. See chapter 2 in this book.

22. Arnold, *Eating Landscape*, 163.

23. Florescano, *The Myth of Quetzalcoatl*, 182.

24. Bierhorst, *History and Mythology of the Aztecs*, 147–148.
25. Sahagún, *Florentine Codex*, Book 2, 7, 36.
26. Ibid., Book 7, 44.
27. Ibid., Book 7, 5 (quotation), 44.
28. Read, *Time and Sacrifice in the Aztec Cosmos*, 24–47n19. Penance as atonement is a more modern interpretation.
29. Sahagún, *Florentine Codex*, Book 7, 5.
30. See chapter 2 in this book.
31. Sahagún, *Florentine Codex*, Book 7, 4 (quotation), Book 2, 7, 36.
32. Bierhorst, *History and Mythology of the Aztecs*, 26.
33. Peter Farb and George Armelago, *Consuming Passions: The Anthropology of Eating*, 21–23, 211 (quotation).
34. Durán, *The History of the Indies of New Spain*, 238.
35. Alvarado Tezozomoc, *Crónica mexicana*, 8.
36. Coe, *America's First Cuisines*, 89.
37. The Codex Azcatitlan, an anonymous colonial manuscript, is divided into three discernible sections: the migration of the Nahuas up to the establishment of the city of Tenochtitlan; Aztec history until the arrival of the Spanish; the conquest and early colonial history: *Codex Azcatitlan*, 1:16–22; Pérez Bolde, *Interpretación del Códice Boturini*. The Codex Boturini is one of many Aztec migration accounts, yet it does not culminate in the founding of Tenochtitlan. The manuscript thus seems to be unfinished, as it ends abruptly and prematurely.
38. *Codex Azcatitlan*, 1:52.
39. Sahagún, *Florentine Codex*, Book 11, 122–124.
40. Pasztory, *Aztec Art*, 50.
41. Federico Navarrete Linares, *La migración de los mexicas*, 52–53.
42. *Codex Azcatitlan*, 1:86–90.
43. Huitzilopochtli was the patron deity of the Aztecs. His role in their migration history is significant: it is he who orders the Aztecs to leave their city of Aztlan and begin their journey. Throughout their migration Huitzilopochtli guides them until they reach their final destination: the location of their new city, Tenochtitlan. Henry B. Nicholson, "Religion in Pre-Hispanic Central Mexico," 425–426, remarks that Huitzilopochtli was identified with an earthly leader during migration and after the rise of the Triple Alliance of the cities of Tenochtitlan, Tetzcoco, and Tlacopan about 1430. Huitzilopochtli's cult was widespread throughout the Basin of Mexico. The deity was associated with war, sacrifice, and the sun.
44. Interpretations of this scene vary in regard to which group continues the migration. See Pérez Bolde, *Interpretación del Códice Boturini*, 9.
45. The term "pulque," *octli* in Nahuatl, is of uncertain origin, yet early written colonial sources were already using the word. See Henry B. Nicholson, "The Octli Cult in Late Pre-Hispanic Central Mexico," 158.
46. Pasztory, *Aztec Art*, 200. Eduard Seler, "The Pulque Vessel of the Bilimec Collection," 206, observes that one of the traditional places given for the invention of pulque is the region of the Huaxtecs on the east coast of Mexico.
47. The Codex Mendoza (folio 71r) illustrates the death of two young men who were caught drunk: Berdan and Anawalt, *The Essential Codex Mendoza*, 147.
48. Ritual uses of pulque are discussed in chapters 1 and 2.

49. See chapter 2 in this book.
50. Sahagún, *Florentine Codex*, Book 2, 36.
51. Hassig, "The Collision of Two Worlds," 94.
52. For further information on chinampa agriculture, see Ross Hassig, *Trade, Tribute, and Transportation: The Sixteenth-Century Political Economy of the Valley of Mexico*, 47–53; and Calneck, "Settlement Patterns and Chinampa Agriculture at Tenochtitlan."
53. Hassig, *Trade, Tribute, and Transportation*, 60.
54. Díaz del Castillo, *The Discovery and Conquest of Mexico*, 215.
55. Ibid., 215–217.
56. Durán, *Book of the Gods and Rites and The Ancient Calendar*, 274.
57. Díaz del Castillo, *The Discovery and Conquest of Mexico*, 216.
58. As noted in Hassig, *Trade, Tribute, and Transportation*, 67. He does not provide a sixteenth-century source for this.
59. Ibid.
60. Blanton, "The Basin of Mexico Market System and the Growth of Empire," 78. Berdan, "The Tributary Provinces," 115, has observed that tributary provinces provided the state with a regular and predictable flow of goods and secured broad areas for relatively safe long-distance trade. She counts thirty-eight different provinces in the Codex Mendoza.
61. Hassig, *Trade, Tribute, and Transportation*, 67.
62. Ibid., 75–84 (the numbers five, nine, thirteen, and twenty are units in the Aztec calendar).
63. Durán, *Book of the Gods and Rites and The Ancient Calendar*, 273, 276. While Durán uses the word "breads," he is actually referring to maize.
64. Both Hassig, *Trade, Tribute, and Transportation*, 87; and Frances F. Berdan (in her 1975 dissertation "Trade, Tribute, and Market in the Aztec Empire" and later publications such as *Aztec Imperial Strategies*) notes the importance of trade for Aztec expansion. My point here is to stress that desired goods included everyday staples as well as goods used for special occasions.
65. All information on the myth is from Bierhorst, *History and Mythology of the Aztecs*, 15–58, unless otherwise noted. Tollan was considered by the Aztecs as the capital of the Toltecs, a central Mexican group believed to have invented the arts, writing, and the calendar. The Aztecs and many other cultural groups claimed to be descended from the Toltecs. Some scholars have linked the mythical Tollan to Tula, a city in Hidalgo, Mexico. Tula was the first large city after the fall of Teotihuacan (after 750) and flourished 950–1150. Smith, *The Aztecs*.
66. Bierhorst, *History and Mythology of the Aztecs*, 156.
67. Ibid., 156–157.
68. Johanna Broda, "Consideraciones sobre historiografía e ideología mexicas: Las crónicas indígenas y el estudio de los ritos y sacrificios," 99.

CHAPTER 4. FOOD AND RITUAL AFTER THE CONQUEST

1. Mark A. Burkholder with Suzanne Hiles, "An Empire beyond Compare," 137, 138.

2. Alfred W. Crosby, Jr., *The Columbian Exchange: Biological and Cultural Consequences of 1492*, 176.

3. Sahagún, *Florentine Codex*, Book 12, 15–16, 19. Note 2 there suggests that indigenous messengers were surprised by the offerings because the food of the Spanish should have been human hearts and human blood if they were gods. Alternatively, I suggest that Moctezuhma's messengers were surprised at the poor selections of gastronomic "gifts" befitting them as messengers of the *tlatoani*.

4. Ibid., 21, 21n5 (Anderson and Dibble identify "custard apple" as *quahtzapotl* [*Anona*]), 22n2 (Anderson and Dibble identify "American cherry" as *capuli* [*Prunus capuli*]), 22n23 (Anderson and Dibble identify "mulberry" as *amacapuli* [*Morus celtidifodia*]).

5. Janet Long-Solís and Luis Alberto Vargas, *Food Culture in Mexico*, 15. The Viceroyalty of New Spain was established in 1535. See Burkholder with Hiles, "An Empire beyond Compare," 117.

6. Coe, *America's First Cuisines*, 229. Coe does not identify her source but notes that this tribute was in 1533.

7. Coe and Coe, *The True History of Chocolate*, 110.

8. Crosby, *The Columbian Exchange*, 106. These include citrus fruits, apples, pears, cherries, mangos, grapes, strawberries, plums, peaches, bananas, melons, and watermelons, all of which arrived in the sixteenth century. For further information, see Long-Solís and Vargas, *Food Culture in Mexico*, 52–53.

9. Crosby, *The Columbian Exchange*, 70, 71.

10. Pilcher, *¡Que Vivan los Tamales!*, 34, 35.

11. Coe, *America's First Cuisines*, 233.

12. Ibid., 229.

13. As quoted in Burkholder with Hiles, "An Empire beyond Compare," 137.

14. Arnold J. Bauer, *Goods, Power, History: Latin America's Material Culture*, 87.

15. Maize continues to be used in rituals in Mexico today.

16. Long-Solís and Vargas, *Food Culture in Mexico*, 16.

17. Coe, *America's First Cuisines*, 229.

18. Long-Solís and Vargas, *Food Culture in Mexico*, 16.

19. Sahagún, *Florentine Codex*, Book 10, 80.

20. Ibid., 69, 71.

21. Burkholder with Hiles, "An Empire beyond Compare," 137.

22. Long-Solís and Vargas, *Food Culture in Mexico*, 74. Other sources, such as Susan Migden Socolow, *The Women of Colonial Latin America*, 52–59, note that the arrival of Spanish women in the Americas did increase over time, especially by the end of the sixteenth century.

23. Coe and Coe, *The True History of Chocolate*, 111. See also Socolow, *The Women of Colonial Latin America*, 62.

24. Asunción Lavrin, "Women in Colonial Mexico," 250.

25. Socolow, *The Women of Colonial Latin America*, 91.

26. Lavrin, "Women in Colonial Mexico," 269.

27. Long-Solís and Vargas, *Food Culture in Mexico*, 17, 19. For more on the many creation myths of mole poblano, see Pilcher, *¡Qué Vivan los Tamales!*, 26.

28. Pilcher, *¡Qué Vivan los Tamales!*, 26n1. For a summary of mole poblano creation stories, see Miguel Guzmán Peredo, *Crónicas gastronómicas*, 27–29.

29. Pilcher, ¡Qué Vivan los Tamales!, 25. The ingredients used by Sor Juana included cloves, cinnamon, peppercorns, coriander, and sesame seeds (Old World) and chiles, tomatoes, turkey broth, and chocolate (New World).

30. Creoles are people born in New Spain whose parents were born in Spain. Mestizos are people of mixed Indian and European descent.

31. Lavrin, "Women in Colonial Mexico," 251.

32. Pilcher, ¡Qué Vivan los Tamales!, 31.

33. Long-Solís and Vargas, *Food Culture in Mexico*, 22.

34. Pilcher, ¡Qué Vivan los Tamales!, 33.

35. Cited in Coe, *America's First Cuisines*, 241. She gives a detailed synopsis of the banquet on 241–246.

36. Bernal Díaz del Castillo, *Historia verdadera de la conquista de la Nueva España*, 2:312 ("cacao" and "fruta de la tierra"; my translation).

37. Charles Gibson, *The Aztecs under Spanish Rule: A History of the Indians of the Valley of Mexico, 1519–1810*, 348.

38. Coe and Coe, *The True History of Chocolate*, 115.

39. Long-Solís and Vargas, *Food Culture in Mexico*, 20.

40. Pilcher, ¡Qué Vivan los Tamales!, 31.

41. Coe and Coe, *The True History of Chocolate*, 125–202.

42. Gibson, *The Aztecs under Spanish Rule*, 100–101.

43. Linda A. Curcio-Nagy, "Faith and Morals in Colonial Mexico," 157.

44. Durán, *Book of the Gods and Rites and The Ancient Calendar*, 278.

45. Ibid.

46. Ibid., 410.

47. Motolinía, *Historia de los indios de la Nueva España*, 185: "Unos ofrecen maíz, otros mantas, otros comidas, pan, gallinas, y en lugar de vino dan cacao" (my translation).

48. Sahagún, *Florentine Codex*, Book 2, 118–126. For images, see Anders, Jansen, and Reyes García, *El libro del Ciuacoatl*.

49. Sahagún, *Florentine Codex*, Book 6, 256.

50. Coe and Whittaker, *Aztec Sorcerers in Seventeenth Century Mexico*, 75. Ruiz de Alarcón was born in Guerrero, where he served as a parish priest in the town of Atenango. Although the work is not from Mexico City, it is a valuable seventeenth-century source.

51. Ibid.

52. See the appendix.

53. Pilcher, ¡Qué Vivan los Tamales!, 35. Neither Pilcher nor Ortiz de Montellano provides a source for similar statements. Bernard R. Ortiz de Montellano, *Aztec Medicine, Health, and Nutrition*, 108.

54. Long-Solís and Vargas, *Food Culture in Mexico*, 41. Hernando Horcasitas and Doris Heyden have identified *alegría* as the present-day survival of these dough offerings. Durán, *Book of the Gods and Rites and The Ancient Calendar*, 80n9. If you go into any Mexican grocery you will also find amaranth bars as part of the healthier snack choices as well as amaranth breakfast cereal.

55. Coe and Whittaker, *Aztec Sorcerers in Seventeenth Century Mexico*, 172, 173, 175–181, 182–185.

56. Durán, *Book of the Gods and Rites and The Ancient Calendar*, 431–432.

57. Coe and Whittaker, *Aztec Sorcerers in Seventeenth Century Mexico*, 175.

58. Sahagún, *Florentine Codex*, Book 1, 13.
59. Coe and Whittaker, *Aztec Sorcerers in Seventeenth Century Mexico*, 171.
60. Sonia Corcuera, "Pulque y evangelización: El caso de fray Manuel Pérez (1713)," 414.
61. Ibid., 414–417; Pilcher, *¡Qué Vivan los Tamales!*, 31.
62. Long-Solís and Vargas, *Food Culture in Mexico*, 24.
63. Berdan and Anawalt, *The Essential Codex Mendoza*, 72–73.
64. Michael D. Coe, *Mexico: From the Olmecs to the Aztecs*, 187.
65. Richard F. Townsend, *The Aztecs*, 109.
66. Davíd Carrasco, "Cosmic Jaws: We Eat the Gods and the Gods Eat Us," 168. He points out that the Aztecs envisioned the earth as a gaping jaw.
67. Jeanette Favrot Peterson, *The Paradise Garden Murals of Malinalco: Utopia and Empire in Sixteenth-Century Mexico*, 11.
68. Robert Ricard, *The Spiritual Conquest of Mexico: An Essay on the Apostolate and the Evangelizing Methods of the Mendicant Orders in New Spain: 1523–1572*, 163.
69. Peterson, *The Paradise Garden Murals of Malinalco*, 22.
70. Ibid., 22, 43. Peterson describes some of the ample food supply available in the Toluca Valley. Other scholars do not agree with these dates and believe that the church is earlier in both construction and painting of the murals. See Samuel Y. Edgerton, *Theaters of Conversion: Religious Architecture and Indian Artisans in Colonial Mexico*, 213.
71. Peterson, *The Paradise Garden Murals of Malinalco*, 40. Peterson classifies them as Artist A (most skilled), Artist B, and assistants C, D, and E.
72. Ibid., 130.
73. Edgerton, *Theaters of Conversion*, 207–208, 216–217, 224, 235.
74. Ibid., 104.
75. Sahagún, *Florentine Codex*, Book 6, 256.
76. Peterson, *The Paradise Garden Murals of Malinalco*, 105. Peterson is referring to the work of H. W. Janson, *Apes and Ape Lore in the Middle Ages and the Renaissance*.
77. Elisabeth Luard, *The Latin American Kitchen*, 232.
78. Durán, *Book of the Gods and Rites and The Ancient Calendar*, 176.
79. Sahagún, *Florentine Codex*, Book 11, 117.
80. Peterson, *The Paradise Garden Murals of Malinalco*, 107; Edgerton, *Theaters of Conversion*, 223.
81. As quoted in Ana María L. Velasco Lozano, "El Jardín de Itztapalapa," 28: "Como cosa jamás soñada" (my translation).
82. Durán, *Book of the Gods and Rites and The Ancient Calendar*, 278, 410.
83. Coe and Whittaker, *Aztec Sorcerers in Seventeenth Century Mexico*, 171, 175–184.
84. Oral communication from Dr. Jane G. Landers, April 2006.
85. Durán, *Book of the Gods and Rites and The Ancient Calendar*, 278.
86. Motolinía, *Historia de los indios de la Nueva España*, 185.

EPILOGUE. SOME FINAL THOUGHTS ON FOOD

1. Pérez Bolde, *Interpretación del Códice Boturini*.
2. Legend of the Suns in Bierhorst, *History and Mythology of the Aztecs* and "Histoyre du Mechique" in Garibay, *Teogonia e historia*.
3. Sahagún, *Florentine Codex*, Book 7, 44.
4. As historian Felipe Fernández-Armesto has noted, "Staples are almost always sacred, because people depend on them: they possess divine power": Fernández-Armesto, *Food: A History*, 34.
5. Oral communication, Dr. Jane G. Landers, April 2006.
6. Alan R. Sandstrom, *Corn Is Our Blood: Culture and Ethnic Identity in a Contemporary Aztec Indian Village*. Especially important to this discussion is chapter 6, "Religion and the Nahua Universe," 229–322.
7. Sahagún, *Florentine Codex*, Books 4–5, 184–188.
8. Sandstrom, *Corn Is Our Blood*, 235–237, 240.
9. As quoted by Johanna Broda, "Templo Mayor as Ritual Space," 107.
10. Sahagún, *Florentine Codex*, Book 2, 101.
11. Timothy J. Knab, "Life in the Holy Earth—The Aztec Underworld in the Natural World of the Sierra de Puebla: A Geography," 110.
12. Timothy J. Knab, "'I Beseech Thee Most Holy Earth': Prayers for the Earth," 77, 82.
13. Sacrifices performed during specific *veintenas* are discussed in chapter 3.
14. Sahagún, *Florentine Codex*, Book 2. See the appendix for *veintenas* that include the ritual use of amaranth dough.
15. Ibid., 45.
16. Bierhorst, *History and Mythology of the Aztecs*, 146–147.
17. Garibay, *Teogonía e historia de los mexicanos*, 107.
18. For a detailed definition of *tzitzimime*, see Miller and Taube, *An Illustrated Dictionary of the Gods and Symbols of Ancient Mexico and the Maya*, 176.
19. Garibay, *Teogonía e historia de los mexicanos*, 108.
20. Ibid.: "y ordenaron que de ella saliese todo el fruto necesario para la vida del hombre. Y para hacerlo, hicieron de sus cabellos, árboles y flores y yerbas; de su piel la yerba muy menuda y florecillas; de los ojos, pozos y Fuentes y pequeñas cuevas; de la boca, ríos y cavernas grandes; de la nariz, valles y montañas" (my translation).
21. The literature on Day of the Dead celebration is quite extensive. Stanley Brandes, "Iconography in Mexico's Day of the Dead: Origins and Meaning," is particularly useful in its examination of preconquest and European models for the celebration.

BIBLIOGRAPHY

SIXTEENTH-CENTURY AND
SEVENTEENTH-CENTURY PRIMARY SOURCES

Alvarado Tezozomoc, Hernando. *Crónica mexicana, escrita hacia el año de 1598*. Notes by Manuel Orozco y Berra. Mexico City: Editorial Leyenda, 1944.

Anders, Ferdinand, Maarten Jansen, and Luis Reyes García, eds. *El libro del Ciuacoatl: Homenaje para el año del fuego nuevo, libro del Códice Borbónico*. Mexico City: Fondo de Cultura Económica, 1991.

———, eds., with Jessica Davilar and Anuschka Van't Hooft. *Libro de la vida: Texto explicativo del llamado Códice Magliabechiano*. Mexico City: Fondo de Cultura Económica, 1996.

———, eds., with Gabina Aurora Pérez Jiménez. *El libro de Tezcatlipoca, señor del tiempo: Libro explicativo del llamado Códice Fejérváry-Mayer*. Mexico City: Fondo de Cultura Económica, 1994.

Berdan, Frances F., and Patricia Rieff Anawalt, eds. *The Essential Codex Mendoza*. Berkeley: University of California Press, 1997.

Bierhorst, John, trans. *History and Mythology of the Aztecs: The Codex Chimalpopoca*. Tucson: University of Arizona Press, 1992.

Codex Azcatitlan. 2 vols. Introduction by Michel Graulich, commentary by Robert H. Barlow, translated to Spanish by Leonardo López Luján, translated to French by Dominique Michelet. Paris: Bibliothèque Nationale de France, Societé des Américanistes, 1995.

Codex Borbonicus. See Anders, Jansen, and Reyes García 1991.

Codex Boturini. See Pérez Bolde 1980.

Codex Chimalpopoca. See Bierhorst 1992.

Codex Fejérváry-Mayer. See Anders, Jansen, and Reyes García 1994.

Codex Magliabecchiano. See Anders, Jansen, and Reyes García 1996.

Codex Mendoza. Edited by Frances F. Berdan and Patricia Rieff Anawalt. 4 vols. Berkeley: University of California Press, 1992.

Coe, Michael D., and Gordon Whittaker, trans. and eds. *Aztec Sorcerers in Seventeenth Century Mexico: The Treatise on Superstitions by Hernando Ruiz de Alarcón*. Translated and edited by Institute for Mesoamerican Studies. Publication 7. Albany: State University of New York at Albany, 1982.

Díaz del Castillo, Bernal. *The Discovery and Conquest of Mexico*. Translated by A. P. Maudslay. New York: Farrar, Straus, and Cudahy, 1956.

———. *Historia verdadera de la conquista de la Nueva España*. Edited by Joaquín Ramírez Cabañas. 2 vols. Mexico City: Editorial Porrúa, 1977.

Durán, Diego. *Book of the Gods and Rites and The Ancient Calendar*. Translated and edited by Fernando Horcasitas and Doris Heyden. Norman: University of Oklahoma Press, 1971.

———. *The History of the Indies of New Spain*. Translated by Doris Heyden. Norman: University of Oklahoma Press, 1994.

Garibay, Ángel M. *Teogonía e historia de los mexicanos: Tres opúsculos del siglo XVI*. Mexico City: Editorial Porrúa, 1965. Reprint, 1979.

"Histoyre du Mechique." See Garibay 1979.

Legend of the Suns. See Bierhorst 1992.

Motolinía, Fray Toribio de. *Historia de los indios de la Nueva España*. Edited by Georges Baudot. Madrid: Editorial Castalia, 1985.

Pérez Bolde, Alfredo. *Interpretación del Códice Boturini*. Mexico City: Centro de Investigaciones Humanísticas, 1980.

Quiñones Keber, Eloise. *Codex Telleriano-Remensis: Ritual, Divination, and History in a Pictorial Aztec Manuscript*. Austin: University of Texas Press, 1995.

Sahagún, Fray Bernardino de. *Florentine Codex: General History of the Things of New Spain*. 12 vols. Translated and edited by Arthur J. O. Anderson and Charles E. Dibble, Monographs of the School of American Research, no. 14. Salt Lake City: University of Utah Press, 1950–1982.

———. *Historia general de las cosas de Nueva España*. 3 vols. Edited by Alfredo López Austin and Josefina García Quintana. Mexico City: Consejo Nacional para la Cultura y los Artes, 2000.

———. *Primeros Memoriales by Fray Bernardino de Sahagún: Paleography of Nahuatl Text and English Translation*. Translated by Thelma Sullivan. Norman: University of Oklahoma Press, 1997.

BOOKS AND ARTICLES

Anawalt, Patricia Rieff. "Rabbits, Pulque, and Drunkenness: A Study of Ambivalence in Aztec Society." In *Current Topics in Aztec Studies: Essays in Honor of Dr. H. B. Nicholson*, ed. Alana Cordy-Collins and Douglas Sharon, 17–83. San Diego Museum Papers 30. San Diego: Museum of Man, 1993.

Arnold, Philip P. *Eating Landscape: Aztec and European Occupation of Tlalocan*. Boulder: University Press of Colorado, 1999. Reprint, 2001.

———. "Paper Rituals and the Mexican Landscape." In *Representing Aztec Ritual: Performance, Text, and Image in the Work of Sahagún*, ed. Eloise Quiñones Keber, 227–250. Boulder: University Press of Colorado, 2002.

Baird, Ellen T. *The Drawings of Sahagún's Primeros Memoriales: Structure and Style*. Norman: University of Oklahoma Press, 1993.

Baudot, Georges. "Fray Toribio de Benavente Motolinía." In *Utopia and History in Mexico: The First Chroniclers of Mexican Civilization (1520–1569)*, translated by Bernard R. Ortiz de Montellano and Thelma Ortiz de Montellano, 246–334. Niwot: University Press of Colorado, 1995.

Bauer, Arnold J. *Goods, Power, History: Latin America's Material Culture*. Cambridge: Cambridge University Press, 2001.
Berdan, Frances F. "Trade, Tribute, and Market in the Aztec Empire." Ph.D. diss., University of Texas, Austin, 1975.
———. "The Tributary Provinces." In *Aztec Imperial Strategies*, ed. Frances F. Berdan et al., 115–179. Washington, DC: Dumbarton Oaks, 1996.
Bierhorst, John. "Introduction." In *History and Mythology of the Aztecs: Codex Chimalpopoca*, trans. John Bierhorst, 1–16. Tucson: University of Arizona Press, 1992.
Blanton, Richard E. "The Basin of Mexico Market System and the Growth of Empire." In *Aztec Imperial Strategies*, ed. Frances F. Berdan et al., 47–84. Washington, DC: Dumbarton Oaks, 1996.
Boone, Elizabeth Hill. "Migration Histories as Ritual Performance." In *To Change Place: Aztec Ceremonial Landscapes*, ed. Davíd Carrasco, 121–151. Niwot: University Press of Colorado, 1991. Reprint, 1999.
———. "Time, the Ritual Calendar, and Divination." In *Cycles of Time and Meaning in the Mexican Book of Fate*, by Elizabeth Hill Boone, 13–32. Austin: University of Texas Press, 2007.
Brandes, Stanley. "Iconography in Mexico's Day of the Dead: Origins and Meaning." *Ethnohistory* 45, no. 2 (Spring 1998): 181–218.
Broda, Johanna. "Astronomy, Cosmovision, and Ideology in Pre-Hispanic Mesoamerica." In *Ethnoastronomy and Archeoastronomy in the Andean Tropics*, ed. Anthony Aveni and Gary Uton, 81–110. New York: New York Academy of Sciences, 1989.
———. "Consideraciones sobre historiografía e ideología mexicas: Las crónicas indígenas y el estudio de los ritos y sacrificios." *Estudio de Cultura Náhuatl* 13 (1978): 97–111.
———. "Templo Mayor as Ritual Space." In *The Great Temple of Tenochtitlan: Center and Periphery in the Aztec World*, ed. Johanna Broda, Davíd Carrasco, and Eduardo Matos Moctezuma, 61–123. Berkeley: University of California Press, 1987.
Broda de Casas, Johanna. "Tlacaxipehualiztli: A Reconstruction of an Aztec Calendar Festival from 16th-Century Sources." *Revista Española de Antropología Americana* 5 (1970): 197–217.
Broda, Johanna, and Félix Báez-Jorge, ed. *Cosmovisión, ritual e identidad de los pueblos indígenas de México*. Mexico City: Fondo de Cultura Económica, 2001.
Broda, Johanna, Davíd Carrasco, and Eduardo Matos Moctezuma, eds. *The Great Temple of Tenochtitlan: Center and Periphery in the Aztec World*. Berkeley: University of California Press, 1988.
Brumfiel, Elizabeth M. "Aztec Hearts and Minds: Religion and State in the Aztec Empire." In *Empires: Perspectives from Archaeology and History*, ed. Susan E. Alcock et al., 283–310. Cambridge: Cambridge University Press, 2001.
———. "Figurines and the Aztec State: Testing the Effectiveness of Ideological Domination." In *Gender and Archaeology*, ed. Rita P. Wright, 143–166. Philadelphia: University of Pennsylvania Press, 1996.
———. "Meaning by Design: Ceramics, Feasting and the Figured Worlds in Postclassic Mexico." In *Mesoamerican Archaeology: Theory and Practice*, ed. Julia A. Hendon and Rosemary A. Joyce, 239–264. Oxford: Blackwell Publishing, 2004.

Brumfiel, Elizabeth M., and Lisa Overholtzer. "Alien Bodies, Everyday People and Hollow Spaces: Embodiment, Figurines and Social Discourse in Postclassic Mexico." In *Mesoamerican Figurines: Small-Scale Indices of Large-Scale Phenomena*, ed. Christina Halpern et al., 298–323. Gainesville: University Press of Florida, 2009.

Burkhart, Louise M. "Mexica Women on the Home Front: Housework and Religion in Aztec Mexico." In *Indian Women of Early Mexico*, ed. Susan Schroeder, Stephanie Wood, and Robert Haskett, 25–54. Norman: University of Oklahoma Press, 1997.

Burkholder, Mark A., with Suzanne Hiles. "An Empire beyond Compare." In *The Oxford History of Mexico*, ed. Michael C. Meyer and William H. Beezley, 115–149. New York: Oxford University Press, 2000.

Calneck, Edward E. "Settlement Patterns and Chinampa Agriculture at Tenochtitlan." *American Antiquity* 37, no. 1 (1972): 104–115.

Carrasco, Davíd. "Cosmic Jaws: We Eat the Gods and the Gods Eat Us." In *City of Sacrifice: The Aztec Empire and the Role of Violence in Civilization*, 164–187. Boston: Beacon Press, 1999.

———. "Give Me Some Skin: The Charisma of the Aztec Warrior." In *City of Sacrifice: The Aztec Empire and the Role of Violence in Civilization*, 140–163. Boston: Beacon Press, 1999.

———. "The New Fire Ceremony and the Binding of the Years: Tenochtitlan's Fearful Symmetry." In *City of Sacrifice: The Aztec Empire and the Role of Violence in Civilization*, 87–114. Boston: Beacon Press, 1999.

———. *Religions of Mesoamerica: Cosmovision and Ceremonial Centers*. San Francisco: Harper and Row, 1990. Reprint, Long Grove: Waveland Press, 1998.

Caso, Alfonso. *El calendario mexicano*. Mexico City: Fondo de Cultura Económica, 1953.

———. *El pueblo del sol*. Mexico City: Fondo de Cultura Económica, 1953.

Clendinnen, Inga. *Aztecs: An Interpretation*. Cambridge: Cambridge University Press, 1991. Reprint, 1997.

Coe, Michael D. *Mexico: From the Olmecs to the Aztecs*. 5th ed. London: Thames and Hudson, 1962. Reprint, 2000.

Coe, Sophie D. *America's First Cuisines*. Austin: University of Texas Press, 1994. Reprint, 2002.

Coe, Sophie D., and Michael D. Coe. *The True History of Chocolate*. London: Thames and Hudson, 1996. Reprint, 2000.

Corcuera, Sonia. "Pulque y evangelización: El caso de fray Manuel Pérez (1713)." In *Conquista y Comida: Consequencias del encuentro de dos mundos*, ed. Janet Long, 411–420. Mexico City: Universidad Nacional Autónoma de México, 1996.

Couch, Christopher. *The Festival Cycle of the Aztec Codex Borbonicus*. Oxford: BAR International Series, 1985.

———. "History, Description and Dating of the Manuscript." In *The Festival Cycle of the Codex Borbonicus*, 1–6. Oxford: BAR International Series, 1985.

Crosby, Alfred W., Jr. *The Columbian Exchange: Biological and Cultural Consequences of 1492*. Contributions in American Studies 2. Westport: Greenwood Press, 1973.

Curcio-Nagy, Linda A. "Faith and Morals in Colonial Mexico." In *The Oxford His-*

tory of Mexico, ed. Michael C. Meyer and William H. Beezley, 151–182. New York: Oxford University Press, 2000.

DiCesare, Catherine R. *Sweeping the Way: Divine Transformation in the Aztec Festival of Ochpaniztli*. Boulder: University Press of Colorado, 2009.

Dietler, Michael. "Theorizing the Feast: Rituals of Consumption, Commensal Politics and Power in African Contexts." In *Feasts: Archaeological and Ethnographic Perspectives on Food, Politics, and Power*, ed. Michael Dietler and Brian Hayden, 65–114. Washington, DC: Smithsonian Institution Press, 2001.

Dietler, Michael, and Brian Hayden, eds. *Feasts: Archaeological and Ethnographic Perspectives on Food, Politics, and Power*. Washington, DC: Smithsonian Institution Press, 2001.

Douglas, Mary. *Purity and Danger: An Analysis of Concepts of Pollution and Danger*. London: Routledge and Kegan Paul, 1966.

Early, Daniel K. "The Renaissance of Amaranth." In *Chilies to Chocolate: Food the Americas Gave the World*, ed. Nelson Foster and Linda S. Cordell, 15–33. Tucson: University of Arizona Press, 1992.

Edgerton, Samuel Y. *Theaters of Conversion: Religious Architecture and Indian Artisans in Colonial Mexico*. Albuquerque: University of New Mexico Press, 2001.

Farb, Peter, and George Armelago. *Consuming Passions: The Anthropology of Eating*. Boston: Houghton Mifflin, 1980.

Fernández-Armesto, Felipe. *Food: A History*. London: Macmillan, 2001.

Florescano, Enrique. *The Myth of Quetzalcoatl*. Translated by Lysa Hochroth. Baltimore: Johns Hopkins University Press, 1999.

Gibson, Charles. *The Aztecs under Spanish Rule: A History of the Indians of the Valley of Mexico, 1519–1810*. Stanford: Stanford University Press, 1964.

Godelier, Maurice. *The Enigma of the Gift*. Translated by Nora Scott. Chicago: University Press of Chicago, 1999.

González Torres, Yólotl. "El banquete como forma ritual." In *Arqueología mexicana, historia y esencia: En reconocimiento al Dr. Román Piña Chán*, ed. Jesús Nava Rivero, 119–123. Mexico City: Instituto Nacional de Antropología e Historia, 2002.

Harner, Michael. "The Ecological Basis for Aztec Sacrifice." *American Ethnologist* 4, no. 1 (February 1977): 117–135.

Hassig, Ross. *Aztec Warfare: Imperial Expansion and Political Control*. Norman: University of Oklahoma Press, 1988.

——. "The Collision of Two Worlds." In *The Oxford History of Mexico*, ed. Michael C. Meyer and William H. Beezley, 79–112. New York: Oxford University Press, 2000.

——. *Trade, Tribute, and Transportation: The Sixteenth-Century Political Economy of the Valley of Mexico*. Norman: University of Oklahoma Press, 1985.

Hayden, Brian. "Fabulous Feasts: A Prolegomenon to the Importance of Feasting." In *Feasts: Archaeological and Ethnographic Perspectives on Food, Politics, and Power*, ed. Michael Dietler and Brian Hayden, 23–64. Washington, DC: Smithsonian Institution Press, 2001.

Heyden, Doris. "Dryness before the Rains: Toxcatl and Tezcatlipoca." In *To Change Place: Aztec Ceremonial Landscapes*, ed. Davíd Carrasco, 188–202. Niwot: University Press of Colorado, 1991. Reprint, 1999.

Horcasitas, Fernando, and Doris Heyden. "Fray Diego Durán: His Life and Works." In *Book of the Gods and Rites and The Ancient Calendar*, translated and edited by Fernando Horcasitas and Doris Heyden, 3–47. Norman: University of Oklahoma Press, 1971.

Janson, H. W. *Apes and Ape Lore in the Middle Ages and the Renaissance*. London: Warburg Institute, 1952.

Johannessen, Sissel, and Christine A. Hastorf. "Becoming Corn Eaters." In *Corn and Culture in the Pre-Hispanic New World*, ed. Sissel Johannessen and Christine A. Hastorf, 427–443. Boulder: Westview Press, 1994.

Joyce, Rosemary A. "Girling the Girl and Boying the Boy: The Production of Adulthood in Ancient Mesoamerica." *World Archaeology* 31, no. 3 (Human Lifecycles) (Feb. 2000): 473–483.

Kellogg, Susan. "The Social Organization of Households among the Tenochca Mexica before and after the Conquest." In *Prehispanic Domestic Units in Western Mesoamerica: Studies of the Household, Compound, and Residence*, ed. Robert S. Santley and Kenneth G. Hirth, 207–224. Boca Raton: CRC Press, 1993.

Klein, Cecilia F., and Naoli Victoria Lona. "Sex in the City: A Comparison of Aztec Ceramic Figurines to Copa Figurines from the Temple Mayor." In *Mesoamerican Figurines: Small-Scale Indices of Large-Scale Phenomena*, ed. Christina Halpern et al., 327–377. Gainesville: University Press of Florida, 2009.

Klor de Alva, J. Jorge, H. B. Nicholson, and Eloise Quiñones Keber, eds. *The Work of Bernardino de Sahagún, Pioneer Ethnographer of Sixteenth-Century Aztec Mexico*. Institute for Mesoamerican Studies, University at Albany, NY, Studies on Culture and Society 2. Austin: University of Texas Press, 1988.

Knab, Timothy J. "'I Beseech Thee Most Holy Earth': Prayers for the Earth." In *The Dialogue of the Earth and Sky: Dreams, Souls, Curing, and the Modern Aztec Underworld*, 73–96. Tucson: University of Arizona Press, 2004.

———. "Life in the Holy Earth, the Aztec Underworld in the Natural World of the Sierra de Puebla: A Geography." In *The Dialogue of the Earth and Sky: Dreams, Souls, Curing, and the Modern Aztec Underworld*, 97–131. Tucson: University of Arizona Press, 2004.

Lavrin, Asunción. "Women in Colonial Mexico." In *The Oxford History of Mexico*, ed. Michael C. Meyer and William H. Beezley, 245–273. Oxford: Oxford University Press, 2000.

León-Portilla, Miguel. *Aztec Thought and Culture*. Translated by Jack Emory Davis. Civilization of the Ancient Nahuatl Mind Series, 67. Norman: University of Oklahoma Press, 1963. Reprint, 1990.

———. *Bernardino de Sahagún: First Anthropologist*. Translated by Mauricio J. Mixco. Norman: University of Oklahoma Press, 2002.

———. "Metaphysical and Theological Ideas of the Nahuas." In *Aztec Thought and Culture: A Study of the Ancient Nahuatl Mind*, trans. Jack Emory Davis, 62–103. Civilization of the Ancient Nahuatl Mind Series, 67. Norman: University of Oklahoma Press, 1963. Reprint, 1990.

Lévi-Strauss, Claude. *The Raw and the Cooked*. Translated by John and Doreen Weightman. New York: Harper and Row, 1970.

Long, Janet, ed. *Conquista y comida: Consecuencias del encuentro de dos mundos*. Mexico City: Universidad Nacional Autónoma de México, 1996.

Long-Solís, Janet, and Luis Alberto Vargas. *Food Culture in Mexico.* Westport: Greenwood Press, 2005.
López Austin, Alfredo. "Aztecs." In *The Oxford Encyclopedia of Mesoamerican Cultures,* ed. Davíd Carrasco, 1:68–72. 3 vols. New York: Oxford University Press, 2001.
———. *Cuerpo humano e ideología: Las concepciones de los antiguos nahuas.* 2 vols. Mexico City: Universidad Nacional Autónoma de México, Instituto de Investigaciones Antropológicas, 1980.
Luard, Elisabeth. *The Latin American Kitchen.* San Diego: Laurel Glen, 2002.
Mariani, Andrew. "Cherries." In *The Oxford Encyclopedia of Food and Drink in America,* ed. Andrew F. Smith, 1:219. 2 vols. New York: Oxford University Press, 2004.
Matos Moctezuma, Eduardo. *Vida y muerte en el Templo Mayor.* Mexico City: Ediciones Océano, 1986. Reprint, Mexico City: Fondo de Cultura Económica, 1998.
Mcpheeters, D. W. "An Unknown Early Sixteenth-Century Codex of the Crónica Mexicana of Hernando Alvarado Tezozomoc." *Hispanic Review* 34, no. 41 (Nov. 1954): 506–512.
Miller, Mary Ellen. *The Art of Mesoamerica: From Olmec to Aztec.* London: Thames and Hudson, 2012.
Miller, Mary, and Simon Martin. *Courtly Art of the Ancient Maya.* Fine Arts Museum of San Francisco. New York: Thames and Hudson, 2004.
Miller, Mary, and Karl Taube. *An Illustrated Dictionary of the Gods and Symbols of Ancient Mexico and the Maya.* London: Thames and Hudson, 1993. Reprint, 1997.
Moreno de los Arcos, Roberto. "Los cinco soles cosmogónicos." *Estudios de Cultura Náhuatl* 7 (1967): 183–210.
Morton, Paula E. *Tortillas: A Cultural History.* Albuquerque: University of New Mexico Press, 2014.
Nabhan, Gary Paul. *Coming Home to Eat: The Pleasures and Politics of Local Foods.* New York: W. W. Norton, 2002.
Navarrete Linares, Federico. *La migración de los mexicas.* Mexico City: Consejo Nacional para la Cultura y los Artes, 1998.
Nicholson, Henry B. "Fray Bernardino de Sahagún: A Spanish Missionary in New Spain, 1529–1590." In *Representing Aztec Ritual: Performance, Text, and Image in the Work of Sahagún,* ed. Eloise Quiñones Keber, 21–39. Boulder: University Press of Colorado, 2002.
———. "The Octli Cult in Late Pre-Hispanic Central Mexico." In *To Change Place: Aztec Ceremonial Landscapes,* ed. Davíd Carrasco, 158–183. Niwot: University Press of Colorado, 1991. Reprint, 1999.
———. "Religion in Pre-Hispanic Central Mexico." In *Archaeology of Northern Mesoamerica,* part 1, edited by Gordon F. Ekholm and Ignacio Bernal, 395–446. Vol. 10 of *Handbook of Middle American Indians,* ed., Robert Wauchope. 16 vols. Austin: University of Texas Press, 1971.
Nicholson, H. B., and Eloise Quiñones Keber. *Art of Aztec Mexico: Treasures of Tenochtitlan.* Washington, DC: National Gallery of Art, 1983.
Ortiz de Montellano, Bernard R. "Aztec Cannibalism: An Ecological Necessity?" *Science* 200 (May 1978): 611–617.

———. *Aztec Medicine, Health, and Nutrition*. New Brunswick, NJ: Rutgers University Press, 1990.

Pasztory, Esther. *Aztec Art*. New York: Harry N. Abrams, 1983. Reprint, Norman: University of Oklahoma Press, 1998.

Peredo, Miguel Guzmán. *Crónicas gastronómicas*. Mexico City: Fontamara, 1991.

Peterson, Jeanette Favrot. *The Paradise Garden Murals of Malinalco: Utopia and Empire in Sixteenth-Century Mexico*. Austin: University of Texas Press, 1993.

Pilcher, Jeffrey M. *¡Qué Vivan los Tamales! Food and the Making of Mexican Identity*. Albuquerque: University of New Mexico Press, 1998.

Quiñones Keber, Eloise. "The Annual Ritual Calendar." In *Codex Telleriano-Remensis: Ritual, Divination, and History in a Pictorial Aztec Manuscript*, by Eloise Quiñones Keber, 133–152. Austin: University of Texas Press, 1995.

———, ed. *Representing Aztec Ritual: Performance, Text, and Image in the Work of Sahagún*. Boulder: University Press of Colorado, 2002.

Read, Kay Almere. *Time and Sacrifice in the Aztec Cosmos*. Bloomington: Indiana University Press, 1998.

Ricard, Robert. *The Spiritual Conquest of Mexico: An Essay on the Apostolate and the Evangelizing Methods of the Mendicant Orders in New Spain: 1523–1572*. Translated by Lesley Byrd Simpson. Berkeley: University of California Press, 1966.

Robertson, Donald. "The Manuscripts of Sahagún." In *Mexican Manuscript Painting of the Early Colonial Period: The Metropolitan Schools*, 167–178. New Haven: Yale University Press, 1959. Reprint, Norman: University of Oklahoma Press, 1994.

Rojas Rabiela, Teresa. "Chinampa Agriculture." In *The Oxford Encyclopedia of Mesoamerican Cultures*, ed. Davíd Carrasco, 1:200–201. 3 vols. New York: Oxford University Press, 2001.

Salmón, Enrique. *Eating the Landscape: American Indian Stories of Food, Identity and Resilience*. Tucson: University of Arizona Press, 2011.

Sandstrom, Alan R. *Corn Is Our Blood: Culture and Ethnic Identity in a Contemporary Aztec Indian Village*. Norman: University of Oklahoma Press, 1991.

Seler, Eduard. "The Pulque Vessel of the Bilimec Collection." In *Collected Works in Mesoamerican Linguistics and Archaeology*, ed. Eric S. Thompson and Francis B. Richardson, 3:199–223. 8 vols. Culver City: Labyrinthos, 1992.

Smith, Michael E. "The Aztec Empire." In *The Aztec World*, ed. Elizabeth M. Brumfiel and Gary M. Feinman, 121–136. New York: Abrams, 2008.

———. *The Aztecs*. Oxford: Blackwell Publishers, 1996.

———. "Domestic Ritual at Aztec Provincial Sites in Morelos." In *Domestic Ritual in Ancient Mesoamerica*, ed. Patricia Plunket, 93–114. Cotsen Institute of Archaeology, Monograph 46. Los Angeles: University of California, 2002.

———. "The Rise of Aztec Civilization." In *The Aztecs*, by Michael E. Smith, 31–58. Oxford: Blackwell Publishers, 1996.

Socolow, Susan Migden. *The Women of Colonial Latin America*. Cambridge: Cambridge University Press, 2000.

Solís, Felipe, ed. *El imperio azteca*. New York: Guggenheim Museum Publications, 2004.

Super, John C. *Food, Conquest, and Colonization in Sixteenth-Century Spanish America*. Lincoln: University of Nebraska Press, 1988.

Tompkins, Ptolemy. *This Tree Grows Out of Hell: Mesoamerica and the Search for the Magical Body*. New York: Sterling Publishing Co., 1990.

Townsend, Richard F. *The Aztecs*. London: Thames and Hudson, 1992. Reprint, 2000.

Velasco Lozano, Ana María L. "El Jardín de Itztapalapa." *Arqueología Mexicana* 10, no. 57 (2002): 26–33.

Weissner, Polly. "Of Feasting and Value: Enga Feasts in a Historical Perspective (Papua New Guinea)." In *Feasts: Archaelogical and Ethnographic Perspectives on Food, Politics, and Power*, ed. Michael Dietler and Brian Hayden, 115–143. Washington, DC: Smithsonian Institution Press, 2001.

INDEX

absence, ix-x, 68–69, 77, 96
abstinence, 39, 57, 59, 65, 67–69, 78, 96
abstract, 40, 55, 69, 97
abundance, ix-x, 16, 19–21, 23–24, 35, 42, 49, 59–60, 90, 94, 110n4
acquisition, 66, 67, 70, 71, 74, 76–77, 85, 96
adornment, 23–24, 30, 41–42, 68, 89
adulthood, 24, 65, 111, 114, 128
aesthetic, 39–40, 46–47
agriculture, ix, 4–6, 10–11, 15, 23, 26, 30–32, 37, 39, 42, 46, 49, 55, 64, 74, 89–90, 96, 118n52
alcohol, 87. *See also* pulque; wine
altar, 49, 90, 97, 101
amaranth, 3, 5, 11–12, 15, 41–44, 47, 50, 61, 66, 70, 77, 89, 91, 97, 99, 103–105, 120n54, 122n14
animals, 3, 48, 63, 81–83, 86, 92, 94, 105
annual, 31, 37, 96, 108, 113
apple, 80, 92–93, 119
archaeology, 5
architecture, 1, 39, 41, 75, 121
arm, 17, 24, 28, 56
art, 1–2, 5–7, 10, 12–13, 18, 23, 38–40, 41, 44–45, 92, 97, 101, 118n65
artist, 3, 6–7, 11, 18–21, 23, 40–41, 44, 46, 61, 71, 75–77, 81, 83, 92, 121n71
Atlcahualo, 41, 53, 100, 103
atole, 53, 103–104
authority, 35, 83, 92
avocado, 80, 85

axe, 28, 98
axolotl, 64
Azcatitlan, 6, 12, 70–72, 74, 77, 95, 108, 117n37

balance, 29, 35, 44, 52, 54, 59, 99, 116n13
bananas, 85, 92, 119n8
banners, 41, 105
banquet, 17, 20–21, 29–31, 110n9, 111n28, 120n35. *See also* feasting
baptism, 17, 88, 94, 111n16
basket, 21, 28, 49, 69, 81, 90
bean, 3–4, 11, 15, 19–20, 35, 42, 44, 50, 66, 70, 76–77, 80, 83, 85, 91, 97, 103–104, 114n34
beef, 81, 85, 88, 94
beverage, 24, 45, 48, 87, 90, 101
bird, 3, 20, 23, 44, 66, 74, 94, 105
birth, 12, 15, 17–19, 23, 40, 67–68, 100–101
black, 43, 47–48, 57, 66, 80, 83
blood, 34, 46, 59, 80, 89, 91, 93, 99, 119n3
body, 4, 18, 30, 54–55, 58, 69, 78, 96, 100
bouquet, 21, 89, 111n26
bowl, 32–33, 72, 95
boy, 20, 26, 28, 36, 43–44, 48
bread, 49–50, 76, 81–82, 85–86, 88, 94, 115n52, 118n63
bride, ix, 26
burial. *See* funeral
burning, 16, 26, 31, 91

cacao, 11, 20–21, 28, 44–47, 61, 86, 88–89, 93–94, 114n34, 120n36. *See also* chocolate
Cacaxtla, 2
cactus, 47, 70, 80, 95
calendar, ix, 1, 7, 11–12, 18, 23, 26, 34, 37–39, 75, 88, 96, 108n22, 113n1, 118n62, 118n65. *See also* time; year
cannibalism, 56
canoe, 74–75
cape, 23, 28, 48, 113n8
captive, 23, 28, 34, 44, 53–56, 61
captor, 54–56
cattle, 81, 83, 86. *See also* beef
caves, 100
celebration, ix, 5, 23–24, 31, 34, 36–38, 41–43, 48–54, 56–61, 63–65, 67–68, 77, 88–90, 94, 97, 101, 111n16, 115n84, 122n21
center, 34–35, 38, 43, 56, 69–70, 72, 76, 83, 91, 109n29, 112n54
ceramic, 5, 28, 30–31
ceremony, 3–6, 8, 11–12, 15, 17–21, 23–24, 26–29, 31–32, 34–39, 41–42, 46, 48–52, 54–60, 74–75, 78, 87, 89, 93–94, 96–97, 99, 101, 115n72. *See also* ritual
chant, 90, 94. *See also* singing
chapel, 89
cheese, 85–86
cherry, 47, 80, 114n43, 119n4, 119n8
chia, 11, 21, 42, 44, 50, 61, 66, 70, 77, 91, 97, 103
chickens, 81, 83, 88, 94
Chicomecoatl, 19, 38, 42–43, 46, 50, 52, 58–59, 61, 65, 89–90, 115n84
chief, 30
child, ix, 7, 15, 17–21, 23–24, 26, 28, 34, 36, 40–41, 43, 46, 53, 56–57, 65, 69, 71, 101, 111n16
chile, 11, 26, 42, 52, 61, 79, 81, 83, 85–86, 104, 120n29
chili, 20–21, 43, 47, 58, 76
chinampa, 10–11, 74, 109–110n47, 118n52
chocolate, 9, 15, 20–21, 26, 28, 30–31, 35, 45, 47–49, 76, 81, 86–88, 93, 101, 105, 111n27, 120n29. *See also* cacao
chroniclers, 9, 16, 37, 53, 60, 74–75
church, 91–92
city, 1, 3, 6, 10–11, 32–33, 35, 38, 46, 55, 57, 69, 74–77, 81, 83, 85, 91, 95, 97, 109n29, 117n37, 117n43, 118n65, 120n50
clay, 3, 32, 40, 42, 47
cloister, 12, 92–93. *See also* convent; monastery
coast, 45, 79, 86, 109n39, 117n46
Codex Borbonicus, 6, 37–38, 42, 52, 108n21
Codex Chimalpopoca, 100, 108n13
Codex Magliabechiano, 6, 37, 56–57, 108n22
Codex Mendoza, 6, 11, 15, 19, 24–29, 46, 86, 118n60
Codex Telleriano-Remensis, 6, 37, 59–60, 116n4
colonial, 2, 5, 7, 9, 12, 38, 40, 81, 83, 85–86, 91–92, 94, 98, 107n8, 109n33, 117n37, 117n45
color, 23, 40, 42, 48, 50, 66, 103
comal, 32–33
commoner, 17, 20, 29, 38, 47, 113n8
communal, 5, 16
communion, 56, 98–99
conquest, 1–2, 7, 9–10, 12, 44, 74, 79–81, 83, 85–87, 89, 91, 93–94, 107n2 (introduction), 109n29, 117n37
consuming. *See* eating
contemporary, ix, 2, 4, 98, 101
convent, 85, 92. *See also* cloister
conversion, 4
cooking, xi, 5, 11, 20, 26, 28, 30–32, 34, 36, 43, 46–47, 48–49, 64–67, 70, 77–78, 83, 85, 86, 89, 104, 116n13
copal, 16, 21, 31
cord, 16, 31, 36–37, 41, 43, 49, 53, 56, 70, 76, 86, 98–99
corn. *See* maize
cornmeal, 51, 104
Cortés, Hernando, 79, 81, 86
cosmos, 15, 32, 40, 59, 61, 63, 65, 69, 76, 89, 96, 99–100

cosmovision, 8, 12, 65, 67, 69, 71, 75, 77
costume, 41, 43, 59, 61, 68, 89
courtyard, 31, 43
cows. *See* beef; cattle
coyote, 41, 48, 105
creation, ix, 1, 4, 8, 10, 12, 32, 35–36, 40, 52–53, 59, 61, 63, 65–69, 77–78, 97, 100–101, 110n9, 119n27
creole, 85–86, 120n30
Crónica mexicana, 6, 70
crop, 11, 76, 79, 85, 92
cross, 5, 71
cuisine, 9, 20, 85, 86, 88
cult, 117n43
cultivation, 4, 45, 64, 79, 89. *See also* harvest
cure, 8, 32
cycle, 4, 12, 15, 17, 23, 26, 37–39, 49, 64–65, 75–76, 92, 96–97, 99, 108n21, 112n54

dancing, 16, 23–24, 37, 52
danger, 51–52, 59
death, 4, 16, 17, 29–30, 32, 34, 36, 52, 56–57, 60, 87, 88, 91, 99, 101, 117n47, 122n21
decorate, 41, 42, 58–59, 61, 96. *See also* adornment
deity, x, 1–4, 6–7, 11, 15, 19, 23–24, 26, 29–32, 34–36, 38–44, 46, 48–59, 61, 63–68, 66, 68, 71, 74, 76–78, 80, 87–90, 93, 95–101, 103–105, 108, 111n34, 112n43, 116n6, 117n43, 119n3, 122. *See also* goddess; *specific deities*
design, 28, 41, 46
destruction, ix, 2, 40, 44, 52–53, 56, 59, 61, 63, 65, 67–69, 76, 78, 95–97
discovery, 66, 100
dish, 11, 36, 39, 47, 50, 58, 85–86, 90, 98
divination, 98, 108
dog, 4, 20, 30, 63, 66, 88, 94, 104
domestic, 12, 15, 17, 31–32, 34–35, 54, 64, 68, 98, 110n9, 113n75
dough, 2–3, 32, 41–44, 50–52, 54–55, 57, 61, 67, 89, 96–97, 99, 103–105, 120n54, 122n14
drawing, 19, 25, 27, 29, 41
drink, 16, 19–21, 26, 28–29, 36, 45–47, 51–52, 56, 61, 64, 72, 77, 81, 86–87, 89, 105
drunkenness, 24, 111n34
dryness, 45, 49, 104
Durán, Diego, 4, 6–7, 11, 16, 30–31, 37–40, 42–43, 45, 49–51, 57, 59–60, 63, 65, 69, 75–76, 87–88, 90–91, 93–94, 110n4, 113n75, 115n52, 115n85, 118n63

eagle, 40, 54, 70, 91
ear, 24, 41–43, 58–59, 76, 93, 104
earth, ix-x, 3–4, 23–24, 31–32, 40–41, 49–51, 63–64, 66–67, 89, 91–92, 98–101, 112n54, 121n66
earthly, 64, 70, 92, 101, 117n43
earthquakes, 68–69
east, 79, 93
eating, x, 2–5, 8–12, 17, 15, 20–21, 24, 28, 31, 34, 39, 44, 48–54, 57–61, 63, 65–67, 69, 76, 80–83, 85–90, 94–96, 98–99, 104
economy, 75, 81, 112n54
eggs, 80–81
element, 2, 4, 12, 16, 30, 39, 41–42, 46, 61, 63, 65, 89
elotl, 43
embodiment, 67
empire, 2, 39, 74–77, 95, 112n54
enemy, 16, 34, 53, 55
era, ix, 2, 35, 53, 63, 67, 78, 96
Etzalcualiztli, 51–52, 61, 90, 104
etzalli, 51–52, 104
European, 1–2, 6–10, 12–13, 18, 75, 79–88, 92–94, 98, 108n22, 120n30, 122n21
exchange, x, 9, 51, 54–56, 79, 99
expansion, 95, 118n64

face, 26, 41, 44, 56, 71, 74
family, xi, 10, 26, 54, 85, 111n28
famine, 38–39, 59–60, 68–69, 77, 115–116n88

farmers, 11, 79
fasting, ix, 39, 48, 54, 57–59, 65, 67–68, 77–78, 80, 96, 103–105
father, 88, 99
fauna, 94
feasting, 4–6, 8–12, 16–17, 19–24, 26, 28–29, 31, 35, 37–39, 41, 48–49, 51, 53, 57–59, 60–61, 65, 86, 88, 94, 101, 104–105, 109n39, 110n9
feather, 20, 23, 40–42, 48, 55, 66, 76, 103, 105
feeding, 46, 50, 80, 96, 99, 104
festival, 37, 39, 49, 52, 58, 65, 88–89. *See also* celebration
fifth, 35, 53, 63, 67–69
figure, 18, 22, 24, 29, 32, 40, 44–46, 57, 61, 63, 66, 72, 80, 82, 84
figurine, 31–33
finger, 50
fire, 23–24, 26, 31–32, 34–36, 44, 47–48, 63, 66–68, 89, 91, 105, 108n21
fish, 3, 41, 44, 63, 65–66, 74, 81, 83, 94, 105
flayed, 41–42, 54, 59, 103
flesh, 42, 44, 50–51, 54–57, 59, 89, 93, 97, 99. *See also* skin
flour, 83–84, 104
flower, ix, 16–17, 19–21, 35, 40, 47–48, 58, 63, 100–101, 104–105, 111n26
foodstuff, 3–4, 11, 21, 30–31, 63–64, 69, 75–76, 91, 95, 99–100
footprint, 19, 51, 71
force, 35, 52, 66, 91
form, 1–2, 5, 10, 16, 30–31, 34–35, 39–40, 42, 44, 52–53, 56, 64, 76, 89, 97, 99, 101
four, 15, 19, 21, 23, 35–36, 46, 52–53, 55–56, 61, 63, 65–66, 68, 76–77, 91, 96–97, 108n21
fowl, 31, 49, 81
France, 19, 25, 27, 29, 60, 72, 86, 110, 118
frescoes, 92–93
friar, 3, 6, 16, 30, 32, 37–38, 43, 50, 57, 76, 87–89, 91–92, 94, 107n10
frog, 44, 103, 105
fruit, 31, 44, 47–48, 64, 70, 76, 80–81, 83, 86, 93–94, 98–100, 103–104, 114n43, 119n8
funeral, ix, 12, 17, 29–31, 87

gallery, 46
garden, 10, 74, 79, 92–94
gender, 21, 23, 101
gift, 16, 26, 28–31, 35–37, 49, 55, 76, 89, 101, 119n3
girl, 19, 26, 43, 58, 85
goats, 81, 83
god. *See* deity
goddess, 3, 5, 19, 31–32, 40, 42, 46, 59, 89–90, 96, 100, 116n6. *See also* deity; *specific goddesses*
gold, 30, 41, 47
gourd, 28, 49, 54
grain, 12, 20, 32, 43, 47, 58, 63–64, 81, 83, 96, 104
grapes, 81, 119n8
grass, 100
green, 5, 23, 26, 36, 41–43, 47–48, 52–53, 58, 66, 76, 93, 98, 104–105
grinding, 30, 32, 34, 36, 71, 77
group, 1, 3, 8, 16, 21, 24, 37, 70–71, 73–74, 77, 85, 95, 98, 101, 107n8, 111n34, 117n44, 118n65
growth, 23, 39, 41, 50, 54–55, 64–65, 75, 76, 81, 96, 99, 105
gruel, 21, 85, 89
guest, 16, 20–21, 32, 35–36, 80, 88, 98
guide, 28, 30, 117n43

hand, 19, 24, 28, 40, 43–44, 71–72, 77, 83, 99
harvest, 4, 39, 55, 60, 64, 73, 89–90, 94, 96
head, 19, 41, 43, 51, 56, 66, 76
health, 32, 69. *See also* cure
heart, 46, 53–54, 56, 64, 72, 89, 91, 93, 99, 119n3
hearth, 27, 34–36, 50, 54, 67–68
heaven, 4, 19, 66, 100, 112n54
hen, 48–49, 55, 80, 103–104
hill, 35, 105
home, xi, 5, 9, 15, 17, 26, 31–32, 34–36, 44, 50, 54–55, 67, 69–71, 85, 90, 98, 101, 109n29

INDEX

136

honey, 11, 42, 47, 51, 81, 104
honor, 5, 16, 19–20, 23–24, 30, 34, 43–44, 48–51, 56–59, 65, 74, 89–90, 93
hosts, 16, 20–21, 31, 35–36, 66, 88, 92, 98
house, 15, 27–28, 31–32, 34, 52, 65, 70, 88
household, 10, 12, 15, 17, 31–32, 34, 36, 81
Huitzilopochtli, 31, 35, 43–44, 50–51, 55–56, 58, 71, 73–74, 89, 95–96, 104–105, 117n43
Hummingbird, 43, 104–105
hunting, 48, 74
husband, xi, 27, 29, 32
husk, 20, 64

iconography, 70, 77, 92, 112n43
identity, 2, 8–10, 15, 65, 70, 95
ideology, ix-x, 1, 8, 23–24, 36, 49, 75, 97, 101
idol, 43, 49, 51, 76, 89
image, ix, 2–3, 5–8, 12, 18–19, 21, 23, 28, 30, 34, 37–38, 41–44, 50, 54–56, 58–61, 67, 69–71, 76, 79, 83, 89, 91–95, 97, 103–105, 107n10, 111n26
impersonator, 23, 44, 50, 58–59, 61, 89
incense, 16, 27, 31, 34, 89
Indian, xii, 10, 81–88, 90, 92, 98, 120n30
indigenous, 5–9, 12, 17–19, 32, 57, 75–76, 81–88, 92–94, 98, 108n27, 114n34, 114n43, 119n3
ingredient, 85–86, 120n29
institution, xi
island, 70, 74
izcalli, 23–24, 26, 36, 41, 48, 51, 65, 105, 111n38

jade, 76, 103
jaguar, 63, 91
jaw, 121. *See also* mouth
jícama, 80
juice, 63, 72–73

kernel, 20, 47, 65–66, 80, 98
king. *See* royal; ruler
kitchen, 85

labor, 11, 40, 81, 83
lake, 10–11, 70, 74
land, 11, 30, 45, 48, 51, 69, 77, 82, 86, 92, 94
landscape, 8, 10, 94
leader, 26, 28–29, 49, 76, 117n43
liquid, 28, 72, 93
litter, 42, 58–59, 61
lobster, 47
lord, 3, 5, 24, 30, 32, 40–41, 45, 47–48, 53, 76, 99–100, 103–104, 108n21, 116n4. *See also* deity; royal; ruler

magical, 68
maguey, 4, 24, 43, 63–64, 72–73, 76, 90, 94, 100, 113n8, 116n6. *See also* pulque
maize, ix, 2–5, 11–12, 15, 19–20, 30, 32, 35–36, 41–43, 46–47, 49, 50, 52, 53, 54–55, 57, 58–59, 61, 63–65, 66, 70–71, 74, 76–77, 79–85, 88–92, 93, 94, 96–98, 100, 103–105, 115n52, 118n63, 119n15
Malinalco, 12, 91–94
mamey, 80
man, 11, 21, 23–24, 27–28, 30, 34, 38, 40, 44–45, 48–51, 53–56, 58–61, 67, 71–72, 79, 82–83, 88, 90, 93, 100–101, 103
mangos, 119n8
manioc, 80
mantle, 16, 27–28, 30, 35–36, 55, 69, 88
manuscript, xi-xii, 2–3, 5–6, 8, 11–12, 28, 37–38, 56, 67, 70, 95, 108n10, 108nn21–22, 109n33, 112n43, 117n37
market, 8, 11, 75–76, 83, 86–87, 91. *See also* tianguiz; tianquiztli
marriage, 12, 15, 17, 26–28, 85, 101
material, iv, 2, 16, 21, 23, 30, 35, 39, 41, 43–44, 54, 64, 78
Maya, 1, 45
Mayahuel, 96, 100, 111n34, 116n6
meal, 5, 43, 46, 54–55, 61, 64, 71, 77–78, 89, 93–94, 101
meat, 11, 20–21, 28, 58, 83–84, 88, 94, 105
medieval, 108n10

melons, 49, 119n8
merchant, 17, 31, 45, 89, 110n9
mestizo, 6, 70, 85, 120n39
metaphor, 13, 23, 26, 36, 42, 55, 60–61, 68, 70, 77, 96–97, 99, 101, 116n13
metl, 24, 111n34
Mexica, xi, 1–2, 6, 46, 70, 95
migration, 1, 6, 12–13, 70–73, 76–77, 95–96, 117n37
military, 28, 40, 91, 112n44
mirror, 31, 59, 65, 104
missionary, 6–7
mixing, 11, 85–86
Moctezuhma, 6, 47–49, 69, 79–80, 119n3
modern, 1–2, 13, 40, 46, 68, 98
mole, 85, 119n27
monastery, 7, 12, 87, 91–92. *See also* cloister
monkey, 63, 93
monster, 40, 100
monumental, 1, 6, 40, 44
moon, 68, 78, 96
moral, 46, 90
mother, xi, 19, 32, 46, 56, 89, 99, 104–105
Motolinía (Toribio de Benavente), 6–7, 37, 87–88, 94
mountain, 42, 52, 66–67, 77, 89, 91, 100, 105. *See also* landscape
mouth, 3, 20, 24, 28–29, 47–48, 50, 67, 71, 91–92, 99–100
Movement, x, 68–69
mulberry, 80, 119
multicropping, 10–11
multiple, 38, 40, 42, 65
murals, 12, 91–94
museum, xii, 2, 6, 44–45
mythology, ix, 4, 12, 31, 35–36, 52–53, 61, 63, 65–71, 75, 77, 95–96, 100–101, 107, 108, 113, 115n65, 118n65, 119n27

Nahua, 7, 70, 98, 101, 107n2 (introduction), 107n10, 117n37
Nahuatl, 1, 7, 68, 107n2 (introduction), 107n10, 117n45
Nanahuatl, 66–67, 78

Nanahuatzin, 68, 78, 96
narrative, 1–2, 36, 63, 65, 68, 77–78
native, xii, 38, 49, 81, 86–87, 92, 94, 107n10
natural, x, 4, 11, 39–40, 64–65, 87, 101
nature, x, 1, 10, 35, 40–41, 50, 52, 59, 65, 98, 110n9
nemontemi, 26, 111n38
nepantla, 88
netherworld, 67. *See also* underworld
newborn, ix, 17
night, 48, 51, 68, 76, 108n21
nine, 75–76, 118n62
noble, 17, 26, 36, 45
nopal, 70, 95
northern, 98
nourishment, 58, 96, 99

object, 6, 23, 30–32, 40, 57, 90
observer, 78, 96
Ochpaniztli, 31, 38, 42, 52, 89, 96–97, 104
octli, 31, 117. *See also* pulque
offering, ix–x, 2, 16, 19–21, 27, 29–31, 34–35, 39, 41, 44, 48–50, 52, 54–55, 59, 61, 68, 77, 88–89, 91, 93–94, 97, 99, 101, 110n4, 112n51, 113n75, 114n33, 119n3, 120n54. *See also* gift
old, ix, 6, 24, 27–28, 34, 36, 40, 51, 59, 79, 81–82, 85–86, 92, 94, 101, 105
Olmec, 1
omens, 32, 36, 98
orange, 48, 85
order, x, 1, 15, 17, 20, 29, 31, 38, 47, 49, 53–54, 56, 60, 64, 68, 75, 81, 83, 87, 92, 100, 117n43
organization, 2, 10–11, 17, 108n10
origin, 13, 63, 76–77, 95–96, 101, 108n13, 117n44

painters, 40–41, 92
painting, 2, 3, 5–7, 11–12, 28, 37, 42, 69, 76, 85, 91–92, 103–105, 107n10, 121n70
paper, 2, 30, 34, 41, 112n51
paradise, 92
parallel, 35, 60, 77, 101
parents, xi, 18, 26, 28, 120n30

participant, ix, 41–42, 44, 50, 54–57, 59, 61, 65, 67, 78, 96–97, 99
paste, 41
patron, 38, 43, 71, 88, 95–96, 117n43
patroness, 41
peaches, 119
performance, 4, 8, 13, 17, 34, 37, 41, 48, 55, 57–58, 67–69, 78, 83, 90, 97, 101
pictorial, 2, 4–6, 12, 37–38, 56, 59, 67, 69–71, 95, 108n21, 112n43
pigs, 81, 83
pinole, 103–104
pitcher, 32–33
plant, 3–5, 11, 24, 35, 39, 43, 46, 54, 64, 67, 70, 72, 78–79, 81, 86, 90, 92–96, 100
pleasure, 9, 16, 40
plum, 80, 119n8
poblano, 85, 119n27
pochteca, 45
pod, 44–46, 48, 61, 93, 114n34
poisoning, 87
population, 1–2, 7–8, 10–11, 74–75, 81, 83, 85–88, 92, 94
postconquest, 3, 6, 12, 89, 108n21
postcontact, 7, 93–94, 108n22, 114n34
pot, 20, 34
potato, 80, 82, 85, 90, 92
prayer, 94, 98–99
precinct, 35
precious, 23–24, 30, 41, 46, 48, 90, 99, 105
preconquest, 6, 89, 93, 101, 122n21
preparation, 11, 20, 30, 70, 77, 89, 99
priest, ix, 5, 7–8, 30–31, 34–35, 41–42, 48, 51–54, 56–59, 61, 87, 89–90, 94, 120n50
priestesses, 5, 31
primordial, 65–66, 77
private, 8–9, 15, 50, 67–68, 78, 87
procession, 26, 58, 92
produce, 49, 69, 79, 81, 83
production, 10, 71–72, 74, 86, 111
province, 2, 11, 45, 70, 80, 86, 91, 118n60
provincial, 38, 108–109
public, 8–9, 12, 15, 26, 31–32, 37, 39, 41, 43, 45, 47, 49–51, 53–55, 57, 59, 61, 67–68, 78, 91
pueblo, 7–8
pulque, 21, 24–26, 28, 34–36, 56, 64–65, 72, 74, 77, 86, 90–91, 96, 103–105, 111n34, 112n43, 116n6, 117n44, 117n46, 117n48
pumpkin, 44
punishment, 36, 68
pyramid, 43, 51

quail, 81, 103–104
Quecholli, 48, 74, 105
quesadillas, 86
quetzal, 23, 40–41, 66, 76, 103
Quetzalcoatl, 4, 49, 52, 66, 75, 77, 96, 100–101, 103

rabbit, 38–39, 44, 48, 56, 81, 105, 111n34, 116n6
raccoon, 40
rain, 29–30, 51, 66, 76, 90, 96, 104–105
rattlesnake, 46
raw, 11, 26, 64, 78, 103, 105
rebirth, 23, 41, 55, 64–66, 105
receptacle, 2, 97
recipe, 85
reciprocity, x, 20, 28, 32, 35, 50, 52, 49, 65, 98–100
red, 23, 26, 41–42, 44, 47–48, 57, 66
region, 17, 38–39, 66, 98
relief, 3, 40, 97
religion, 1–8, 10, 15, 24, 30, 31, 49, 61, 64, 66, 68, 70, 71, 74–77, 83, 85, 87–94, 107n10
renewal, 35, 42, 46, 54–56, 66, 115n72
representation, ix, 3, 8, 12, 32, 40, 44, 66, 92, 93, 97–98, 112n43
representative, 90, 96
residence, 75
riots, 91
ritual, ix-x, 1–2, 4–10, 12–13, 15–19, 21, 23–24, 26, 29–32, 34–35, 37–59, 61, 63–65, 67–71, 74–78, 81, 83, 85, 87–101, 108n22, 109n38, 110n4, 113n8, 115n52, 116n13, 119n15. *See also* ceremony
river, x, 71, 100

road, 31, 38, 89–90, 104
rope, 56, 58. *See also* cord
royal, 6, 16, 47, 49, 69
rubber, 41
rule, 46, 51, 58, 80
ruler, 6, 8, 47–48, 69, 75, 79–80, 110n9, 112n54
rural, 87, 94, 98

sacrifice, 1, 4, 23, 24, 30, 36–38, 40–42, 44, 51, 53–56, 58, 61, 63–64, 67–68, 77–78, 88, 91, 99–101, 113n8, 117n43, 122n13
Sahagún, Bernardino de, 3, 6–8, 11, 16–24, 26, 28–32, 34, 36–38, 41–42, 45–48, 50–57, 64, 68, 70, 75, 77, 79–84, 87, 90–91, 93–94, 96, 98–99, 103, 107–108n10, 108n27, 110n4, 111n16, 114n43
saint, 88
salamander, 4, 63–64, 105
sale, 75, 87–88, 91
salt, 81, 104
sapota, 80, 93
sapote, 93–94
sauce, 26, 30, 51, 105
savory, 64
scale, 29, 40, 83
scene, 16, 19, 21–24, 26, 28–29, 71–74, 93, 108n22, 117n44
school, 26
scrolls, 20–21, 24, 28–29, 71
sculpture, 2–3, 5, 40–41, 44, 50, 91, 96, 114
season, 49, 79
seed, ix, 4, 31, 41–45, 47, 50, 52, 58–59, 61, 63–64, 70, 76, 78, 83, 89–90, 96, 103–105, 120n29
sell, 75, 81, 83–84
sequence, 17, 21, 37
series, 12, 35, 37, 74, 91, 96
serpent, 2, 32, 46, 48, 61, 63, 66, 90–92, 100, 103, 105
servants, 30
server, 17, 21
service, 11, 43–44, 71
settlement, 1, 70, 81
shapes, 30, 40, 42, 74, 101, 114n34

sheep, 81, 83
shield, 23, 28, 71
shrimp, 105
shrine, 5, 34, 42, 51, 61, 76, 101, 113n75, 115n85. *See also* altar
sign, 34, 36, 40, 51, 68, 70, 88, 90
silver, 30
singing, 16, 23–24, 37, 52, 89. *See also* chant
size, 1, 10, 44, 46, 89, 114n34. *See also* scale
skeletons, 2
skill, 41, 74
skin, 23–24, 42, 54–55, 59, 100. *See also* flesh
sky, 67
slave, 23, 76, 104
small, 7, 10, 18, 28, 32, 40, 43, 47, 49, 51, 76, 90–91, 98, 103–105. *See also* scale
smoking, 16, 65, 104
snake. *See* serpent
society, 3, 5, 8–9, 12, 16–17, 21, 24, 26, 29, 35–36, 39–40, 43, 47, 53, 65–66, 69, 74, 82, 85, 87, 89, 91
soil, 10, 79
solar, ix, 12, 34, 37, 43, 55, 96
south, 1, 83
speak, 24, 43, 71
specialist, 5, 18, 98
spell, 90
spider, 93
spirit, 32, 55, 67, 91, 97–98, 101
spring, 64
squash, 3, 11, 42, 44, 47, 58, 61, 90, 104
stage, 5, 50, 59, 64, 69
stand, 59, 86, 91, 99
staple, 4, 10, 13, 15, 35, 47, 54, 61, 63–64, 66–67, 71, 76, 81, 83–84, 97, 118n64, 122n4
stars, 67–68, 96
starving, 32, 60
stew, 20, 43, 48–49, 54, 103
stick, 72, 90
stone, 2–3, 6, 23, 30, 32, 34, 36, 41, 44, 50, 54–56, 67, 71, 76–77, 91, 95, 97–98
straw, 27, 63

strawberries, 119n8
stream, 18, 71
structure, 17, 20, 82
style, 40, 47
subject, 3, 9, 91
substance, 13, 54, 64, 99
substitution, 30, 85–86
success, 34, 36, 70, 76–77, 81, 95
sugarcane, 86, 92
sun, 3–4, 6, 35, 53–56, 63, 65–69, 77–78, 95–96, 100, 115nn65–66, 116n7, 117n43. *See also* solar
superfood, 46, 61
supply, 81–82, 91
sustenance, 10, 12, 30, 32, 50–51, 54, 56, 67, 71, 74, 90, 95, 98–99
sweeping, 31, 38, 89, 96, 104
sweet, 80, 89–90, 92–93, 101
symbol, ix, 4, 13, 42, 46, 59, 66, 70–71, 77, 93, 95–97, 112n43, 116n13
system, 11, 69, 74–76, 80–81, 86

Tainos, 79
talocan, 99
tamale, 9, 20–21, 23, 26, 28, 30, 34, 36, 41, 47–49, 53, 83–84, 103–105, 112n43
taste, 19, 48, 70, 82–83, 86, 88
tear, 4, 71, 100
Tecuiciztecatl, 68, 78, 96
teeth, 3, 43
temple, 5, 23, 26, 31, 34–35, 42–44, 49, 52–54, 56–58, 61, 70–71, 75, 91, 96, 114n33, 115n85
Tenochtitlan, 1–2, 6, 10–11, 31, 38, 47–48, 55, 70, 74–75, 91, 95, 109n29, 112n54, 117n37, 117n43
Teotihuacan, 118n65
Tetzcoco, 1, 7, 109n29, 117n43
Tezcatlipoca, 4, 50, 57, 65, 96, 100–101, 104
theme, 8, 28, 31, 92
thirteen, 75–76, 118n62
threat, 12, 39, 51–53, 87. *See also* danger
three, 4, 20–21, 23, 34, 46, 48, 55–56, 63–64, 67, 77, 81, 117n37
tianguiz, 76

tianquiztli, 75
time, ix, 2, 10, 15, 23–24, 26, 28–30, 35, 37–38, 40, 47, 51, 53, 56–58, 60, 63, 66–68, 71, 74, 78, 83, 86, 88, 90–91, 93, 96, 98, 100
Tlacaxipehualiztli, 38, 53–54, 93, 103, 113n8, 115n72
Tlaloc, 3, 29–30, 41, 49, 64, 76, 96, 99, 103
Tlatecuhtli, 3, 40, 96
Tlatelolco, 1, 75
toasted, 41, 43, 103–104
tobacco, 16–17, 20, 90
Tollan, 76, 118n65
Toltec, 2, 76–77, 118n65
tomatoes, 47, 52, 61, 76, 94, 120n29
tonalpohualli, 37
tool, 34, 36, 55, 90
topic, 9, 37, 108n10
tortilla, 5, 10, 24, 30, 32, 41, 43, 46–47, 53, 80–81, 83, 86, 89, 97–100, 103, 105
town, 7, 32, 38, 88, 92
trade, 11, 45, 75–76, 81, 114n34
transformation, 4, 13, 24, 26, 56, 61, 63–65, 67–68, 77, 95–97, 101, 116n13
tree, 45–47, 65, 71, 76, 81, 86, 93–94, 100
tributary, 91, 118n60
tribute, 2, 11, 45, 70, 75, 80–81, 95, 112n54, 119n6
Tula, 118n65
tuna, 47, 70, 80
turkey, 28, 48–49, 55, 63, 80, 103–104, 112n43, 120n29
turquoise, 23, 104
twin, 4, 63, 116n4
two, 9, 21, 28, 34, 37, 44, 46, 57, 59, 61, 63–64, 66, 69, 71, 81, 83, 86, 88–89, 91, 100–101, 107, 112n43, 113n14
tzoalli, 42–43, 51–52

uncooked. *See* raw
underworld, 30, 112. *See also* netherworld
universe, 1, 15, 36, 63, 65, 67, 69, 96

value, 41, 43, 45, 83, 86
vegetables, 3, 10, 59, 76, 81
vegetation, 23, 95
veintena, 12, 31, 37–39, 41–42, 46, 48, 50–53, 55, 57–61, 65, 74, 96–97, 99–100, 103–105, 108n21, 112n54, 122n13
vessel, 18, 20–21, 28, 30, 54, 56, 69, 71–72, 93, 112n43
viceroyalty, 85, 86, 91, 107n8, 109n33
victim. *See* sacrifice
viewer, 19, 46, 83, 94
village, 38, 88, 98
violence, 12, 52
visual, 2, 5–6, 11, 39, 41–42, 49, 55–56, 61

wafer, 94, 98
wall, 92–93
war, 2, 8, 28, 34, 54–56, 71, 95, 115n72, 117n43
warrior, 2, 28, 40, 45, 53, 55–56, 71, 91, 113n8
water, 18–20, 23, 29, 32, 41, 47–49, 63, 76, 80, 90, 99–100, 103, 105
watermelons, 119n8
wealth, 2, 5, 16, 20–21, 23, 35, 45
weapon, ix, 12, 39, 51, 55, 100

wedding, 26–28, 31, 87–88, 94
wheat, 81–83, 86, 94
white, 20, 43–44, 47–48, 66, 80, 103–104, 113n8
wife, xi, 27–28, 57, 69, 85
wine, 21, 31, 51, 79–81, 85, 88–89, 91
woman, 5, 11, 20–21, 23–28, 30–34, 40, 42, 50–51, 53–54, 59, 67, 71, 77, 83, 85, 87, 101, 119n22
wood, 2–3, 41–43
word, 23, 28, 43, 68, 79, 91, 93
writing, 7, 30, 50, 64, 85, 89, 118n65

xihuitl, 37
Xilonen, 5, 104
Xiuhtecuhtli, 26, 34, 44, 48, 89, 104–105
Xochicalco, 2
Xochimilco, 71, 77
Xolotl, 4, 63–64, 77, 116n4

year, xi, 2, 6–7, 9, 23–24, 34–35, 37–39, 46, 59, 64, 68, 70, 74, 76–77, 80, 96, 100, 108n21. *See also* calendar; time
yellow, 23, 66, 80
yield, 10–11
youth, 15, 16, 26, 28–29, 43–44, 48, 51, 58–59, 85, 101

www.ingramcontent.com/pod-product-compliance
Lightning Source LLC
Chambersburg PA
CBHW020915180526
45163CB00007B/2738